THE
PHOTOGRAPHY
GAME

By the same author

How to Take Better Pictures

Creative Photography

With Alfred Eisenstaedt
The Eye of Eisenstaedt

THE PHOTOGRAPHY GAME

What It Is and
How to Play It

by

ARTHUR GOLDSMITH

A Studio Book

New York • The Viking Press

ACKNOWLEDGMENTS

The author wishes to thank the following for their kind permission to reprint material from the articles listed below:
Infinity: The Ambiguity of the Photographic Image. Copyright © 1964 by American Society of Magazine Photographers, Inc. *Dorothea Lange: A Harvest Of Truth.* Copyright © 1966 by American Society of Magazine Photographers, Inc. *The Eye of Eisenstaedt.* Copyright © 1966 by American Society of Magazine Photographers, Inc.
Photography Annual: How to Look at a Photograph. Copyright © 1965 by Ziff-Davis Publishing Company.
Popular Photography: Getting Started as a Pro. Copyright © 1969 by Ziff-Davis Publishing Company. *What You Should Know About Model Releases.* Copyright © 1970 by Ziff-Davis Publishing Company. *W. Eugene Smith Talks About Lighting.* Copyright © 1956 by Ziff-Davis Publishing Company.
35-MM Photography: Cartier-Bresson Revisited. Copyright © 1960 by Ziff-Davis Publishing Company. *Seeing, or How to Use All 24 x 36.* Copyright © 1969 by Ziff-Davis Publishing Company.
Travel and Camera: Eisenstaedt: A Snapshot. Copyright © 1969 by U.S. Camera Publishing Corp.

FOREWORD

In writing this book I have had occasion to draw upon the knowledge, expertise, advice, and insights of many more friends and colleagues in photography than it is possible to list individually. My thanks to all the people over the years who have been so helpful to me when I needed information and so generous in sharing their experiences with me.

In particular, my thanks to my former employer, the Ziff-Davis Publishing Company, and to Sidney Holtz, publisher, for permission to reproduce in full and in part a number of articles written for *Popular Photography, Photography Annual,* and *35-MM Annual*; to *Photographic Business and Product News* and publisher Rudolph Maschke, to adapt material originally prepared for my column in that publication, and to the American Society of Magazine Photographers and their official publication, *Infinity,* to reproduce articles which originally appeared there.

Also, special thanks to members of the Guiding Faculty of Famous Photographers School: Richard Avedon, Richard Beattie, Joseph Costa, Arthur d'Arazien, Alfred Eisenstaedt, Harry Garfield, Philippe Halsman, Irving Penn, Bert Stern, Ezra Stoller, and Victor Keppler for much valuable information gleaned during conversations and interviews. My appreciations to Charles Reynolds for so often serving as a sounding board for many of my ideas, to Bryan Holme for encouraging me to write this book, and to Grace Boutin for her excellent typing and manuscript proofreading.

Arthur Goldsmith

For

Carol, Art, Jimmy, Sue, and Amy

CONTENTS

PART I

EYE AND CAMERA

IF LOUIS JACQUES MANDE DAGUERRE AND JOSEPH NICÉPHORE NIEPCE HAD IT TO DO ALL OVER AGAIN, WOULD THEY?

Of course they would.

There is a time when certain ideas, insights, inventions, and technological breakthroughs are in the air, permeating it like an invisible virus, contagious to any number of sensitive minds. Photography was like that in the early decades of the nineteenth century. No single individual invented it; the birth occurred simultaneously through a number of gifted individuals in the Western world.

Elements of the fundamental technology had been in existence for some time. Arabian physicist-mathematicians and Renaissance princes had worked out and produced the optical apparatus necessary for photography. Upside-down and inverted left-to-right on the wall of the *camera obscura*—literally, a "dark room"—you could see projected an image of the sunlit world outside: a source of amusement and wonder. Later the *camera obscura* was miniaturized into a portable box with a mirror and ground-glass top, remarkably similar to contemporary single-lens-reflex cameras in design. You could put a piece of translucent paper on the ground glass and trace the reflected image of the scene as viewed by the lens. The trick, obvious in concept but elusive in practical application, was how to capture *instantaneously* this image in all its faithful detail.

Thomas Wedgwood, a member of the Wedgwood family of dinnerware fame, scored a near miss in his experiments to record permanently images from the *camera obscura*. In France Joseph Nicéphore Niepce (pronounced nyeps) created a protophotographic process he called heliography. He managed to capture, in an image still reproducible today, a view from the window of his house. Working independently along similar lines was a younger, more flamboyant personality, Louis Jacques Mandé Daguerre. A minor painter, colorful showman, and inventor of the Diorama (practically the Disneyland of its day), he successfully fixed a visual image onto a sensitized, silver-plated sheet of copper, the daguerreotype. Niepce and Daguerre worked together as partners during the older man's later years. Daguerre was known by later generations as the "inventor" of photography, but more recently Niepce has come into his own, deservedly, as the equally famous "forgotten" father of the invention.

Meanwhile, back in England, inventor William Henry Fox Talbot, a rival of Daguerre, independently evolved his own method for making permanent images—the calotype, the first successful negative-to-positive process and the first process to use the "latent" image formed by the action of light on silver halide. Thus the technological mainstream of photography, until the dawn of the electronic age, was set by Talbot. The distinguished British astronomer, Sir John Frederick William Herschel, after hearing the news of Daguerre's and Talbot's success, invented his own photographic process within a few weeks. A key chemical in the Herschel process was a sour-smelling acid mix called "hypo," which has been in use ever since. It was Sir John, too, who coined the phrase "photography," from the Greek *photo* (light) and *graphia* (drawing). (Sir John, it might be noted, is the only photographer to be buried in Westminster Abbey; he lies near Sir Isaac Newton.)

These men, and the general public too, were quite aware of the enormous importance of what they were doing, although they could not, of course, comprehend the ultimate scope and ramifications of what they wrought. When Daguerre made his process public in Paris on August 19, 1839, the event stimulated tremendous popular excitement. It was recognized, in an age both impressed by and accustomed to technological breakthroughs, as a major achievement, even as people a hundred-plus years later would understand that something radical and profoundly new had beeen born with the unleashing of atomic power.

Some even considered the discovery to be sacrilegious. The *Leipziger Stadtanzeiger* commented: "The wish to capture evanescent reflexions is not only impossible, as has been shown by thorough German investigation, but the mere desire alone, the will to do so, is blasphemy. God created man in His own image, and no man-made machine may fix the image of God. Is it possible that God should have abandoned His eternal principles, and allowed a Frenchman in Paris to give the world an invention of the Devil?" (Quoted by Helmut and Alison Gernsheim in *The History of Photography, 1685–1914.*)

What did the pioneers of photography think they had accomplished? We can only guess, based on what they wrote and how they acted. Photography was, above all, a labor-saving device, a democratization of the artistic process which made visual art, in the form of the portrait, the scene, the historic landmark, suddenly accessible to a far wider audience than ever before. What it formerly took a skilled artist hours, days, weeks, or even months to render could be recorded in a tiny fraction of that time and in far more faithful detail by a person with no talent or training in drawing at

all. The camera was a "mirror with a memory," according to Oliver Wendell Holmes. Photography was "the pencil of nature," in the phrase of Talbot. Every man became potentially (so it seemed) a Rembrandt. The economic and sociological implications of this were clearly recognized. Other potential effects, in the area of communications and man's perception of the universe, were less obvious. They are, in fact, only beginning to be recognized and at least partially understood today.

The early pioneers believed there was money to be made with this fantastic new invention. They were right about that. In the United States alone, in 1970, the gross national photo product (the net value of photographic goods shipped to the American market) was about $4 billion, most of which was supplied by about 540 companies. More than sixty million still cameras, from instant-loads to Hasselblads, are currently in use, and amateur photographers in the United States take an incredible four and a half billion pictures each year. (More than 70 per cent of these are in color, and about ten out of twelve shots come out all right). To have this astronomical quantity of film processed, United States amateurs pay more than $800 million a year to some 3500 photofinishing laboratories. Vast sums are spent on photography by industry, the graphic arts, the medical and dental professions, and in scientific research. In the past five or six years expenditure in the audio-visual field alone—money spent mostly on photography—rose from $650 million to $1.26 billion. Eastman Kodak, Agfa, Polaroid, Bell & Howell, and other corporations have become international Goliaths of photography. The highest-paid practitioners of photography gross several hundred thousand dollars a year.

The camera has become a status symbol, too. I landed at Orly, outside of Paris, one day. As I walked away from the plane, I noticed a man from the first-class section, obviously a Rich American, portly and sixtyish, followed at a respectful distance by that rarity today, a faithful retainer. The man was carrying only one item of impedimenta: a bright, immaculate Hasselblad. Halfway across the embarkation strip, the Rich American halted momentarily. "Henry, my camera, please," he said. Taking the camera with the air of an expert hunter accepting an elephant gun from his native bearer, he fiddled with the controls and took a bead on the 707 behind us. I could hear the mirror click. One shot. "Thank you, Henry," he said, returning the Hasselblad. They continued the walk toward the airport buildings, Henry several paces in the rear, bearing the Hasselblad, its chrome gleaming in the sunlight.

But there is the anti-status of newness, too. Among the young

magazine photographers of the 1950s, it was considered humiliating to be seen with a brand-new gadget bag. When it became necessary to buy a new bag, the accepted practice among some of my friends was to drag it behind a car for several days, until it was thoroughly battered, before they'd appear in public with it.

In the Western world and Japan, photography has become a great folk art, although "art" is too self-conscious a word for the activity of millions of amateur photographers. For them, the takers of billions of snapshots every year, the camera is not "art" but a means of documenting moments of importance and significance in their lives: weddings, family picnics, a new baby, birthday parties, vacations, travel. Time, place, and event are crystallized for a more or less permanent record; fragments plucked from the seamless web of experience to be recalled at pleasure, fragments with remarkable nostalgic power. For novelist Marcel Proust, the past was evoked by the almost forgotten taste of a cookie dipped in tea. Along with taste and smell, photographs possess this ability to conjure up a vivid re-experiencing of time past. "Did I ever really look like that? Did we ever look so young? See, there's What's-his-name. . . . I'd forgotten all about him." So much that we have forgotten is brought to consciousness again by a snapshot and its triggering of total recall.

Thus photography gives everyone a measure of power over time and a kind of partial immortality. Sometimes, indeed, the snapshot does reach the level of art, a spontaneous, naïve, artless kind of art. But the vast majority of amateur photographers, the "mass market" so important to manufacturers of film and simple cameras, do not think of photography in these terms at all. For them, its value lies in personal documentation.

However, photography also has evolved as a form of creative visual expression. One result has been to force contemporary painting and graphic art away from the representational, to the increasingly abstract and expressionistic. *The New York Times* critic John Canaday expressed it well in the title of a chapter in his book *Culture Gulch* (published by Farrar, Straus & Giroux), "The Camera Did It. Why Deny It?"

According to Canaday, "The camera's invasion of a world that has been the painter's domain since prehistoric times created changes so fundamental, so preempting the foundation upon which painting has always rested, that we must recognize the calamitous truth that painting in the twentieth century has been mostly a matter of redesigning a weakened superstructure."

What the camera did, of course, was to make the ability to draw less relevant. Representational painting became outmoded because it

now proved to be inefficient and unnecessary. The camera lens could record almost instantaneously, in far more accurate detail, the visual details that a skilled draftsman would slave over for a long period of time. Until the invention of photography, only a trained and talented artist could reproduce segments of the vast three-dimensional world of visual reality onto a small, flat piece of paper or canvas. "When only men could do this," Canaday comments, "their painted worlds held a kind of magic. . . . But when a machine learned to do it, the magic was gone." Not gone, but transferred. The photographer/magician usurped some of the traditional role assigned to the painter/magician. He could do it better, more quickly, and less expensively.

So it was more or less open warfare from the very beginning. The nonphotographic artists had centuries of prestige on their side. If you take a yardstick as the rough measure of the time span in which man has been known to create graphic representations of the visible world, you have a spread equivalent to at least 10,000 years. The written word comes in at approximately the 18-inch mark, giving writers a junior but important status. Photography appears only within the last half-inch or so.

"Is photography really an art?" The debate has been going on for more than one hundred years. The painters have consistently overemphasized the mechanical aspects of photography—the fact that a machine (the camera) actually records the image—and have undervalued the role of the guiding human eye/brain/heart that controls the machine. The photographers, on the other hand, sometimes have fallen into a countertrap of claiming that a photograph "is just the same as" or "just as good as" or even "superior to" a painting. A meaningless, if humanly understandable kind of gamesmanship. Today almost the worst insult you can inflict on a photographer is to tell him that one of his pictures "looks just like a painting," and, conversely, to praise the "photographic realism" of a contemporary painter is likely to make him want to punch you in the nose.

Photography is photography. It can do things that other visual, graphic media cannot do. It has its own limitations, powers, and conventions. The evolution of photography as an art form has been a progressive discovery of the potentials and power of the medium, not as a substitute for or a displacement of painting, but as a new entity unto itself. Today photographs are acquired for the permanent collections of leading art museums, bought by a small but growing group of connoisseurs, and reviewed by critics in the pages of important cultural publications. A start.

But photography, as an art, still rides in the back of the bus.

Little things give its relative status away. At the Museum of Modern Art, a pioneering institution in the recognition of photography as an art, the Photography Department, both its permanent exhibition space and administrative offices, is located in one of the less accessible areas, on higher floors, away from the main bank of elevators. In *The New York Times'* Sunday "Arts and Leisure" section you will habitually find that "Art" is reviewed about ten pages sooner than "Camera," which is followed only by "Gardens," "Coins," "Stamps," and "Home Improvement." Among all the art galleries, there are only a few devoted in whole or in part to photography. Nobody has yet discovered a way to sell photographs, on a wide scale and at comparable prices, to a public which buys paintings, lithographs, water colors, etchings, and pencil sketches. There is a long way to go before photography firmly establishes itself as a member of the visual establishment, although it seems certain to happen.

The early pioneers evidently sensed the radical implications of the camera as it applied to "art." What they were not able to see so clearly was the profound impact it would have on communication. The leverage of the still photograph first was multiplied by the development of means of mass print reproduction: the halftone plate, the high-speed rotary press, the proliferating transport system for distribution. We had *Godey's Lady's Book*, the New York *Daily News*, the *Berliner Illustrierte*, the *National Geographic*, *Life*, *Look*, and *Paris Match*. Then came a further multiplication via electronic reproduction. There are network TV and closed-circuit TV and, coming up fast, video tape and EVR cartridges which you plug into your TV set, plus facsimile, video telephones, cable distribution of images, the linking of giant computers to the retrieval of photographs, and other developments not yet imagined. The multiplication potential of visual images is continuing to expand at an explosive rate.

How many photographs did you see today?

On an ordinary day, for most of us, the number is in the hundreds if not the thousands, serving the purposes of information, advertising, propaganda, education, public service, entertainment, and aesthetic pleasure.

Photographs have created a new reality, the reality of the remembered image, not seen firsthand with our own eyes, but through the camera's eye. It is unlikely that you ever met Churchill or Einstein in person, but you probably have a vivid mental image of both men. What you are seeing, in your mind's eye, probably is Karsh's portrait of Churchill and Halsman's portrait of Einstein. "Photographs used to be a reflection of the world," Canaday further comments in his

chapter on the camera, "but now we see the world in terms of photographs."

Both Niepce and Daguerre would be astonished, I think, if they could see the impact of photographs in the area of human communication. It took the prophetic, if sometimes distorted vision of Marshall McLuhan to indicate the scope and power of this visual universe. But we know now that we are experiencing a world in which the spoken and printed word are losing their primacy of place as the media of communication, while the visual image, including the still photograph, is growing in importance. If we ever reach a functioning global culture, photography will of necessity play an essential role. You do not have to translate a photograph into German, French, or Japanese to communicate a message.

But of course Niepce and Daguerre and all the other pioneers of still photography could not have been expected to be so farsighted. One of the factors which involved them, more than a hundred years ago, and which involves anybody who picks up a camera today, is the *fun* of photography. It is such a fascinating blend of the mechanical and the artistic, of chemistry and creativity. Magic, the magic of the painter which Canaday speaks of, becomes your own. The act of photographing is not only a mechanical but also a very human performance. When the first man since the birth of the universe landed on the moon, his first act upon setting foot on the lunar surface was not picking up the contingency sample of soil, according to the schedule, but to take a photograph. "Look, Ma, here we are" . . . at Niagara Falls, the Empire State Building, the Eiffel Tower, the Sea of Tranquillity, or Jupiter or a planet in the Andromeda Galaxy or wherever.

Photography is an extraordinarily absorbing, challenging, and uninhibited way of relating to the universe. When I talk to photographers, whether they're dedicated artists or successful businessmen in this field, there is almost always a common bond. They are in it, they stick with it, they love it because it is so much fun, although they might never be willing to admit that simple truth to themselves or to anyone else.

Photography *is* fun. It's a game, a great game, to be played sometimes for the highest of stakes, against the intractable forces that try to prevent you from getting the picture you want and need to get.

What follows is an informal and personal introduction to that game: a kind of guidebook, survival manual, and stimulant for anybody starting out in photography. I hope it will help you along your way.

A CRASH COURSE IN PHOTOGRAPHY

You can talk about writing without getting involved in how an IBM electric typewriter works, but you can't discuss photography intelligently without knowing a few fundamental facts about cameras and the photographic process. Photography is (can be) an art; it also is a science. It has its creative but also its mechanical aspects, and the two are as profoundly interlocked as the symbols for yin and yang.

If you're already an experienced photographer, beautiful. You can skip this chapter. But if you are not yet photographing or are just beginning to become actively involved with a camera, follow me. I will give you as brief and as nontechnical a rundown on cameras and the photographic process as I can. I don't really assume you're an absolute idiot—except maybe about math and mechanics. But we all were absolute idiots when we started out in photography. When you finish reading this chapter, you won't know much. But you'll know something, enough to join the club at least, and that's a start.

The photographic process is a remarkable chain of events. It begins when an image from the world "out there," the solid, three-dimensional domain of physical reality, is projected onto the light-sensitive surface of film. You can see this image—on the ground-glass back of a view camera, for instance—an upside-down, detailed little picture of whatever the camera lens happens to be looking at, a pattern of lights and darks, of shapes and colors.

The energy of light, during exposure, transplants this visible optical image into an invisible "latent" image on the film. Whenever you trip your camera's shutter, you are tapping a minute fraction of solar energy.

The latent image is a somewhat Zen-like conception. Trying to imagine it is like trying to imagine the sound of one hand clapping. You can't see it. If you could see it, it wouldn't be a latent image.

18

It is only a potential for a picture, not a picture, a matter of changes at the sub-atomic level in the grains of silver bromide on the emulsion. But the latent image exists, in its ghostly way, and it can endure. Exposed film retrieved decades later from an ill-fated Arctic expedition was developed, the pictures "came out" and were published in *Life*. Better late than never.

We do not usually wait so long. Photographers are an impatient breed, always in a hurry to see results. So we send the exposed film to a processing service as fast as we can, or go into the darkroom ourselves.

"Developing" is the chemical process that converts the latent image into a visible form. It has to take place in darkness. For a specified time and at a specified temperature the film is immersed in a solution called the developer. The silver molecules which were affected by light are converted into black, metallic silver. The potential becomes a fact.

After a thorough rinse the film next goes into the "hypo," a sour-smelling acid solution that washes away the unexposed silver, leaving a fixed and permanent image. The light can come on. (Color film requires additional steps.)

What you now have, of course, is a "negative," the familiar translucent image with all the tones reversed: what was white is black, and vice versa. The negative is a master stencil from which any number of positive duplicates—"prints"—can be made.

The payoff, the ultimate product, is the print itself. Making a print involves a repeat of the initial process. Light is projected through the negative onto the light-sensitive surface of a sheet of printing paper. The paper is developed and fixed. (One of the Great Moments in photography is the first time you see one of your own pictures materializing on the surface of a print under a darkroom safelight.)

The printing process reverses the tones again. It is a negative of a negative, which means it is a positive, and we are back where we started from, tonally speaking. White is white again and black is black.

There are two kinds of prints—"contacts" and "enlargements." A contact print is made by placing the negative in direct contact (hence the name) with a sheet of printing paper. The resulting print thus is exactly the same size as the negative from which it was made. For an enlargement, a magnified image of the negative is projected onto a sheet of printing paper. It is a "blowup," to whatever size you want. Commonly used standard sizes of enlargements are 8 × 10 inches (for press releases, newspaper reproduction, and other workaday purposes), 11 × 14 inches (for the shots you're really proud of),

and 16 × 20, 24 × 30, and 30 × 40 (for display and exhibition). A creative and practical advantage to enlargements is that you can "crop" the picture—i.e., enlarge only a selected portion of the negative.

Now let us backtrack to the camera and see what happens during the moment of truth when you trip the shutter.

I assume you own a camera or perhaps are shopping around for one. You probably are confused (who isn't?) by the hundreds of makes and models you see, and possibly appalled by their apparent mechanical complexity: too many dials, levers, symbols, numbers, arrows, attachments. What does it all mean? Who needs it?

In the first place, don't let a camera intimidate you. If you can drive a car, operate a typewriter, play a piano, or even outwit a pinball machine, you can learn to use a camera. All those activities involve considerably more skillful motor-coordination and practice that does the simple act of making a picture. Your camera is nothing more than a sophisticated cigar box. You're not in awe of a cigar box, are you?

This particular cigar box must be lightproof. At the back end it holds film. At the front end is a hole with a lens that projects an image onto the film. In these basic essentials cameras haven't changed much since 1839 and the heyday of Daguerre. An Instamatic, a Nikon, a Hasselblad, your grandmother's box Brownie, a Leicaflex, or an 8 × 10 studio view camera all are constructed on the same basic principle.*

With the simplest types of cameras you just point and shoot, but with more advanced models it is necessary to focus the lens by moving it in or out and changing its distance from the film until you get the sharpest possible image of your subject. Not having to focus is convenient but inexact. A focusing control enables you to get critically sharp images across a wide range of distances, from very close subjects to ones that are far away. Also, it makes it possible to create certain effects which are part of photography's visual language, as will be explained later.

You need some kind of viewfinder to show you what you're getting on your film. A photographer is like an artist who walks around with a picture frame, holding it up to portions of the world that interest or excite him. An accurate frame is required for good work. Most modern cameras use some type of optical viewfinding

* It's possible to take pictures *without* a lens. A pinhole in the front end of a lightproof box will produce an image, although a very fuzzy one. It will be so dim that you will need to expose the film for many minutes or even hours to obtain a picture. Obviously, this is not a practical approach to camera design. A lens gives a much sharper, brighter image.

system, either separate from the lens or actually working through the lens. In more advanced models the viewfinder not only shows you what you are getting in the picture but also what parts of the subject are in focus.

The film in the back of your cigar box has a certain degree of sensitivity to light and must receive neither too much (overexposure) nor too little (underexposure) to give you a satisfactory picture. An overexposed photograph has a white, washed-out appearance, the way things look to your eyes when you first step from a darkened room into bright sunlight; an underexposed one is dark and muddy, like the interior of the Black Pussy Cat Café. You've probably taken both kinds often enough yourself.

Obviously, it would be a good thing to be able to regulate exposure so that the film always received the proper amount of light regardless of the illumination on the subject. We want to be able to shoot at blazing noon on a tropical beach, in the cool shade of woods, or even at midnight inside a discotheque.

There are two basic ways to control exposure. One is *brightness* —the amount of light the lens lets through into the camera. The second is *time*—how long this light is allowed to fall on the film. We can increase exposure by letting more light into the camera (thus creating a brighter image), by leaving the image on the film for a longer period of time, or a combination of both. We can reduce exposure by cutting down the amount of light entering the camera (thus dimming the image), by reducing the exposure time, or both.

The time control on any modern camera is its shutter. This is a mechanical device that opens and closes, allowing light to enter the camera for a precisely regulated length of time. Some types of shutters are metal blades located in front of the camera; others are window-shade arrangements covering the film. At one stage in the camera's evolution you did not use a shutter but merely placed a metal cap, or even the photographer's hat, over the lens. To make an exposure, you removed your derby, counted "one rhinoceros . . . two rhinoceros" or whatever, and then covered up the lens again. We have made progress. Modern spring-powered or electronic shutters are much more convenient, reliable, and accurate than a derby hat.

The range of shutter speeds on many medium-priced cameras today runs from about 1/1000 second (a very fast blink indeed) down to a full second. Mostly, you'll be using fraction-of-a-second shutter speeds. With a little practice you should be able to hold your camera steady enough at 1/60 second so you don't jiggle it and blur the picture. When lighting conditions permit, though, you're safer using 1/125 and faster. An experienced photographer can make

pictures hand-held at 1/30 second and even longer without getting camera-movement blur, but it's not easy. For exposures longer than 1/30 second, a tripod or other firm support for your camera is practically a necessity.

A full range of shutter speeds (you won't find the whole scale on all cameras) runs like this: 1/1000, 1/500, 1/250, 1/125, 1/60, 1/30, 1/15, 1/8, 1/4, 1/2, one second. When you move from one setting to the next fastest one (1/60 to 1/125, for example, or 1/15 to 1/30) you *reduce exposure by one-half.* Moving the other way (1/125 to 1/60, 1/1000 to 1/500, 1/8 to 1/4, and so forth) you *double the exposure.*

The second way to control exposure, as noted above, is by letting in more or less light on the film. This is accomplished by another mechanical device called the iris diaphragm, which is usually located inside the lens mount. It is named after the iris of the human eye and serves a similar function. The iris diaphragm provides an opening, like the pupil in your eye, which can be varied in size depending on the amount of light you want to let in. In photographic terminology this opening usually is called an aperture.

You can see the effect of an iris diaphragm quite clearly by looking onto the ground-glass back of a view camera, which is the best way I have ever found to demonstrate these matters. With the lens "wide open" (to its largest aperture), the image will be fairly bright. "Stopping down" the diaphragm to smaller and smaller apertures gradually dims the image until you can barely see it at all. You may find it useful to think of the diaphragm as a kind of valve that regulates the volume of light flowing into the camera.

I must now burden you with a few more technical terms and numbers. You can take pictures without understanding the relationships explained in some detail below, but they really are part of the ABC's of photography. Getting the hang of them immediately will put you on a more advanced level and make it possible for you to do many creative, exciting things with a camera. Even if you hate math (which I do, myself), the going shouldn't be too tough.

The apertures—the openings of various sizes provided by the iris diaphragm—are marked by number so you can dial them at will. These numbered settings are called "f stops" or sometimes just plain "stops." On a typical 35-mm camera they might run something like this: $f/1.4$, $f/2$, $f/2.8$, $f/4$, $f/5.6$, $f/8$, $f/11$, $f/16$. If you have an adjustable camera around, look on the lens mount, where the f-stops usually are engraved. Sometimes the "f" is left off and there is just a set of numbers: 2.8, 4, 5.6, 8, 11, and so on.

Perversely enough, the numbers mean just the opposite of what

you'd logically expect them to mean: the larger the number, the smaller the aperture, and vice versa. The opening "$f/4$" indicates a relatively large aperture, "$f/16$" a small one. It's confusing, but based on a simple formula. If you're interested, you'll find it all explained in any basic photographic reference book, such as the *Focal Encyclopedia of Photography*.

The important thing to remember is this: small f number = large aperture/more light; large f number = small aperture/less light.

A second essential concept: When you stop down (move from small to large f numbers), each marked aperture lets in one-half as much light as the preceding one. For example, changing the setting from $f/4$ to $f/5.6$ reduces the exposure by one-half; going down from $f/5.6$ to $f/8$ again reduces it by one-half, and so on. When opening up (from large f numbers to small), each aperture setting lets in twice as much light as the preceding one. Changing the lens setting from $f/11$ to $f/8$ doubles the exposure; from $f/8$ to $f/5.6$ doubles it again, and so on.*

To recap, we have two independent variables for controlling exposure: time (shutter speed) and brightness (lens aperture). The sequence of marked setting for each control gives a doubling effect for every step going in one direction and a halving effect in the other.

WE CAN OBTAIN THE SAME EXPOSURE BY VARIOUS COMBINATIONS OF SHUTTER SPEED AND LENS APERTURE.

The old water-faucet analogy comes in handy here. Or better yet, let's make it a keg of beer. You want to fill your stein to the brim, but not overflowing. This is like giving your film exactly the right amount of exposure. If the beer keg has a wide spout, you'll fill your stein rather quickly—it's like using a wide aperture and a fast shutter speed. If the spout has a small diameter, you'll need to let the brew flow for a longer time—similarly, a small aperture requires a longer exposure.

For instance, $f/2.8$ and 1/1000 second give the same exposure as $f/11$ and 1/60 second. At wide-aperture $f/2.8$, the lens is admitting about 16 times more light than at stopped-down $f/11$, but the exposure is only about 1/16 as long. The number of combinations for any given exposure is limited only by the range of shutter speeds and lens openings on your particular camera. It's not necessary to memorize all these combinations if you understand the relationships involved.

* The f numbers listed in the sequence above are all a full stop apart. However, you may encounter a few oddball f numbers that are *not* a full stop in difference. For instance, $f/1.2$ is only about 1/3 stop faster than $f/1.4$; likewise with $f/1.8$ and $f/2$, and with $f/3.5$ and $f/4$. The limiting factor here usually is the speed of the lens when it's wide open. It may not hit exactly on the scale given above.

In practice, you just remember that if you open up two stops, let us say, you also need to increase your shutter speed two notches in order to maintain the same exposure. Or if you stop down a notch, you must double the exposure time by moving to the next slowest shutter speed setting. At first you'll have to think it out each time, but soon the whole thing will become quite easy and natural to you.

Why bother with all this? Why not settle for a fully automatic camera and ignore shutter speeds and *f* numbers? You work with shutter speeds and *f* numbers for the sake of control and creativity. The two basic exposure controls, shutter speed and lens aperture, also affect two important visual qualities of the photograph: *motion* and *sharpness*. Although the combination of *f*/2.8 and 1/1000 yields the same exposure as *f*/11 and 1/60, they create two very different styles of image. By exercising your personal judgment in these matters you can make more expressive, interesting pictures.

The motion effect in a still photograph is controlled by shutter speed. At high speeds, such as 1/1000 second, the extremely brief duration of the exposure will "freeze" even very fast movement and reveal what unaided human vision cannot perceive. The slower speeds, on the other hand, record motion as blur and can produce a visual poetry obtainable in no other way. Adjustable shutter speeds give the photographer freedom to record a moving subject in sharp detail or with more or less blur, as he wishes. The continuum of visual effects is broad and exciting. In 1878 Eadweard Muybridge was the first to succeed in photographing a galloping horse with a high-speed camera: his stopped-action pictures proved that generations of artists had been painting the leg action all wrong. The blurred, slow-shutter color images of Ernst Haas captured the beauty of motion in a graphic new way. Like Muybridge and Haas, you also can explore the way a shutter slices time: the beauty and violence of sport, children playing, machines in motion, fleeting gestures and expressions, ballet dancers and birds in flight.

The lens aperture is no less responsive than the shutter in enlarging the vocabulary of your visual language. It does so by its effect on "depth of field," the technical term for what might be described as "the zone of sharp focus" or "sharpness in depth."

As you look out of a window at a landscape, everything in the scene, near to far, will appear sharp to your eyes. Your camera won't necessarily "see" things that way, nor do you always want it to. You might wish to focus selectively on just one object in order to emphasize it. You might want to blur an object in the foreground or to soften harsh background details by throwing them softly out of focus. You might want everything to be as sharp as possible, or you

might want to achieve an opposite effect. An adjustable lens aperture provides a way to control these matters.

Let's define depth of field somewhat more precisely by example. You are at a crowded beach with your camera. Some distance away you see a beautiful girl in a bikini. You focus on her and take a picture. Up to a certain point, people closer to you will be in sharp focus, but at some minimum distance the camera will begin to record them in a blurred, out-of-focus way. Those just in back of the girl will be in sharp focus, but farther away there comes a point where the sharpness falls off appreciably. If you planted a stake at the closest point where you were getting a sharply focused image and another at the farthest point, the distance between those two stakes would be the depth of field. Anything inside this zone or belt will be sharp; anything outside its limits, near or far, will be unsharp.*

Depth of field can be controlled by the lens aperture. The smaller the aperture, the more depth of field, and vice versa. By stopping down, you widen the sharp focus zone; by opening up you make it narrower.

Certain visual and emotional effects are associated with this optical phenomenon. A number of West Coast photographers, including the late Edward Weston, once formed what was known as the "f/64" group. A distinguishing characteristic of their photographs was great depth of field, with everything crystal-clear and razor-sharp from near-to-infinity—an effect achieved by using a very small aperture like f/64. (This is an exceedingly small aperture; you'll find it only on some view camera lenses.)

The wide apertures, such as f/1.4 and f/2 and even f/5.6, produce a very different effect: narrow selectivity of focus, extreme blur in foreground and/or background, an atmosphere of softness, mystery, and ambiguity. (Also these apertures are used as a matter of practical necessity by photographers working in dim light.)

From the standpoint of style and approach, it can be summed up this way: *small aperture = reality/wide aperture = * fantasy.

There's a second variable I haven't mentioned yet: focusing distance. The depth of field decreases with the focusing distance. At very short working distance, such as you might encounter when photographing a flower close up, it shrinks to a few inches or less, even with your lens stopped all the way down. You must focus very exactly. At medium-to-long focusing distances the depth of field may

* The depth-of-field boundaries are not, in actuality, like an invisible fence. There is no instant cutoff point. The transition from sharply focused to considerably blurred is more or less gradual. But stay within the posted limits to be sure of sharp details.

expand to include everything from a few feet away to the infinitely remote. Then you have a generous margin for error.

How do you know what the depth of field is? You can obtain charts with depth-of-field tables giving the figures for a wide combination of apertures and focusing distances, and for different lenses. (Yes, the effect will vary with different types of lenses, but that's beyond our scope here.) Your camera instruction booklet probably has a depth-of-field table for your particular lens. But who wants to stop to study a chart during the fun, excitement, and pressure of shooting?

The most convenient solution is to use a type of camera that shows you a through-the-lens image of what the lens actually is seeing. The ground-glass back of a view camera does this. So does the popular single-lens-reflex (SLR, for short) type of camera. You can see what's sharp and what isn't and adjust your camera controls accordingly.

The next-best solution is to use the depth-of-field scale engraved on the lens mount of most adjustable cameras. The numbers sometimes are cramped and a bit hard to read, but they will give you a rough idea at least.

A third way (in practice, what most experienced photographers do) is to fly by the seat of your pants. After a time you get to know just about what effect you will achieve at various apertures and focusing distances. Not precisely, of course, but close enough for most photographic purposes. It comes with doing and is part of learning to see with a photographer's eye.

To review and reinforce what we've covered so far:
YOU REGULATE EXPOSURE BY (1) SHUTTER SPEED (TIME) AND (2) LENS APERTURE (BRIGHTNESS).

YOU CONTROL MOTION BLUR BY SHUTTER SPEED
YOU CONTROL DEPTH OF FIELD BY LENS APERTURE.

When stopping or blurring motion is your main concern, first select the shutter speed you want and then choose a lens aperture that will give correct exposure.

When depth of field is your main concern, first select the lens aperture, then the shutter speed required for correct exposure.

If you understand these simple rules and (more important) apply them in a free-fall, exploratory way to your own shooting, you will have accomplished something of considerable value, having passed through a threshold of competence that separates the artless snapshooter from the honest-to-goodness photographer. It's a start. As a matter of fact, it takes some people years, if ever, to reach this level of sophistication.

Now we come to the question of camera types and makes. I know the subject is bugging you; it's a subject of interest to all photographers. I myself am essentially anti-equipment oriented, but I also love photography's panoply of gadgets and can easily be seduced by them. Secretly, I, too, am looking for the Ultimate Camera, the Magic Box that will solve all my problems and enable me at last to create the images I've always wanted to make. It does not yet exist; it never will. For me or you. It is wiser to start out realistically with this in mind.

Cameras are classified according to two main features: (1) film format, and (2) viewing system.

Big cameras are those that use non-roll film of $2\frac{1}{4} \times 3\frac{1}{4}$ inches and up. The most famous big camera is the classic 4×5 Speed Graphic, the mainstay of newspaper photographers for many years, now phasing out into nostalgic obsolescence. The 8×10 studio cameras, including such brand names as Deardorff, Sinar, Linhof, and Calumet, still are essential for many kinds of commercial, architectural, and product photography. Film for the big cameras is supplied in individual sheets (about the size of a postcard or larger), or in packs of a dozen sheets. Expense, if nothing else, conditions your approach to big-camera photography. You do not tend to overshoot when you are using 8-\times-10-inch sheets of color film.

A small camera is anything that isn't a big camera. All the camera types using roll film fall into this category. The most common sizes of roll film include 120 (a dozen $2\frac{1}{4}$-\times-$2\frac{1}{4}$-square-inch negatives on a roll), 220 (with 24 negatives), and 620, which was the classic box camera roll film prior to the coming of the Kodak Instamatic. Roll film is not "in" now, for a number of reasons, but it is used by some professionals and expert amateurs who want a larger-than-35 negative without going up to the more cumbersome studio camera types mentioned above.

The most popular small camera today by far is the Instamatic. The introduction of "drop-in" cartridge loading was as revolutionary as George Eastman's first Kodak. The Eastman Kodak Company has sold several million of them since the design was introduced. Other manufacturers have brought out models that accept the 126 cartridge (12 or 24 negatives per load). Some rather advanced (and expensive) models have come out, but essentially the Instamatic and its cohorts remain the snapshooter's special, ideal for grandmas, kids, vacationers, tired housewives, and family historians.

Smaller yet is the 35-millimeter format. A cartridge of 35-mm film puts 20 or 36 exposures of tiny negatives (somewhat larger than

a postage stamp) onto perforated strips of film. About 10 per cent of all cameras sold in the United States today are 35-mm, but the total impact of the "miniature" camera, as it is sometimes called, is much greater than this figure would indicate.

There are various other film formats, including subminiature film (for Minox and other tiny "spy" cameras), 70-mm film, which is perforated but twice as wide as 35-mm, and Polaroid film, of course, for the Polaroid Land cameras which develop the film within the camera by a special process and deliver you a black-and-white print in 10 seconds, a color print in 60. Polaroid film is available in a number of sizes, from roll-film-type small cameras up to 4×5 equipment.

Now for the viewfinding systems. The simplest method would be to add a wire frame or a peep sight to the top of the camera, and some press cameras do have such a device as an auxiliary system for fast shooting. More precision is desirable, however, and the following methods have been devised:

GROUND-GLASS BACK. A sheet of translucent glass mounted in the back of the camera. It shows the upside-down image projected by the lens, as I mentioned earlier. The photographer composes the picture, focuses, and then inserts a sheet of film and makes the exposure. With the film in place, the ground-glass is blocked off. This is practical only for controlled or stationary subjects, and with the camera on a tripod. The ground-glass screen is found on studio view cameras and some press cameras using sheet film.

OPTICAL VIEWFINDER. An optical system, separate from the lens, which gives you an image of the subject approximately as the lens sees it. Some are designed for eye-level and some for waist-level use and are commonly found on the less expensive roll-film, cartridge-loading, and Polaroid cameras.

OPTICAL VIEWFINDER PLUS RANGEFINDER. A more advanced variation of the above. The optical viewfinder is combined with a rangefinder coupled to the focusing system. The viewfinder usually has *frame lines* which indicate the boundaries of the picture area, and a *rangefinding spot* for focusing. It is very accurate and gives a bright, clear image even in dim light but does *not* show you depth of field. Rangefinders are found on 35-mm cameras, from inexpensive ones up to top-line Leicas and Nikons.

TWIN-LENS REFLEX. A pair of lenses, one mounted above the other, the top-story lens for viewing/focusing (with a 45-degree mirror and ground-glass), the bottom lens actually taking the picture. This type is designed for waist-level or chest-level viewing and is

usually found in 120-roll-film camera size. (Rolleiflex is the classic example.)

SINGLE-LENS REFLEX (the famous SLR type). Some (Hasselblad, Bronica) are 120-roll-film cameras; most are 35-mm (Minolta, Miranda, Pentax, Nikon F, Leicaflex, etc.). The reflex camera is very popular, because it lets you see *through* the lens. A mirror mounted at a 45-degree angle reflects an image onto a ground-glass in an eye-level prism. The mirror flips out of the way during the moment of exposure, then goes back into position; you lose your viewing image only for a brief blackout period. You see the depth of field, as the lens actually sees it.

I can't advise you what type of camera is best for you. That's a highly personal matter, like selecting a vacation area or finding the right husband or wife. Most cameras, including the simplest non-adjustable Instamatic, can perform at a much higher level than the owner ever demands or dreams they are capable of attaining. Buying the same brand of camera some well-known professional has used successfully is no guarantee that you can take the same kind of pictures. Having the fastest lens, the latest model, the most advanced accessories may be inhibiting rather than liberating. Some of Irving Penn's most distinguished portraits were taken with a well-used Rollei of a type you can now pick up at a camera exchange for maybe $70. So don't be too concerned with hardware.

Most amateur photographers, when they move beyond the Polaroid/Instamatic level, go 35-mm today, for reasons of convenience, versatility, economy, and wide choice of interchangeable lenses. And most go SLR, rather than rangefinder, because they like the advantage of through-the-lens seeing. But that's not necessarily the best choice for you. It's a question of purpose and personality. Start with any camera—the main thing is to start photographing. You'll discover what's best for you through personal experience.

The one thing I would advise is to use a fully adjustable camera, one that allows you to focus, change lens apertures, and set shutter speeds. Which brings up the question of automation.

Not so long ago you set your exposure by hand, using the chart provided by the film manufacturer or reading the brightness of the light with a hand-held exposure meter. Then along came exposure automation, a built-in electric eye that measured the light and automatically set the exposure. At their level of technical proficiency today, these devices are, in general, quite reliable, especially the type that works through the lens. In the beginning, exposure automation was only for greenhorns; the pros wouldn't touch it. Now many

professionals use automatic or semi-automatic exposure control as a time-and-labor-saving device which frees them to concentrate more fully on the subject.

However, in its pure form, exposure automation is a mixed blessing. It automatically programs a particular shutter speed/lens aperture combination, depriving you of the ability to select what you want for a particular effect. It doesn't allow you to underexpose or overexpose deliberately, to compensate for special conditions, or to enjoy full freedom to experiment. However, a number of automated cameras today permit you to bypass the automatic feature. It's like a car that has both automatic and stick-shift transmission. If you buy an automated camera, get one that has *convenient*, optional manual exposure control. Check out this feature carefully; it's important.

There's not a great deal you need to know about film in order to get started. There are two basic kinds, of course—color and black-and-white. Color negative film, as the name indicates, produces color negatives from which color prints can be made. Color transparency film is different. Its end result is a transparent positive image, without going through the intermediate step of a negative. (A reversal takes place during the complicated processing cycle.) The most popular form is the familiar cardboard-mounted color slide for projection on a screen.

Films are given a numerical rating, an *exposure index*, according to their "speed" or sensitivity to light. For example, Tri-X, rated at 400, is a fast film and requires a relatively slight exposure to yield a satisfactory negative. Kodachrome II is a rather slow film rated at 24 and therefore not an ideal choice for shooting in dim light.

The faster the film, the "grainier" it tends to be. (Grain is a kind of background pattern of clumps of silver in the negative.) Photographers used to fuss a lot about grain and strive mightily to eliminate it. With the films and developers available today, it seems to be less of a problem. Also, tastes have changed, and grain is no longer regarded as so undesirable. In fact, rather than being regarded as a flaw, it is considered an interesting graphic effect which some photographers deliberately strive to achieve.

There are many good films on the market. My advice is to pick one for color, one for black-and-white, and to use these exclusively for at least a year. It is far better to know one film really well than to experiment superficially with a dozen. Use fresh, dated film only (and use it up before the expiration date on the box). Store color film in the top part of your refrigerator if you need to keep it around for more than a few days. Have your film (especially color) processed just as quickly as possible after exposure.

Accessories? Go slow with these; pick them up only as you find a real need for them. A shoulder strap for your camera is a must. You'll want a gadget bag. Obtain a good exposure meter if your camera isn't equipped with some type of built-in automatic or semi-automatic metering system. A small tripod, unipod, chestpod, or other device for holding your camera steady during long exposures is occasionally useful. Don't worry about filters right now; 90 per cent of the time you don't need one. Maybe somewhere along the line you'll want to pick up a small portable electronic flash unit. Extra lenses? That is a large and important subject, especially for 35-mm photographers. We will return to it later on.

That's quite enough about hardware and products, math and mechanics, for the time being. You can get hung up on technical matters if you don't watch out; many photographers do. They collect cameras but never take pictures, forgetting that all the fascinating equipment of photography (and all its theory) is only a means, not an end. Photography is a mechanical extension of an organic process: visual perception. However, the way a camera "sees" and the way the human eye works are not identical. These differences and similarities are extremely important in photography and worth a close examination.

THE BIOLOGY OF VISION

A man peering through the viewfinder of a Leica or composing on the ground-glass of a studio camera is the logical, if unpredictable, result of an evolutionary process many millions of years old. From the beginning, when some tiny mammal began to experiment with tree climbing, our branch of the family has relied primarily on visual perception to survive and reproduce. Our world, above all, has been the visible domain, the portion of the universe which is defined and illuminated by the narrow band of electromagnetic energy we call light.

This, of course, is not the only method by which organisms can live and thrive. My golden retriever has extremely poor vision and can scarcely recognize me at a few paces against the light. If the wind is wrong, she squints and growls uncertainly, obviously needing corrective lenses, and would never be able to find game by vision alone. However, she also has access to a complex world of smells that I can only imagine as I watch her sniff the autumn air, translating scents into meaningful bits of information.

Moles, worms, certain species of lizards, and the blind fish deep in limestone caves lead their active, complex lives without benefit of sight, being able at best to make only a gross distinction between light and dark. Other creatures have developed organs which enable them to sense an electric world, an infra-red world, or an ultrasonic world which we can never perceive directly. Man, however, in the course of evolution, came to live by his eyes, and that has made a profound difference.

The camera was invented only once, but the eye has been invented three times: by the insects, the mollusks, and the vertebrates, each type having distinctly different structural variations. The eyes we have inherited are most similar to the camera. In fact, the basic structure of the human eye and that of a camera resemble each other

so closely that diagrams of one frequently are used to illustrate the functions of the other. Both consist of a lightproof chamber with a lens at one end which projects an inverted image onto a light-sensitive surface at the other. However, the differences between the two are at least as striking as the similarities, and have great importance to photographers, who must learn to translate the seeing of one into the vision provided by the other.

"A camera is no more a copy of an eye than the wing of a bird is a copy of that of an insect," George Wald comments in his essay on "Eye and Camera," in *Scientific American Reader*, published by Simon & Schuster. "Each is the product of an independent evolution, and if this has brought the camera and the eye together, it is not because one has mimicked the other but because both have had to meet the same problems and frequently have done so in much the same way. This is the type of phenomenon that biologists call convergent evolution, yet peculiar in that one evolution is organic and the other technological."

The eye possibly originated from specialized skin cells which developed a sensitivity to light; in the beginning they may have been odd little spots with an ability to make only the general distinction between bright sunlight and anything else. In its latter-day, refined state the human eye is far more than a cluster of specialized skin cells; it is a direct extension of the brain. In the human embryo the eyes first appear as a pair of stalks and bulbs sprouting laterally from the brain, later shifting toward their familiar position in front. The light-sensitive cells of the retina are a kind of exposed surface of the brain in confrontation with the visible universe. When you look directly into the eyes of another person, one brain, in quite a literal sense, is peering into another brain, which may account for the powerful psychological and mystical effects so often associated with eye contact.

Unlike the camera, the eye is not merely a recording device, but also a high-speed data-professing computer, actively sorting, organizing, and coding information before sending it on to the great visual centers of the cortex. This filtering and gestalt activity takes place within the retina where the sensor cells convert light into bits of electromechanical energy. It has been estimated that the eye is about a thousand times more effective than the ear in gathering information. There are some 130 million light-sensitive cells in the retina, but they pass along only a much smaller number of messages to the million or so fibers of the optic nerve, the trunk line to the brain. Through an intricate system of micro-circuits, irrelevant information

is sifted out and only the most interesting data, such as color, edge contrast, speed and direction of motion, is sent along to the high command.

By comparison with a conventional camera, the human eye is an ultraminiature device, being a sphere less than one inch in diameter and weighing about ¼ ounce. Light rays enter the eye through the cornea, the thick, transparent "front lens element" which accounts for most of the eye's refractive power. The rays next pass through a fluid-filled front chamber and then through the pupil, the opening in the iris diaphragm. Further bending of the light rays takes place in the lens itself, a transparent lima-bean-shaped organ directly behind the iris, and the rays next pass through the interior of the eyeball, which is filled with a clear, semiliquid jelly, the vitreous humor, until they reach the retina itself at the rear of the eyeball.

The human eye is equipped with a 25-mm, $f/2.8$ super-wide-angle lens system that covers an angle of view of more than 180 degrees horizontally and about 130 degrees vertically. The area of sharpest vision is a much smaller part of this large field, covering an angle of less than 2 degrees. Thus, in terms of seeing details clearly, the human eye is about as narrowly selective as a photographic spot meter which reads the light reflected from only a tiny area.

You can check the limits of vision in your own eye (which is greater than most people realize) with a simple experiment. Shut an eye and focus on a point straight ahead, then extend your arm in front of your face with your forefinger raised. Now, while continuing to look directly ahead, swing your arm around to the side. You should have at least a dim perception of your finger even with your arm straight out in line with your shoulders. You may not be able to see the shape of your finger, but if you wiggle it you should be able to detect the motion.

The reason for the wide field of fuzzy vision and the narrow spot of sharp vision is found in the nature and distribution of the receptor cells in the retina. A photographer selects his film according to the lighting conditions encountered, using a fast but coarse-grained emulsion for dim illumination and a slower but finer-grained one for bright light. The eye's retina works in a similar manner, having a choice between two basic types of "emulsion": the rod cells and the cone cells.

There are about seven million cone cells in the eye, supplying the eye with its slow "Kodachrome II" emulsion. The cone cells are clustered in a very fine-grain mosaic, each one having an individual input tap to the optic nerve, and give the eye its ability to discriminate fine detail. The cones also enable us to detect colors. The cones are

most densely packed near the center of the retina in a tiny area less than the size of the head of a pin, called the fovea. When you "look straight at" something, you adjust your eyeballs so that the image of the object falls directly on the fovea.

Surrounding the fovea is a yellow, oval patch, the macula, which also contains many cone cells but in less dense concentration. We get about 12 to 15 degrees of relatively sharp color vision from the macula, and use it, among other things, for reading.

The rod cells provide the eye with its fast "Tri-X" emulsion for dim available light. The rods generally work in clusters of up to several hundred linked to a single nerve fiber, giving an effect like coarse-grained film: greater sensitivity to light but less definition. The rods are most richly distributed in the marginal areas of the retina, away from the fovea with its dense population of cone cells. In dim light the rod cells take over more and more of the burden of seeing; we lose color perception and the ability to see fine detail. Thus colors seem to fade in the dying illumination of twilight, and at night "all cats are gray" in a literal sense. In viewing a dim star or other faint light, you can perceive it most clearly by looking at it askance so that the image falls on a region of the retina thick with sensitive rod cells. (Incidentally, the famous "blind spot" does exist, at the point where the optic nerve joins the retina.)

I explored this rod-cell vision one summer night, lying on my back and focusing on a star directly overhead. Once the rod cells were fully activated, the resulting impression was remarkable, as I became consciously aware of what was happening. I could continue to see my little guide star clearly (although it had a tendency to jump around a bit, reflecting the nervous twitches of my not fully relaxed eyeball muscles). Gradually, however, I became distinctly aware of a vast field of vision, the shapes of tree branches and leaves above me, of surrounding foliage, of the flutter of a white moth as it traversed a flight path far off to one side. Nothing had color and nothing had sharply defined contours or detail, but while continuing to stare straight up, I was simultaneously aware of an enormous body of visual information, seeing with the full wide-angle vision of my afterdark eyes, so different from the selective sniping of daylight seeing.

The narrow sector of sharp macular and foveal vision does not turn out to be, in practice, the handicap one might expect, because the human eye, unlike the camera, operates as a type of scanning device. When we look at a landscape, a human face, a picture, or printed type, our eyes swiftly jump around the visual field under inspection, picking up detailed information first from one point, then another, until we gain a satisfactory over-all impression. Special recording

devices fitted to the heads of subjects have been used to measure eye movement. Research by E. Llewellyn Thomas and Norman Mackworth at the Defense Research Medical Laboratories in Toronto indicates that the eyes spends much of its time rapidly flicking from one fixation point to another. These "eye flicks" are extremely swift, requiring only a few thousandths of a second as the eye travels in a straight, curved, or even hooked path from one stopping place to another; the fixations themselves commonly last a half second or less. (About 1/30 second seems to be about the minimum exposure required to imprint a visual image onto the brain's visual memory.)

The human eye can focus sharply on objects from only a few inches away to those at a remote distance. It makes the necessary adjustment quickly and without conscious effort; a nearly perfect "automatic self-focusing camera." As a result of this facility, when our eyes make their typical zigzag exploration of a scene, details come into hard focus at each fixation stop, and we get the impression that everything in the scene is sharp. A camera lens may not necessarily be seeing things this way at all; therefore, part of a photographer's skill is in knowing how to control the sharpness of objects at various distances from his lens and to visualize how his lens will "see" the scene.

With a camera, focusing usually is accomplished by moving the lens farther away from or closer to the film plane. In the human eye the lens-to-retina distance remains constant and focusing is achieved by changing the shape of the lens itself, through the contraction or relaxation of the ciliary muscles, but the camera cannot do this.

Human eyes not only focus automatically but are equipped with fully automatic exposure control as well. In bright light the iris contracts so that less light enters the eye; a direct analogy to stopping down the aperture of a camera lens. Moving from bright light into dim illumination, the iris opens up. The full range is from approximately $f/2.8$ wide open to about $f/11$ fully stopped down.

Despite this relatively modest range of stops, which is about what you'd find on any medium-priced 35-mm camera, the human eye is an incredibly light-sensitive instrument—far more so than any camera. The capacity of shifting from cones to rods, from detailed daylight color to nondetailed night vision, enables it to respond to an enormous brightness range, on the order of one to several millions. Under good lighting conditions, photographic film can handle about 1:1000, and a black-and-white print can reproduce only a fraction of that.

In dim light a photographer will be able to see more than even the fastest lens, combined with a high-speed film, can record, and the human eye will continue to function long after the level of illumination has sunk so low that photography is impossible. It is believed that

the eye will respond even to one photon of light, the ultimate minimum packet of visual energy. In practice, though, it appears that several cells must be fired simultaneously before a message goes through, presumably to mask out the "noise level" of the eye where individual cells may be firing at random without any outside stimulation whatever. Expert estimate is that five retinal cells must be fired simultaneously to trigger an impulse through the optic nerve. This minimum threshold of sensitivity is incredibly low. During World War II, air-raid wardens were warned that the flare of a match, from somebody on the ground lighting a cigarette, could be detected by a bomber pilot at 20,000 feet, and that may not be so farfetched as it seemed to many of us at the time.

As an image-producing device, the eye must cope with problems long familiar to lens designers. No perfect lens has yet been produced, either by man's ingenuity or the millennial grind of evolution's mill, nor will one ever be. Fundamental laws of physics and optics must be overcome, and correcting for certain errors tends to intensify others. Nevertheless, highly successful optical systems have resulted both from organic and technological evolution.

To achieve the superb lenses available on contemporary cameras, optical designers play a complicated game of compromise and trade-off, combining up to seven or more individual elements, utilizing the special refractive characteristics of rare-earth glasses, and working out the intricate mathematics with the aid of computers.

One of the basic image-forming distortions of any lens with a curved surface is spherical aberration. Unless this is corrected, a pinpoint source of light will form an image that is not a distinct point but a little blur circle, the famous "circle of confusion," and a picture composed of these blur circles will be fuzzy and unclear. The eye corrects for this error with a high degree of success, but with chromatic aberration, it has been less successful. Chromatic aberration is the image-forming flaw caused by light of short wave length (from the ultraviolet and blue end of the spectrum) being focused at a shorter distance than light of longer wave lengths (from the red end of the spectrum). Again, the effect is to degrade and blur image quality.

The human eye manages to correct rather well for the yellow-red wave lengths but has difficulty with the blue-ultraviolet rays. Evolution has simply copped out of this problem. The lens of the human eye also is a yellow filter, which absorbs the bothersome ultraviolet light. The macula, where the most detailed vision takes place, also is tinted yellow, absorbing more of the blue-ultraviolet end of the spectrum, and the cone cells themselves are relatively more sensitive to yellowish than bluish light. By these strategies, the human eye

discards the color of light—ultraviolet and part of the blue—which are the most troublesome to correct.

The fact that we perceive color at all is remarkable. Full color vision is a rarity among animal species on this planet; among mammals we share it only with some Old World monkeys. The details of how the human eye perceives color are not clearly understood, although it has been established that any animal which can see color must have two or more visual pigments in the cone cells of its retina. The human eye, with full color vision, has three pigments, each sensitive to light from different but overlapping portions of the spectrum. The analogy to color film, with its triple layers of dye, is obvious.

The precise role of color vision in man's evolution remains a mystery. Other arboreal vegetarians seem to get along quite well without color vision, and even today, in a complex, color-oriented civilization, color-blindness is a relatively mild handicap, a nuisance rather than a catastrophe. In our species the ability to see color hardly seems central to survival.

Perhaps its most important function has been to act as a psychological catalyst, intensifying emotions and accelerating the creative activity of human brains. The world as we perceive it is far richer and more varied than it would be without color. Another unusual aspect of human seeing is that we have true stereoscopic vision, an ability, as with color vision, not shared by many other species. It required the evolution of a pair of forward-looking eyes with coordinated muscle movement which provides the brain with two overlapping but slightly displaced images, across a horizontal field of about 130 degrees. Thus we are able to see objects "in the round" with a direct visual experience of three-dimensional space.

When the first men landed on the moon, the last few feet of the lunar module's descent were guided not by electronic computer but by the depth perception of a skilled test pilot's vision. When you play tennis, hit a golf ball, or drive a car, you rely strongly on stereoscopic seeing.

One of the essential differences between the still camera and the human eye is that the human eye, during normal waking operation, sees continuously, interrupted only by periodic instants of blindness during a blink (a self-cleansing action necessary to the comfortable functioning of the eye). A still camera is exactly the reverse, remaining blind until the selected instant of blink, when the shutter opens and an image is recorded onto the film. The photographer's function is to select the most meaningful frames from the endless footage of visual images flowing continuously through his consciousness. The sensitivity and skill with which a photographer selects

these frames is, of course, one of the basic aspects of photographic seeing.

When I was in journalism school, one part of the training in our basic reporting class was a surprise staged event. Without warning, during class session, a student pursued one of the graduate assistants through the room, a mock fight took place, and they both ran out again. We were asked to report the details of what happened, write a description of the two antagonists, describe who did what to whom and in what order. Needless to say, the reports varied widely from one another and from the events as they actually occurred. The obvious point is that people are poor observers, especially under the stress of surprise and fast-moving events. However, another, far more radical idea also is suggested, an idea that is gaining currency with a number of contemporary observers of human behavior: *different individuals literally may not perceive the same event in the same way at all.*

As the biological mechanism of sight—our most recent and sophisticated mode of perception—is traced far enough through its fantastic path, we find ourselves ultimately in the labyrinth of the cerebral cortex and among the electronic impulses of the human brain. Here is where the photographer learns to see in his particular way, matching the images that fall on the emulsion of his camera with the retinal images of his eye, and selecting from the infinite raw visual data of the universe those fragments that have meaning for him. Through the medium of the photographic image, he can share his vision with others. It is one of the most important ways by which one brain can communicate with another, and if the camera did not already exist, it would be necessary to invent it.

HOW TO LOOK AT A PHOTOGRAPH

There are many rewards to looking at a good photograph: the pleasure you get from its beauty, order, and visual richness; the interest you may find in its subject; the truth it may tell you about human beings or the universe; the way it can recapture the past or bring distant events close. But all these rewards can be lost if you look without truly seeing, and if you allow barriers of prejudice, preoccupation, or ignorance to cut you off from the picture.

Looking at photographs so that you really see them is something of an art. It means shaking off bad habits of superficial, insensitive seeing that most of us tend to acquire in this age of mass-reproduced photography. Of course, the majority of photographs we are so relentlessly exposed to are not intended to be studied with care. Their purpose is to smack the viewer in the eye, attracting attention just long enough to impress an idea, a trademark, a brand name, a face, or a fashion into the subconscious before we turn the channel selector switch or flip the page. Out of self-preservation we tend to build up a degree of tolerance to these competing, conflicting images.

The trouble is, this numbness isn't always so easy to shake off when you look at a photograph that has enduring human and aesthetic value (and that is the only kind we're concerned with here). A preliminary step to looking at photographs is simply to make the physical conditions as favorable as you can. You need adequate light, of course—bright but not harsh or glaring. Quiet usually helps, too. If you're visiting a gallery or museum and have a choice of time, try to go when the place will be least crowded—in the morning, say, or on a weekday rather than a weekend.

If you're viewing loose 8 × 10 or larger prints, prop them against the wall so you can move back for a long view or come close to inspect details. This is a method art directors and picture editors often use when they're making a final selection of photographs. Often you can get quite different impressions of a picture and increase your enjoyment of it by looking at it from different distances. The long view shows you the photograph and its composition as a whole, while closer viewing reveals textures, tones, and fine details you might otherwise miss.

Much more important than the physical conditions are the psychological aspects of picture viewing. Above all, you should be willing to give the photograph your total attention. A still photograph needs this full attention because photography is a relatively quiet, small-scale form of art. A photograph doesn't have motion to excite your mind and eye, or a sound track or orchestral accompaniment to give the picture a second sense dimension. You shouldn't expect a still picture to sweep you out of yourself as readily as a motion picture or a ballet may do. Also, a photograph does not usually depend on huge size to help make it impressive as some paintings do. You must help it reach you with whatever it has to give.

Put yourself in a relaxed, unpreoccupied frame of mind while you look at a photograph. Relaxing and not being preoccupied seem to be exceedingly difficult for modern man. However, achieving this state is as natural and easy as falling asleep if you go about it in the right way. You can't do it by trying hard. Instead, psychologically speaking, unclench your teeth. Calmly and deliberately shut off the insistent clamor in your mind. For a few minutes forget about the train you have to catch, your job, your unpaid bills, where you're going to eat lunch, or whatever immediate, practical concerns are buzzing in your brain. Let them go—all at once if you can, or gradually, one by one, just as you might relax your body by first letting just one finger go limp, then another, and so on until your whole body was relaxed.

Don't think. Just look. Allow the photograph to take over your consciousness fully. Let yourself drift into a state of total awareness of the photograph. Don't strain for a response or try to put what you feel into words. (Leave that to the critics, who usually do it rather badly.) Just let come whatever response comes naturally to you, flowing out of your visual contact with the image. When you're in this relaxed state of awareness, with all channels open, the photograph has its best chance of reaching you and you of seeing all its qualities and enjoying it.

Once you put yourself in contact with a photograph, don't be in a hurry to break off and move on to the next one. There may be good reasons for lingering.

In viewing a still photograph you can enter a world of frozen time, where all the clocks have stopped and nothing ever changes. You can see things with a greater clarity than you usually can in the shifting, confusing world of physical reality. You can study an expression, a gesture, or a play of light and shadow that is transfixed forever. This is one of photography's great gifts. Take the time to enjoy it.

Another of the charms of photography is its ability to record the unique "thingness" of things in rich detail: the texture of a concrete wall or a burlap bag, the planes and ridges of the human face, the glare of ice, the ghostliness of fog. Photographs with this visual richness are what Irving Penn has aptly called "inspection" pictures. They invite your eye to wander across them and savor their delicious profusion of tones, shapes, details, and textures.

Portraits, too, often invite and reward leisurely study as you try to discover the personality of the subject and interpret the emotions reflected in the face. Another kind of photograph that requires time to enjoy it is one having subtle, complex composition. Your eye needs an opportunity to move around the picture area and sense the structure and relationship of the parts.

Just how long a look is long enough depends on you and the photograph. But one quick glance is scarcely enough for any good picture. So be willing to give the photograph at least a few seconds' worth of your total attention—and, of course, much more if the picture deserves it.

Even if you take your time about it, a single encounter with a photograph of any value rarely is enough to let you know it. Photographs are rather like people in this respect. Some are brash and insistent, reaching out to grab you by the lapel. "Look at me!" they say in effect, with their startling technique, dramatic clash of tones, or visual gimmickry. Others are shy and reticent; they whisper rather than shout. You may easily pass them by the first time without fully tasting what they have to offer. But if you go back and take a second look, you may find that the stopper is a bit of a bore and that the quiet picture has something rich, subtle, and complex to show you.

Even better than a second look is to live with a photograph for a time. (It's an especially good idea to do this with any picture you want to acquire for your own permanent collection.) Cut a reproduction of the picture out of a magazine, make a copy of it, or borrow a print. Hang the photograph on your wall in plain sight and look at it many times a day. Within a few days or a few weeks you should know that picture very well indeed. You'll see things in it you'd otherwise miss, and you may change your opinion about it, too. In fact, you may find you're sick of the sight of it—it's a rare photograph that can retain its freshness after this kind of frequent, repeated viewing. But if it survives the test, you can be pretty sure you've found a photograph that will have enduring value for you through the years.

Whether you look once or many times, the pleasure and meaning you get from a picture depends not only on what the photographer

put into it but also on what you bring to it—your taste, sensitivity, awareness, and experience in looking at other pictures.

In your looking you'll naturally tend to favor the kind of pictures (in terms of style, technique, and subject matter) that already appeal to you. But to broaden your experience you should also make a point of looking at photographs you *don't* like. Photography is capable of making many kinds of statements about the universe and of doing so in very diversified ways. You'll miss much of the richness that photography offers if you limit yourself to just one school or approach or narrow your viewing to just one type of subject.

For example, if you're a person who enjoys looking at landscapes photographed with meticulous craftsmanship by Ansel Adams, have you also looked—really looked—at the bitter surrealistic fragments of contemporary life recorded by Robert Frank? If you like candid, photojournalistic pictures of people, are you also aware of the imaginative work being done by studio photographers?

When you look at photographs that aren't naturally your kind of picture, do so in an honest attempt to see the good qualities other people have found there. Is it the picture that's at fault or is it possibly you? Is there some prejudice or aesthetic or emotional blind spot that blocks you from enjoying the photograph?

This doesn't mean you should abandon your personal taste and standards or meekly accept every picture you see printed in an annual or displayed on a museum wall. But be willing to look, without prejudice, at the work of photographers with different styles, approaches, and outlooks. Give each picture a fair chance. Let your response to it arise from broad knowledge, not narrow ignorance.

Still another way to increase your enjoyment of photographs is, whenever possible, to *look at the photographic print itself.* No printed reproduction, not even a very fine one, is a fully adequate substitute for the original. The printing process inevitably tends to coarsen the tones and wipe out subtle distinctions.

A good print has a living quality—it is much richer and more exciting than a reproduction can be. To feel the full impact of an Edward Weston photograph you need to see the luminous silvery grays of the print itself—tones that seem to glow and shimmer with an interior light. The shadows of a W. Eugene Smith print speak in a language of darkness, deep and voluptuous as the night. The clear tranquillity of window light captured and intensified in an Irving Penn photograph or the austere, understated grays of a Cartier-Bresson are basic aspects of each photographer's style, but these effects often become diluted and dulled in reproductions.

The opportunities for looking at original photographic prints

are considerably greater today than they used to be. An increasing number of art museums are adding photographs to their permanent collections and opening up gallery space to photographs. There usually are a number of photographic exhibitions in circulation from the Museum of Modern Art, George Eastman House, the Smithsonian Institution, and other sources. Of course, these exhibitions vary greatly in interest and quality, but they do give a large public the chance to see original prints rather than reproductions.

In New York the Edward Steichen Photography Center of the Museum of Modern Art has both permanent and special photographic exhibitions. There are a number of small photographic galleries in Manhattan, too, that are worth hunting up. In many communities around the country, art galleries, schools, colleges, camera clubs, stores, banks, and churches sometimes hang photographic exhibits.

Finally, and perhaps most vital of all, you can increase your enjoyment of photographs if you look at them with a spirit of adventure. You are a lone explorer in unknown territory where there are no signposts. You must find your own way. A good photograph is alive, suggestive, sometimes even ambiguous. It is a touchstone that can trigger a psychological chain reaction in the viewer. But you and I, being different people and having experienced life in our own ways, may not have identical responses to the same picture. We may find different meanings and values in it—mine valid for me, yours for you. So as you look at a photograph, seek your own response to it and form your own opinion.

In looking, don't expect every good photograph to tell a story or make a clear-cut "statement" or convey the kind of "message" you can neatly wrap up in words. The visual language of photography communicates directly through images, and its meaning may be emotional rather than verbal, implicit rather than explicit. Often your response to a photograph may be one that's quite impossible to put into words—a kind of electrical disturbance that makes the back of your neck tingle, a sensation of peace, a complex blend of sadness and elation, a feeling of completeness because all the elements in the photograph are exactly right.

Be satisfied if the picture lets you share the photographer's vision, see through his eyes, and discover the beauty, wonder, strangeness, or terror of something you've looked at a thousand times and never saw that way before. In fact, this is your greatest reward for looking at a good photograph—that it can expand and clarify your own vision, making you more alive by bringing you, through the primal sense of sight, into closer touch with life.

PART II

NUTS AND BOLTS

SEEING 35-MM

Like so many other people, I first fell in love with photography through the viewfinder of a 35-mm camera. There is an exciting, dynamic quality about 35-mm photography that you intuitively sense the first time you pick up a miniature camera. Although it looks like a toy, it is the most successful mechanical apparatus yet devised to close the gap between the inner "you" and the outer "other." It is compact, mobile, and instantly responsive—the next-best thing to having a retina in your eye that can, with a blink, capture an image for future study and enjoyment.

I had dabbled with photography as a small boy, up to the stage of developing rolls of film under a red safelight by the open-tray method. These early experiences were interesting but not entirely satisfying, and perhaps the most rewarding pictures I took were fuzzy semi-close-ups of model airplanes (Spads and Fokkers built from balsa wood *Comet* kits), that had cracked up during their maiden flights.

In high school, however, a photographer friend lent me a Contax II to use for a few weeks, which was most considerate of him since I wasn't noted for my mechanical aptitude. The instant I held that solid, precisely functioning instrument in my hands, I knew I had encountered something new and important. To lift it up to my eye and see *through* the camera was entirely different from looking down at the obscure, remote images on the viewfinder of my waist-level box camera.

"Try some indoor pictures with Super-X film," my friend suggested. "This camera has a fast lens. Open up to $f/2$ and shoot at 1/25 second—you'll be surprised. You don't need flash inside if the light is good."

So I tried it during an art class in Nashua, New Hampshire, senior high, photographing my art teacher, classmates at work, events going on around me just as if there were no camera and no photographer present. And the amazing thing to me was that my pictures all came out. There they were: people caught in natural, unposed activity, by the light that was there, just as you would see them with your own eyes.

In retrospect, with the ultrafast lenses and vastly improved films

of today, all this seems naïve. We take the ability to make candid, available-light pictures so much for granted, forgetting the difficulties that had to be overcome by stubborn, imaginative photographers, picture editors, engineers, optical designers, and chemists. But not entirely. The miniature camera still remains something of a miracle in that it enables you to catch instants from the flow of time and fix them—not as impaled and lifeless butterflies, but as vividly alive as the visions of memory—and also in that it can record the world, with an infinite treasure of detail, on a tiny area of film not much larger than a postage stamp.

Like the wheel and the typewriter, the 35-mm camera was invented more than once. Two models appeared on the American market in 1914, but they failed to catch on, so 35-mm photography had to be invented all over again, this time in Germany, by Oscar Barnack, who had never heard of the American cameras.

Barnack was a bright young technician employed in the microscope division of the E. Leitz plant in Wetzlar, shortly before World War I, and his hobby was cinematography. In those days there were no exposure meters, and good results were difficult to obtain. The approved method was costly and cumbersome: shoot test footage with your cinema camera, varying the exposures, then study the results before going ahead with the final movie. Barnack thought about the problem and hit upon a solution. He devised a small still camera that could be loaded with short lengths of 35-mm movie film, allowing you to expose an economical one or two frames at a time when making exposure tests.

Barnack, experimenting as a good inventer will, tried enlarging some of the tiny negatives. They were very small rectangles measuring 24 × 36 millimeters, yet when blown up, they produced printed images of surprisingly high quality. The results impressed young Barnack, and they impressed the E. Leitz management, too, who foresaw interesting market possibilities here. The motion-picture exposure testing device had proved to be a remarkably good still camera in its own right.

World War I, the postwar economic ills of Germany, and the customary methodical pace of Leitz engineers delayed the birth of a production-line model until 1924. Finally the world's first Leica, dubbed like Henry Ford's car the Model A, was introduced at the 1925 Leipzig Fair. Photography has never been the same since.

In the beginning most people thought of it as a novelty, a gimmicky plaything. How could you do serious professional or creative work with anything so small? (The Model A Leica measured only 5½ inches long, and with the lens mount collapsed, you could easily

tuck it into your coat pocket.) They were wrong, of course, and fifty-odd years later the progeny of Barnack's handmade experimental camera have proliferated and divergently evolved like a successful mutation whose time has come. There are probably upward of 12 million 35-mm cameras being used in the United States alone, and another 500,000 or more are sold each year, mostly imports from Germany and Japan (the U.S. has produced almost no successful 35-mm cameras). Recent issues of camera-buying guides list upward of 130 different makes and models, the single-lens-reflex type with an eye-level prism finder being by far the most popular. Most of the photojournalistic pictures reproduced in newspapers, magazines, and on television are shot with 35-mm equipment, and the miniature camera has been successfully adapted to fashion, industrial, public relations, advertising, wedding, and other areas of photography, once the exclusive domain of big cameras. The list of notable living 35-mm photographers reads like an industry *Who's Who*. In fact, for an increasing number of advanced amateurs and professionals, photography and 35-mm are practically synonymous.

The emergence of 35-mm did not come quickly or easily, though. There always have been and still are photographers, editors, critics, and technicians who dislike the miniature camera, sometimes vehemently so. Those who believed in 35-mm often have had to struggle with the opaqueness, ridicule, and downright hostility of their colleagues. Sam Falk, a 35-mm pioneer on *The New York Times*, used to receive his film back from the lab badly scratched and mutilated by darkroom men who objected to working with 35 rather than the conventional 4×5 sheet film of the Speed Graphic. Printers and engravers wouldn't touch 35-mm transparencies. Picture agencies refused to handle them. At one point even *Life* magazine forbade the use of 35-mm equipment on assignments. Until the past decade or so, photographers who insisted upon covering important stories with a miniature camera and available light were considered members of photography's lunatic fringe. Letters to the editors of camera magazines attacked 35-mm photography in violent language and in tones of moral indignation. For such a small object, the miniature camera has stirred up an enormous quantity of controversy. But then, most revolutionary devices do.

The 35-mm camera was truly revolutionary not because of its success in the marketplace (Instamatics and Polaroids far outsell it) but because of its influence on the way photographers see and the quality of the images they are able to capture. It both sensitized and expanded human vision.

A basic fact about 35-mm photography is the format of the 35-mm

rectangle itself. A single, standard frame of 35-mm film gives a ratio approximating the famous "Golden Section" of classical antiquity and the Italian Renaissance. The Golden Section has a proportion of 5:8 (the 35-mm frames work out to be 5:7.5). It was considered the ultimate expression of beauty in spatial proportions. Although most artists no longer attach any mystical importance to the Golden Section, it is a dynamic and aesthetically pleasing format. So is the 35-mm frame, being not so obvious as the $2\frac{1}{4} \times 2\frac{1}{4}$ roll-film square or as squat as the 4×5 or 8×10 sheet film format.

Learning to see and organize space in terms of this narrow rectangle is an essential part of the discipline of 35-mm seeing, although "discipline" is perhaps too harsh and forbidding a word for something that comes quite naturally to most people. You get into the habit of "thinking oblong." After some experience you should find yourself seeing subjects as verticals or horizontals, of sensing the relationships that can be created by including two or more objects within the frame, and by discovering the varieties of balance and imbalance possible inside the 24×36-mm borders. When using a 35-mm camera, don't forget to shoot verticals. The natural way to hold a 35-mm camera when you're handed one for the first time is in its horizontal position. The vast majority of amateur 35-mm pictures are horizontals, even when the subject lends itself naturally to a vertical composition. A hallmark of the professional 35-mm photographer is the intelligent use of verticals you see on his contact sheets.

"Cropping" (enlarging only a section of the full picture area) is a subject you'll hear hotly debated if you talk to 35-mm photographers. There is a purist wing which holds to the doctrine of Henri Cartier-Bresson that you should compose fully and tightly within the 24×36-mm rectangle and never crop. There are many others who say that's nonsense.

As for myself, I believe that cropping is a matter of personal taste, necessity, and common sense. Some pictures definitely are improved by cropping. However, there are sound reasons for trying to compose full-frame unless you have compelling aesthetic or practical reasons for doing otherwise. One reason not to crop is purely technical. The more drastically you crop a 35-mm picture, the smaller is the piece of an already tiny negative that must be blown up to 8×10 or 11×14 inches, or whatever the size of the final print. Why waste areas of the negative if you don't have to, with a resulting loss of sharpness and increase in grain? When shooting color transparencies, there's an even more compelling functional reason to compose full frame: color slides are a nuisance to crop. You can buy ready-made masks in various sizes and shapes, or you can alter the

picture with masking tape, but why bother unless absolutely necessary? It's much better to train yourself to compose accurately, using as much of the full picture area as possible, at the instant you expose. At the same time, you are forcing yourself to develop more clarity and precision in the way you visualize a photograph.

The 35-mm camera is an optical machine gun. With its 20- or 36-exposure film loading and its rapid-acting thumb-wind for advancing the film, it comes close to being a variation of a motion-picture camera. The ease with which it enables you to shoot rapidly is seductive, sometimes too seductive. It can lead to overshooting, pointless grabbing of shot after shot, and much wasted film. But the difficulty here lies not in the camera itself; rather it reflects indecision, anxiety, or inept seeing on the photographer's part. (You don't blame a sports car for breaking the speed limit; you arrest the driver.)

Historically speaking, the invention of 35, with its use of strips of perforated cinema film and its capacity to make many pictures in rapid sequence, was a quantum jump in photographic technology—a breakthrough that profoundly influenced the evolution of photography and its media applications.

There were small cameras long before the Leica. A rash of "spy" cameras were concealed in hats, canes, buttonholes during the 1880s; however, they were limited by the relatively slow lenses and film emulsions of their day. There were cameras with very fast lenses before the Leica, too. Consider the Ermanox, a legendary piece of hardware used by early available-light photojournalists, including Salomon and Eisenstaedt. It had an $f/2$ lens (fabulously fast for the time), and you could take available-light pictures with it even on the Ilford-Zenith glass plates with their exposure rating equivalent to about ASA 32 (little more than Kodachrome II). But it used glass plates and was a one-shot camera. Here is how Eisenstaedt describes what it meant to use this equipment on assignment. The subject was General Hans von Seeckt, and the place was a ball in Berlin during the late 1920s.

"The lighting was good, fortunately, but I had to use a tripod—as I did for practically every picture I made with the Ermanox. The General was seated at a table. Visualize in your mind the process.

"You approach with camera and tripod, ask permission to photograph, and set up. First, you must focus through the camera's ground-glass back, using a small pocket magnifier. Then, put in the metal plate holder with its glass plate and remove the slide. Next you have to watch very closely. 'Look this way, General!' Click-click—about a half-second exposure. You must be extremely careful not to catch

him while he's moving. Replace the slide, remove the plate and holder. *One* shot. You want another? Then you must repeat the whole procedure. Needless to say, we didn't tend to overshoot in those days. In looking back, I'm amazed we were able to get the 'candid' results we did."

Legendary the Ermanox may have been; convenient to use it was not. With the coming of the Leica, the mechanics of the picture-taking process were greatly speeded up. If you missed one shot you could almost immediately take another—and still have as many as 34 more frames to go. A new excitement was generated by photography, a concern with time, with slicing off meaningful instants of life, with saturation "in-depth" pictorial coverage of a subject. To appreciate this flexibility, freedom to respond, and chance instantly to second-guess, try photographing any mobile, unpredictable subject —an unposed person, an event, an activity—with a view camera and ground-glass focusing. It can be done, of course, but, like constructing the Eiffel Tower from 100,000 toothpicks, is it really worth the effort? The large camera has its uses and its attributes, but they lie in other areas of photography.

The compulsion and tension felt by a contemporary photographer working in the fluid medium of today was well expressed by Young & Rubicam's art director, Steve Frankfurt, in his introduction to the *1970 Photographis* annual. "Life of course doesn't stand still," he wrote. "The model is dying. The dress will ultimately rot. The studio will collapse with age. But some moment before it all happens, the photographer is going to preserve a moment that won't ever exist again. Assuming he ponders these ponderous ponderables, that he approaches his assignment fully aware that his subject, his very world is deteriorating before his eyes, isn't it reasonable for him to keep clicking away as long as he can? To stop as much of time as is possible? Mightn't something wonderful happen before the camera that he didn't plan on? Certainly! Which is why the best photographer will keep shooting to the point of exhaustion. Will keep pushing until there isn't anything left to push."

But then exercise selectivity, Frankfurt advises. "Does he have to send me every blessed take? Does he have to include the tails, the underexposed, barely discernable images? The repeats? He doesn't, of course. And he shouldn't. He should edit as carefully as I will have to. If only to remove those bad things that will reflect upon his ability."

I once asked the late Dan Weiner, one of the finest 35-mm photojournalists of the 1950s, about his attitude toward the tendency for 35-mm photographers to overshoot. He gave a good answer.

"There's no doubt that it [the 35-mm camera with rapid wind] may lead to a certain amount of undisciplined shooting. There's always the danger that a photographer may be tempted to rely on quantity rather than quality, instead of getting the picture, to shoot around multiple situations and to expect they will carry the essence of the situation or story. I try to discipline myself—not too much wild shooting, naturally, and with each shot trying to make the best picture. But you can't think according to the old concepts of shooting because by the standards of the view camera we all overshoot. . . . It's in a way similar to a writer who is making a lot of notes. You go along in a given situation and you're making notes. You may think you've made a profound observation, then suddenly something else happens to change your ideas and you automatically discard all the notes or photographs you've made up to than point and you start off with a new idea. Now when I get back to my contact prints, when I edit, I may reject that whole space of shooting. So it is over-shooting, yet it's part of the whole discovery."

Close as the seeing and thinking involved in using a 35-mm camera is akin to the way a motion-picture photographer some-times works, 35 still photography isn't shooting movies. An essential dimension is missing: 35-mm pictures don't move. They must stand on their own as individual, fixed images, or, on a more complex level, in relationship to other fixed, individual images, as in a slide show or a printed magazine layout.

For all its mobility and dynamism, a 35-mm camera produces "frozen" images, as does any other still camera, with a section of time and space fixed for us to examine at leisure. However, "frozen" has a hard, static connotation. A good 35-mm picture reminds me more of a motion picture that is suddenly stopped at a single frame. The effect is surprise or shock and then pleasure as you study the frame and see the details that escaped you when the image was in motion. Like that held movie frame, the strong 35-mm picture conveys a feeling of life arrested but only temporarily. The projector is likely to start up again at any moment; the picture is going to come to life. We are seeing the subject transiently immobilized but not embalmed.

A 35-mm camera is a portable, hand-held instrument weighing only a few pounds, and can go anywhere that man himself can penetrate, to the abyssal depths of ocean trenches or into the solitudes of space. Making use of this ultramaneuverability is part of 35-mm seeing, too. You can, if you want to, use a 35 as you'd use an 8×10 studio view camera on a tripod (and some powerful images have been recorded with this static, big-camera approach). But it's not expanding the miniature camera's potential to its fullest.

The beauty part of 35-mm is that you're not locked into a fixed position but are free to explore the world from any angle or vantage point. We exist in a spatial universe of three dimensions, and a 35-mm photographer has considerable freedom to use the tridimensionality any way he likes. Part of learning to become a good 35-mm photographer is getting to loosen up and use this freedom. You're no land-locked, monolithic behemoth; you don't have roots attaching you to the ground. You're like an aquatic, free-swimming creature who can explore any angle and discover its surprises and perspectives.

See things the way a movie director does, in terms of long shots, medium shots, and close-ups. Be fluid, not rigid. Variety, in other circumstances a great luxury, is encouraged by the very nature of 35-mm equipment.

Some possibilities: Show the subject in relation to its environment. Move in for a tighter composition that reveals all the atmospheric, concrete details in close review. Get in closer. Closer yet. Especially, don't neglect the truly close look (a most common failing of inexperienced photographers, who retain inhibitions about coming to grips with what they are photographing). Robert Capa is supposed to have said, "If your pictures aren't good, you aren't close enough." An oversimplification, perhaps, but the statement contains a hard core of truth.

Then there's the matter of angle. As a child you may remember how much fun it was to bend down and look through your legs, seeing the world upside down. How different even the most familiar and banal objects appeared! With a 35-mm camera, too, you can explore unexpected viewpoints and angles. There are the usual clichés, of course: the "bird's-eye" view and the "worm's-eye" view. They were radical and exciting when first tried; today they are commonplace. But there are an infinite number of angles from which any given subject can be viewed. Sometimes even a subtle shift in perspective or adjustment of angle can produce astonishing effects. Again: stay loose, explore, experiment, discover, invent.

One of the qualities that instantly leaps out at you when you look at somebody's 35-mm contact sheet is the *variety* of the seeing. You can sense a lively, searching, sensitive eye practically from across the room. You find the long shots and the close-ups, the unexpected viewpoints, the surprising juxtaposition of things, the object reduced to symbol or abstraction, the human interactions. You see this and sense it and say to yourself, "Here's a good 35-mm photographer."

Another one of the great things going for 35-mm photography is the vast array of lensware available for most models today. Depending on what visual-emotional effect you're after or what prac-

tical problem you want to solve, you can choose anything from a super-wide angle to a super-telephoto lens. This variety of optics is being used today with verve and imagination by many 35-mm photographers.

Of course, you can become obsessed with a concern for equipment. If you want to be a gadget collector, 35-mm equipment offers an embarrassment of riches. But if your main concern is being a photographer, go easy on adding new lenses. Probably 90 per cent of the pictures most photographers ever take or want to take can be made successfully with a 50-mm lens. Switching lenses is a nuisance, and so is carrying a passel of cameras, each with a different lens (which tends to defeat the very freedom and spontaneity of seeing that makes 35-mm photography so much fun). Zoom lenses offer a partial answer, but many still aren't any better than they should be.

With that warning out of the way, let's begin with the short of it, the wide-angle lenses. You can categorize them any way you like, but the basic definition is that they have a shorter focal length but take in more than the lenses of "normal" focal length for 35-mm cameras—lenses in the 44-to-58-mm range. Some of the reasons you might want to use wide-angle lenses are:

You're cramped for space and can't back off far enough to include everything you want with a normal lens.

You'd like to produce the perspective distortion effects possible when you move very close with a wide-angle lens or take angle shots with it. (A wide-angle doesn't *actually* distort perspective, but that's the way it looks.)

You want a "deep space" picture with objects sharp from the immediate foreground to infinity.

You want to use the greater depth of field possible with a wide-angle lens to free you from the need for critical focusing.

The long lens, on the other hand, shows you less, but the subject image is bigger. The uses here are pretty obvious—for wild-life photography, for example, when you would frighten your subject if you got too close, or for candid pictures from a distance. Then there are special applications, such as astronomical photography.

Just as a wide-angle lens tends to *explode* space, making distances between objects seem greater, a long lens tends to *compress* space. This creates interesting visual possibilities. (One of these, a cliché by this time, is the apparently enormous disk of the setting sun behind a sailboat, a skyscraper, or whatever.)

Alfred Eisenstaedt says that on some days he sees with telephoto eyes and on other days with wide-angle eyes, and it's true that both types of lenses tend to necessitate different categories of vision.

With a wide-angle the search is for compositions in deep space; with a telephoto it's more often an exercise in visual plane geometry, looking for the flat designs and patterns of the world. With a single-lens reflex camera it is possible to observe these effects directly; with a range-finder 35-mm it takes a bit more experience in previsualizing. Either way, the spectrum of lenses from 21- to 1000-mm plus opens up a vast domain of seeing for the 35-mm photographer.

Richard Avedon once told me that for him the perfect camera would be no camera at all; you'd just look, see, and blink. The state of photographic technology being what it is, we still need to interpose an intricate glass-and-metal artifact between eye and world, and rather than blinking, we have to squeeze a shutter release, which produces a mechanical blink. But the reflex arc between seeing, responding, and recording is a fraction of a second with a 35-mm camera. It truly does become, in Henri Cartier-Bresson's famous phrase, an extension of the human eye, and a characteristic quality of much 35-mm photography is that of spontaneity and immediacy.

Surely you'll want to exploit this capacity for "instant seeing" in some of your own 35-mm shooting. It's not the only kind of photography, of course, but the directness and speed with which 35-mm enables you to photograph is one of its principal charms and attractions.

Image hunting with a 35-mm is a visual adventure filled with surprises, serendipity, suspense, and altogether unpredictable failures and successes. I think of one serene November Sunday afternoon in the Luxembourg Gardens in Paris, on my own with a 35-mm camera, loaded with color film, just looking and feeling. Waiting for the clouds to shift until sunlight illuminated the ornate façade of the old palace. Discovering a blaze of late chrysanthemums among windrows of chestnut leaves. Trying for—and missing—a child rolling a hoop down a slant of sidewalk. Working fast to catch two lovers locked in a passionate kiss, then finding that speed wasn't necessary—true Parisians, they held the kiss so long I could have set up a view camera and leisurely focused on the ground glass.

Each 35-mm photographer must create his own way of seeing. We do, each of us, in this sense, have to invent the wheel all over again. But what we invent is our own personal wheel, which is unique. Maybe it isn't even a round wheel but a square one. Surely few mechanical devices have permitted the expression of creativity that the 35-mm has given us, or provided more pleasure, or shown more incisive images of man and the universe. And I'm sure there is more to come from the 24 × 36 rectangle.

MAKING IT WITHOUT A DARKROOM

A central social event of the New York photographic scene, over the past couple of decades, has been the annual Modernage party. With Ralph Baum, president of this Manhattan custom photofinishing service as host, the function traditionally is held in January, well after the crush of holiday parties. Several hundred guests (an exact count being neither possible nor seriously attempted) crowd together at the East 44th Street Modernage headquarters for a few noisy smoke-filled hours of sociability, boozing, and shouted conversation. It is like Broadway and 42nd Street in microcosm, for if you stood at the door of all the Modernage parties, eventually you would see everybody who has been, now is, or ever will be anybody in the photographic domain. Events are dated from the party. "I got the assignment just before the Modernage party," somebody will say, or, "I met her, must have been late January or early February—it was just after the Modernage party." Even confirmed non-party-goers, if they wish to make one public appearance in New York during the year, tend to drift in and out of the Modernage party. ("He was here, he was here—didn't you see him?" "No. Where is he?" "I don't know. I think he left." Bitter disappointment.)

The establishment that sponsors this event is the best known of a small but elite group of service companies, the "custom labs," whose importance to the photographic industry is all out of proportion to their size. They are not, actually, laboratories, of course, "lab" in this case being the common trade term for a darkroom. They provide individualized, quality photofinishing for professional clients (and amateurs who are willing to pay the relatively high prices charged for these services). It would be a terrible thing for the free-lancers if the custom labs all went out of business. Everybody would have to go back into the darkroom again—and today half of them wouldn't know what to do in there.

In his quiet little third-floor office at Modernage, I talked to Ralph Baum about how he got started. Baum is a vigorous sixty-plus-year-old German-born refugee, part of that great migration of talented people who left Europe during the 1930s for the haven of the United States. (One thing Hitler and the Third Reich achieved was to make the United States, rather than Germany, the world center of pho-

tography.) Baum has a strong, aquiline face, permanently weathered and deeply tanned, like that of an Alpine skier, which indeed he is. Known to be hot-tempered and demanding on the job, off duty he is a warm and courteous friend. He knows everybody in the field.

"Like so many other people, I dreamed of becoming a great photographer," he said. "But I didn't have much success, outside of winning a prize or two for pictures in a camera club. I decided I couldn't make a living along those lines, but I thought I was a good technician, and I started printing for other people."

Back in 1946 Ralph was occasionally photographing babies and weddings, using a Rolleiflex and flash. One day he ran into a friend.

"He was just out of the army," Baum recalls. " 'How is it going, Werner?' I asked him. 'Are you doing well?' He didn't know yet; it was too soon. I offered him the use of my darkroom if he ever needed it. Then he called me a little later. He had an assignment from the Black Star picture agency and needed a hundred prints in a hurry. 'Why don't you come over and help, and together we'll get the work out,' I told him. We made the prints, Black Star liked them, and then they called back with other jobs for me. I became a photographer less and less, a photofinisher more and more, working for free-lance photographers and other clients."

By 1949 Ralph had founded Modernage, and there was a staff of five people; today 150 people are employed in two Manhattan locations. The concept and growth of Modernage represent, in small scale, a major trend in photography since its inception: the split between the picture-taking and the processing functions.

In the beginning the photographer was both artist and scientist. He not only composed and created a beautiful picture, he also performed the complicated chemistry necessary to make the image visible. If anything, the darkroom aspect of photography, its scientific-technical side, was the more miraculous. Arcane, complex skills were required in the days when photographers coated their own "wet" glass plates and location shooting required that you bring a horse-drawn laboratory with you, as did Roger Fenton in Crimea and Brady and his associates during the Civil War. If horses were not available, you had to outfit yourself with a cumbersome backpack, including chemicals in a wooden crate, and a rolled-up tent, as well as your tripod and camera. "In those days," George Eastman commented, "one did not 'take' a camera; one was accompanied by the outfit of which the camera was only a part."

The introduction of dry photographic plates during the 1880s changed all that, because, unlike the wet plates previously used, they could be developed any time after exposure. (Wet plates had to be

processed immediately, before the emulsion dried out.) You no longer had to carry your darkroom along with you and process the plates on the spot. A differentiation in function between photographer/artist and photographer/scientist became not only possible but convenient.

A further wedge between the two functions was driven in 1888 when George Eastman introduced an inexpensive roll-film camera which he called the "Kodak," a nonsense name he chose because it was short, memorable, and easy to pronounce. It was a radical device —the perfect amateur's camera—and won a Silver Medal at the Photographers' Association of America convention in Minneapolis that year. The camera came to you loaded with enough film for one hundred shots. After exposing the film, you sent the whole ensemble, camera and all, back to the factory. Processed negatives, mounted prints, and reloaded camera were returned to the customer for a total cost of $10.

"Photography Reduced to Three Motions," an early ad claimed. "1. Pull the Cord. 2. Turn the Key. 3. Press the Button. And so on for 100 Pictures . . . Anybody Can Use It."

Indeed they could.

Eastman quickly discarded the idea of sending both film and camera back to the factory. With later model Kodaks, you loaded and unloaded the film yourself (a seemingly simple act but one that was habitually bungled by millions of photographers for more than half a century until Kodak introduced its drop-in Instamatic cartridge). Sometimes the Kodak user chose to develop his own film and make his own prints. More often he preferred to have it done for him by professionals. The photofinishing lab as a mass service grew up along with photography as a mass hobby.

Today it is an $800-million-a-year business (about 85 per cent of it is color work) with hundreds of dust-free, air-conditioned, highly automated plants all over the country. Some are individual companies; many belong to one of the big chains. The drugstore is still the place where most people leave and pick up their film; other outlets include camera stores, discount houses, and mail-order firms. One chain even provides drive-in service for dropping off and picking up amateur film.

Every day a four-engine jet plane takes off from an airport in New Jersey, flying a load of exposed color film to the vast processing plant at Kodak Park in Rochester. Every day a plane flies back with processed film ready for distribution to Kodak's East Coast customers. A strange air life. Ghostly cargo going out, a cargo of latent images, the potential for pictures only. On the return, a cargo of time past, moments frozen into a pattern of colored dyes.

In general, the quality of color processing provided by these photo-finishers is satisfactory. In general, the quality of black-and-white processing is dreadful. It always was, even when most amateurs were shooting only black-and-white. But the vast majority of casual snap-shooters, people who have never developed a roll of film or made a photographic print, are uncritical customers. They are mainly concerned that their pictures "come out." (A recent survey showed that on a 12-exposure roll, an average of about 10.5 do.) Remember, this is photography at its most casual, unpretentious level: snaps of babies, visiting grandparents, birthday parties, Christmas gatherings, visits to the Grand Canyon and Paris, the sentimental personal mementos of millions of lives. A reasonably clear, recognizable likeness is sufficient. Who needs a darkroom?

George Eastman made it simple; Dr. Edwin Land made it fast. A brilliant, sometimes controversial inventor, he formed the Polaroid Company in 1937 to manufacture polarizing plastic sheets for use in automobile headlights and windshields to reduce glare. That idea didn't catch on, and the company turned to other products, including sunglasses. In 1947 Land introduced the astonishing Polaroid Land camera which not only took the picture but actually developed it within the camera and gave you the finished print within about sixty seconds. The prints were sepia-toned in those early days, and the quality left much to be desired, but it was a remarkable feat. Later came color, and ten-second black-and-white processing, and the under-$20 Swinger. Polaroid became one of the great glamour stocks of the 1950s and 1960s, and for millions of Polaroid owners the dark-room was as obsolete as the kerosene lamp.

Even among advanced amateurs and professionals, a decline in darkroom activity has been evident, the split between photographer/artist and photographer/technician growing wider. More and more hard-core amateurs, the kind of person who in 1936 or 1952 would outfit an elaborate darkroom in the basement (or at least black out the kitchen window) and spend hours struggling to make an 11 × 14 salon print, now seemed to take no interest in this aspect of photography. Everybody is shooting color, for one thing, and color processing is still too complex, expensive, and time-consuming for all except a relatively few aficionados, the true heirs to the nineteenth-century photographer/chemist.

As for professionals, they are increasingly too busy to do their own darkroom work. Today a large number of portrait studios farm out their work to specialty color and black-and-white labs. In many cases it's simply not profitable for the owner of a small studio to spend his time in the darkroom or to hire competent darkroom help,

even assuming he could find somebody. (Good lab technicians are difficult to come by these days; everybody wants to be up front with a camera.)

The majority of free-lance photographers rarely, if ever, develop their own film or make their own prints. A custom lab does it, or the exposed film is turned over to the client or publication, who takes it from there. Again, it doesn't pay for the photographer to spend all those long hours under the safelight. He needs the time to be out shooting, selling, contacting clients, researching ideas. Moreover, the quality of most printed reproduction being what it is, this lack of handcraftsmanship does not seem to make much difference.

"It's a waste of time," a photographer remarked to me recently. "Sure, I could slave away making a beautiful print. But what for? By the time the picture is published it comes out looking the same as if they'd plated from a routine print from my lab."

However, the individual darkroom has not quite gone the way of the icehouse and woodshed, nor is it likely to in the near future. There exists a small but marked countervailing trend, led by hard-core perfectionists who insist on quality and personal control, even if that doesn't seem to be the economically practical thing to do, and by a new generation of photographers who have rediscovered the fun of darkroom work and are concerned with the print as an essential creative aspect of photography.

If you have never watched one of your own captured images magically materializing in a tray of developer, the ghostly ectoplasm appearing quickly at first, sketching in the shadows, then slowly darkening and filling out all the details, you don't know the half about photography.

It is a mind-blowing experience the first time around. And once you've tried it, you want more. The hours pass quickly in the dark-room; few activities I know are so totally absorbing as making photographic enlargements. (Developing film, however, is something of a nuisance; it requires care but no great skill, and you can't see the process taking place under your direct control as you can when you're making a print.)

So there are portrait photographers who may not be turning out masterpieces but who demand the quality that only personal control over the entire photographic process can give. They are installing their own color processing equipment and learning how to use it. There are free-lance photographers who, for any portfolio or display print, will spend the necessary hours in the darkroom to achieve it. There are periodical and book publishers fighting an uphill battle against increased production cost to maintain a high quality of

reproduction. There are photographers who give a damn, dedicated to the importance of the print as the last word, the ultimate statement of the photographic process.

A couple of years ago the Museum of Modern Art prepared an exhibition that reflected, in part, the importance of the print. Here, though, the emphasis was on the photographs that were, in a literal sense, "made" in the darkroom: by use of montage, multiple printing, superimposed images, special techniques. There has been a revival of interest, too, in obsolete and long-neglected printing techniques, such as Bromoil and paper negative printing. All this enlarges the vocabulary of photography, but it seems to me that *any* print, even a "straight" unmanipulated one, deserves tender, loving care if it is worth displaying at all.

"I print for content," Dan Weiner used to say, which requires more skill and aesthetic sensibility than it might seem. He did, and simultaneously achieved a low-key moody personal style, the reticent somberness of the prints reflecting his own personal life-view, with its overtones of Dostoevskian pessimism. "At heart I'm a gloomy Slav," he once told me wryly. "Even my happy pictures look sad." His way of printing helped make them so.

Today it is rare to find so distinctive a printing style. An experienced viewer could identify a Weiner print from across the room. The style was as distinctive as a person's handwriting or the brushwork of a painter. You can't say the same of many contemporary photographers. Charlie Brown displays a photograph. What you see is not Charlie Brown's print. You see a routine commercial print, competent perhaps, but devoid of the photographer's own personality.

In photography the only way to inject personal style into a print is the hard, lonely, sometimes frustrating way (but rewarding and pleasurable, too) of making your own. But you can't, you say. You don't have the time. You don't have the facilities. You don't shoot enough pictures you care that much about. Your skin breaks out in a rash whenever you touch photographic chemicals. Or whatever. The second-best way out for discriminating amateurs is the custom lab, which fills the gap between automated, mass production photofinishing and individual craftsmanship.

Like Modernage, many of these labs grew up during the post-World War II years to serve the needs of photojournalists and magazines. Today the mainstay of their business still consists of professional clients (individual photographers, publications, business corporations, industrial plants, advertising agencies), but most of them also welcome work from amateurs who are willing to pay the relatively high prices charged, and most such labs are happy to conduct business with you

by mail. Some of the custom labs do black-and-white work only, some specialize in color, and others handle both. The greatest number of them (and there are not very many altogether) are located in the New York metropolitan area, with a few others in major cities around the United States. (See Appendix I.)

In a typical commercial photofinishing lab the film is processed at high speed and in large quantities on automated equipment. In most custom labs, by comparison, your individual roll of film is hand-developed by inspection, which means that the technician visually checks the film during at least one point in the developing process. If necessary, he can compensate for a degree of underexposure or overexposure. Also, you may be able to specify the use of a particular type of developer, and the effective speed of your film can be increased by "pushing" (processing in a powerful developer or being given longer than normal development). No custom lab can perform miracles if your original exposure was too wide of the mark, but they can give a degree of individual treatment impossible with standardized mass-photofinishing operations.

Normally the next step is for the lab to print up a contact sheet from your negatives. Strips of negatives are placed on a piece of 8 × 10 printing paper and printed "same size"—without enlargement. You can get a full dozen 2½ × 2¼ roll-film frames or 20 to 36 frames of 35-mm film on a single 8 × 10 sheet this way. A good custom lab will compensate for frames that are badly underexposed or overexposed, providing you with a clean, sharp record of a full roll's shooting on each sheet. (All professional picture people are accustomed to working from a contact sheet, using a magnifier when necessary.)

To order an enlargement, you send in the contact sheet (clearly marked) along with the film. That's another important service of the custom lab: to make enlargements according to individual order and specifications. The standard minimum size is 8 × 10 inches. The 11 × 14 and 16 × 20 sizes often are used for display and portfolio prints. Some labs specialize in exhibition work and will go up to mural size prints if you can afford the considerable cost involved.

In ordering a print, be sure to mark it accurately for cropping. A red or yellow china marking pencil (sometimes called a "grease" pencil) is the best thing to use. If you make any mistakes, wipe them off with a cloth or tissue and start fresh. A wavy line indicates approximate cropping; a straight one means follow the guide exactly. You also can indicate areas that need to be "burned in" (made darker) or "dodged" (made lighter). Diagonal slash marks or crosshatching are the generally accepted symbol for burning in; small circles are

used to indicate areas that should be lightened. "Spotting," the filling-in of white dust specks on the print, is normally included in the basic fee for making the enlargement, but the use of special paper, mounting the print, and any unusual special techniques bring extra charges. A premium is usually charged for rush work.

Give clear directions as to the number of prints, size, cropping, paper surface. "Unferrotyped glossy" or "semimatte" is the standard finish preferred by most professionals. For portraits a matte or textured surface sometimes is preferred.

Custom labs are not cheap. If you have your own darkroom equipment and require an appreciable amount of developing and printing, you will come out way ahead financially by doing your own. Before ordering any work from a custom lab, write for a list of services, prices, and billing procedures.

I've been using a number of leading custom labs on and off over the years, and in my experience the quality of the work tends to vary rather widely, not only among different labs but in the same lab at different times. Changes in personnel and the volume of business can play an important role here. There is a peculiar syndrome that occurs again and again in the custom lab business. The top printer in an established lab (whose importance can be compared to that of a good chef in a popular restaurant) decides to quit. He sets up a small lab on his own. Super Nova Lab, let us say. For a short time Super Nova is great: the best quality in town. And why not? You have a top man personally making your prints. As business grows for Super Nova, so do the problems. Additional help must be hired. Scheduling the darkroom workload becomes more complicated. Billing and salesmanship have to be attended to. Quality and speed of service begin to decline. Then, like many chefs who try to start up their own restaurants, the master printer goes bankrupt. Don't cry; he usually gets his old job back, good printers being hard to find. But custom labs do come and go, and only a few hardy perennials are able to survive the long pull.

So if you decide to use a custom lab, do some testing first. Contact several, for prices and services. Send in an expendable roll to each for developing and proofing. Compare the results. Then try sending the same negative, along with a carefully marked proof sheet, to your two top choices for a trial 8 × 10 enlargement. Again compare results. This is time-consuming, but it can save you considerable expense and disappointment in the long run, and it is the only way I know of to locate a custom lab that best suits your personal taste and requirements.

WHO GOES TO PHOTO SHOWS AND WHAT FOR?

"What do I think of this photo show?" the Leica expert said, mopping the sweat from his balding forehead with a crumpled handkerchief. "What's to think? A photo show is a photo show, and if you've seen one, you've seen 'em all. The products change, sure, but everything else is the same—same manufacturers, same crowds, same faces, same press parties, same conversations, same lousy hot dogs. Believe me, if they didn't pay me to cover it, I wouldn't be here."

Well, in a sense, he's right, as usual: there is a sameness to photographic trade shows, but they persist as one of the industry's major institutions, and a giant international photographic fair will attract great throngs of human beings to its core of overheated, overcrowded exhibition halls the way a powerful electromagnet gathers iron filings when the switch is turned on. There must be compelling reasons why nearly 100,000 people visited the 1969 Coliseum show in New York (a gate surpassed only by the automobile and boat shows) or about twice that number flock to Germany for the Photokina in Cologne.

The amateur photographers go to see the new products, of course. They want to touch and examine and admire, to hold in their hands the expensive, glamorous new cameras they've read about in the photography magazines. They are looking for their dream camera, the magic touchstone that will realease them from their limitations and frustrations as photographers, enabling them to make fabulous pictures and achieve success at last. This camera does not exist, nor will it ever, but the search for it goes on because people always tend to look for external modes of salvation rather than turn inward where the only real possibilities for growth and change lie. And so the equipment, the lovely, complex artifacts of photography, casts its spell. Some amateurs may get their kicks photographing the models in bikinis, but the most powerful seduction at a photo show is not that of sex but of machines. "I went down there almost every evening it was open," a photographer friend told me after a recent show. "I guess I just love equipment. I love to be around it and see what's new."

The crowds are largely male. In the United States, women probably take more pictures and buy more film than men do, but women mostly use Instamatics or other simple cameras and, with a few excep-

tions, couldn't care less about what new products Rollei or Minolta or whoever is introducing this year. Most hard-core amateur photographers, the people deeply fascinated by equipment and with the money to buy it, are men. Some of them start big at a surprisingly young age. You'll see many youngsters at photo shows, including kids of junior-high-school age and younger, with Leicas, Nikons, Hasselblads, and expensive lenses that surpass the outfits owned by many working professionals, and even in this age of affluence you wonder where all the money comes from to supply a boy with a thousand dollars' worth of camera equipment before he's old enough to shave.

Not that the throngs at a photo show give an over-all impression of great wealth. It is a conglomerate group, with people from a diversity of economic, educational, and ethnic backgrounds, and you receive no impression of homogeneity as you might from an opera crowd, say, or from the crowd at a stock-car race. To look at these faces is to understand that photography is the most democratic of hobbies, and that in no strata or segment of our society are people immune to being bitten by the camera bug. If there is a common denominator here it is *inquisitiveness*. This is a restless, question-asking group of people, probing and poking into every corner of the show with the passionate curiosity of gerbils let free in a strange room.

Products draw the big crowds, but some people go to photo shows to see the pictures displayed there. At Photokina considerable effort and expense go into the preparation of major photographic exhibitions; at shows in the United States the pictures too often are hastily gathered, tastelessly hung, and relegated to remote nooks and crannies. However, even the less impressive exhibitions attract their share of viewers. Photographers are not intimidated by photographs on display, the way they might be by abstract expressionist paintings or kinetic sculpture. Here they are confronted with nothing arcane or incomprehensible. They relate to photographs, believing (with truth, in some cases) that with a little luck they could do just as well or better. And so every photographer is a picture critic.

Standing near an exhibition of technically skilled but uninspired color prints at a recent show, I listened to reactions. "I like these a lot better than the ones on the other side," one woman said. "They're more *sympathetic*." A father pointed out a close-up of a puppy to his son. "Look at the expression the photographer caught. You've got to have some patience, boy, to make a picture like that." A girl minutely examined the surface of a heavily retouched color print. "Look," she said triumphantly to her companion. "He's painted all over it! See all the lines through here. No wonder it looks like a painting—it's all touched up." "O.K., so I *like* paintings," her friend

replied. "What's wrong with that?" A man wandered past, shaking his head. "Awful," he commented. "This is really the most cretinous exhibit."

Some people go to photo shows to photograph the photographs, bizarre as it may seem. You'll see them standing in front of a mounted 16 × 20 print, camera at their eye, rocking back and forth to frame the picture exactly right in the viewfinder. Here's a rabbi photographing, of all things, a Japanese nude, and there's an elderly man, with rimless glasses and neat, fussy mannerisms, recording African big-game pictures, and there's a young man in a sports shirt carefully copying a dramatic football action shot by a *Sports Illustrated* photographer. What are they doing it for? If you ask, the person usually acts embarrassed and says it's just for the record; he likes the picture and wants a copy for his own pleasure. But you wonder where some of these borrowed images are going to show up, mixed in with other prints or slides, and who is going to take credit for them. "Why, that's a great shot, Harold! You must have been right on top of the lion." "Well, I was using my telephoto lens, of course, but it was scary, I tell you. Now here's one of our safari guide. . ."

Annual surveys by the photographic industry give statistics on amateur photographers from which you can draw up a profile of the fictitious Mr. Average Consumer. Except that he's not fictitious: I'm certain I've seen him at every photo show I've attended. He is about forty, has a wispy sand-colored moustache, and is getting a paunch. He comes to the shows in the evening, wearing a crumpled two-button brownish business suit. I suspect he works in the city and commutes to Long Island or Westchester; he has the nervous, harried air of a man with an ultimate train to catch. Photography has been his hobby since high school, he owns three cameras worth $1500, shoots 54 rolls of color film each year, and the manufacturers love him. There's a gadget bag slung from his shoulder, and in his left hand he carries a red-and-white plastic give-away bag from GAF. He stops at every booth, seizes the available free literature, and stuffs it into the bag, like a chipmunk filling his cheek pouches. (He's in too much of a hurry to stop and read anything now; he'll do it later.) If only I could get him in a quiet corner and talk to him, discover his motives and goals, it would be the key that could unlock the mysteries of the great amateur photographic market, and together we could make a fortune, forecasting market trends. "Murray," I call. I don't know if that's really his name, but he looks like a Murray. At that point he always vanishes in the crowd.

The manufacturers and importers go to these shows to sell, of course, and the dealers to buy. As an economic institution, a modern

photographic trade show is directly descended from the great trade fairs that arose in Western Europe during the twelfth-century renaissance. According to historian Carl Stephenson: "Annual fairs, each lasting for several days, were eventually organized in series, so that great traders arranged their trips in order to attend as many as possible. Thus they disposed of merchandise in large quantities, while small dealers obtained stocks for resale or for use in manufacture, and the lord of the fair got a handsome revenue from stallage, the fees for displaying goods in stalls." (*Mediæval History* [New York: Harper, 1943].

Eight hundred years later, with a little updating of nomenclature, that's an apt description of any contemporary photo show. They, too, usually are annual events lasting several days while the great traders transact business with the retailers, and the organizers of the fair, although lords no longer, still hope to net a profit or at least break even.

The medieval trade fairs were general, open to products of all kinds, but a contemporary photo show is a highly specialized event. It has to be. The variety and quantity of photographic equipment and materials manufactured today are staggering, and you can scarcely believe the scope of it even when you see it with your own eyes. At the Photokina, the wares of more than 700 firms from all over the world are exhibited in a display area that totals nearly one million square feet and fills a complex of eleven huge halls: like sixteen football fields filled with arrays of cameras, lenses, exposure meters, tripods, projectors, flashguns, enlargers, photo albums, cable releases, gadget bags, minature batteries, and giant automated photofinishing machines. If all other material evidence of our civilization were destroyed, I suspect that archaeologists of the future could reconstruct a fairly accurate picture of the state of our technology from the rubble of Photokina alone.

Some photographic shows are essentially trade-oriented. Manufacturers usually save their important new products for this type of show because here they can be sure of thorough international press coverage and contact with the important dealers who write the big orders. The so-called consumer shows tend to be smaller and the atmosphere more carnival-like, or maybe "honky-tonk" is the better word. Megamammalian models from Iowa or Brooklyn pose on rotating sports cars, a chimpanzee rides a tricycle while strobes and flash cubes wink, you can photograph your wife in front of a spray-painted backdrop framed by plastic palm trees, and the orangeade concession is doing more business than most exhibitors.

A third category is the Super Show, which tries to be every-

thing at once, and sometimes succeeds. It attempts to attract industry participation on a global scale, to put on a good show for the public, and usually has a number of events—conventions of photographic organizations, picture exhibits, film festivals, lectures, special programs—coinciding with the exhibition itself. At a recent New York example of the Super Show you could easily have had a rich, full day. If you got tired of looking at the wares of more than 350 exhibitors (from Accura, Ltd., to Zoomar, Inc.), you might catch the Kodak-Pathé Multivision demonstration, watch Beaumont Newhall's slide presentation on the history of aerial photography, or if hard-pressed, attend a lecture on "Lens Fun and Fantasy" by Harold H. Cuthbert, F.R.P.S. That is, if you weren't a member of one of the sixteen professional and trade associations involved with the show, and then maybe you were at the Waldorf or the Americana attending a conference on "Holding Price Levels through Credit Sales," or listening to a speech on "The Direction of Photofinishing." Or if you were really eye-sore and foot-weary, maybe you split the whole scene and were just having a beer and a quiet talk with old friends.

The exhibitors are at the shows to work. For them, it is a grind, a nine-day marathon of twelve-hour days. You walk into the exhibition floor on the night before a trade fair opens and you find a shambles. The booths, products, pictures, displays, handout literature, and visual presentations are supposed to be ready by ten o'clock tomorrow morning when the first dealers start checking in, but now, with these few hours to go, the place resembles a vast, half-completed housing project: loops and snippets of wiring all over the place, the floor littered with scraps of plastic, sawed-off ends of sheet rock, cigarette stubs, and flattened paper coffee cups. Everybody is tired, frustrated, irritable. The managers of the different booths, their designers and work crews, are going to be up most of the night. The rear projection screen is malfunctioning again, a vital panel of photographs has been mislaid in transit, somebody goofed on the measurement of the booth, the marketing assistant broke his leg skiing last week and his boss has to fill in with the heavy work instead of meeting a schedule of important customers today, and the difficulties with the intransigent unions have to be experienced to be believed. But somehow, of course, everything will get done, if not exactly on time.

The crowded, self-contained universe of a photo show takes on a special look when seen from the exhibitors' side of the counter. I talked to a friend of mine, manning an important booth at a recent Coliseum show, toward the end of the affair when the pressures begin to take their toll.

"How's it going?" I asked.

He looked at me wearily. "Well, by any measurable standard I guess I should say 'terrific.' We're getting more attention than anybody else, but frankly, you can have it. For one thing, it's putting a terrific physical strain on all our staff, and secondly, the orders we get aren't as significant as they might be because we're back-ordered on most major items anyhow. . . . I'm the first to admit we ought to meet the public and demonstrate our new products, because the dealers certainly aren't doing the job, but this is too much. You don't know who you're talking to—they have the trade sessions overlapping with the public sessions, and anyone can go up to that trade registration window, pay two bucks, give a fictitious name and association, and walk in with a trade badge."

I asked if he had any suggestions for improving the situation.

"Yes," he said, waving his hand in the direction of the hordes of people pressing in on the booth. "Send 'em all to charm school."

Another survivor of several nine-to-nine days behind the counter was beginning to feel the strain, too.

"It's rough. I've been doing it for twelve years and I ought to be used to trade shows by now, but these New York crowds are too much. I mean the wise guys who know it all. They've seen all your competitors' equipment, and they want to know why you don't improve your line to meet their personal specifications. You've got a button here, they want it there. They tell you they've written to the factory suggesting improvements and how come you haven't done anything about it yet. Well, you get this kind at every photo show, but usually it's one at a time and you can cope with them. In New York they come at you in droves."

Security provides an added headache because some people go to photo shows to heist the equipment. "It's a tough problem," my friend said. "That's why we chain down most of the cameras at the counter, and that's why we have the little old wine maker sitting over there." He pointed to a frail and ancient guard in a blue uniform seated on a tall stool. "Trouble is, he sleeps most of the time."

I asked if he'd had any equipment stolen.

"Oh, yes. I lent one of our projectors to a friend of mine at a French exhibit. He wasn't aware of the problems at a New York show and didn't lock up the projector properly. It was stolen, demonstration slides and all. But we recovered it—one of the guards was caught trying to sneak it out."

Of course, it isn't all hard work and headaches for the participants. No businessman I ever knew found it painful, exactly, to write up a lot of orders, and in total, this can run into the millions. Also, the people involved in a big photographic exhibition become turned

on by the crowds, the pace, the excitement, the sense of being involved in something vast and powerful. There always are more business-social functions than one can possibly attend, in addition to the extracurricular methods of relaxation by which conventioneers traditionally blow off steam at the end of a long day. So some people go to photo shows for fun, although the Protestant Ethic and the IRS regulations being what they are, hardly anybody will admit they're actually *enjoying* themselves. But for dealers, particularly, it's a chance to combine business with pleasure. As the owner of a camera store, for example, you might fly to Chicago or New York (with or without wife), spend a couple of days covering the products, catch some hit shows, generally have a ball, and write a lot of it off your income tax. The more glamorous cities have an edge here.

Representatives of the photographic press go to photo shows to report on the new products. As the great trade shows increase in size and complexity, this job becomes more and more difficult. It now takes teams of reporters to accomplish a thorough coverage, whereas only a few years ago one or two knowledgeable individuals could handle it. The physical environment adds to the difficulty of clearheaded reporting. Exhibition halls invariably are overheated and underventilated. When the general public comes in during open hours, you can feel the temperature rise from all that body heat, the oxygen content drops to a level barely sufficient to sustain consciousness, and the humidity rises to the saturation point.

Public relations people go to photo shows to publicize the manufacturers' products. The press conference, in any of its myriad forms, is the central institution by which this is accomplished, and in the photographic industry it has been raised to the level of ritual art, as exquisitely stylized as the Kabuki dance or the courtship of New Guinea bowerbirds. Come with me. Let us attend one and observe.

It is the day before the great exhibition opens. The Grand Moguls of the photographic industry are congregating in New York. They are flying in now from Tokyo, Chicago, Cologne, London, Paris, and Amsterdam. Some have already checked into their hotels and had time for a shower and a nap to relieve their jet fatigue before the action starts. Their myrmidons and viziers have previously arrived to set up the booths. It is the time for preopening press conferences.

One is being held from two-thirty to five by a West German camera manufacturer at the Sky Garden of the St. Moritz. A difficult problem for public relations people scheduling press conferences at a photo show is to avoid overlapping with a competitor's function. Everybody wants prime time, of course, but there are too many luncheons, cocktail parties, previews, speeches, press brunches, and

memorial dinners to fit into a twenty-four-hour day without overlapping. This one is early in the game, however, and has no competition, so almost everybody will be here.

The checking in is done by a pair of pretty, smiling girls at a table just inside the door. Next, you must sign the leather-bound guest book. (What ever happens to the thousands of press party guest books that have been accumulated by the photographic industry over the past decade? Are they stored in corporate archives? Burned at the year's end? Pulverized and resold as pulp paper? Read late at night by retired and nostalgic vice presidents in charge of public relations?)

Identification badges are issued. Since almost everybody at these functions already knows almost everybody else and some people refuse to attach the ID cards anyway, they serve small purpose, but they are part of the ritual and one can scarcely imagine a press party without them.

The first hour or so is for drinks and sociability. The room is crowded and it's Old Home Week, with a cocktail party's subdued uproar as you greet friends you haven't seen since last Photokina. Hot and cold hors d'oeuvres are being served from silver bowls, and the bar is having a run on gin and tonic because it is unseasonably warm for May. The Sky Garden of the St. Moritz, with its ponderous crystal chandeliers, bathes this group of businessmen and reporters in its gentle, glamorous glow. Out of the north windows is the spectacular view of Central Park unfolding the new green of its foliage into the misty yellow haze of Harlem.

An old-timer is reminiscing about an early photographic show he participated in. "You remember, we had them at the 34th Street Armory. I'll never forget—we brought in a few show biz people as a part of it, and we had a little girl there nobody knew anything about—Lucille Ball. And another girl name of Nina Foch. They did some little thing, some little act—about five minutes. My God, that must have been twenty-five years ago! We lost about five thousand dollars."

Somebody else is discussing photo shows in general. "I hope this time the public doesn't get short-changed for their admission. The attitude at the booths is too much like the photo dealer's. You ask the average dealer to show you a piece of equipment and demonstrate it. He won't show you anything unless he thinks you're going to buy it. He won't waste time with you. They go about things all wrong at these shows. I mean, these booths they have, they're simply booths that were designed for a trade show. They're not equipped for a consumer show. You get a line of people who are interested in a new camera and they're more than three or four deep. Nobody can

see what goes on. The booths should be designed to accommodate a number of people—the guys should be on a raised platform. They ought to use closed-circuit TV or audio-visual aids more effectively. . . ."

"Are you going to the Midlands, Paul?" somebody asks. Midlands is the location of the E. Leitz Canadian plant.

"Not this time. Too far away."

There are press kits stacked neatly on the table. They are not supposed to be distributed until later, but a few curious people are sneaking an advance look at them now. The kit contains two mimeographed releases. One is a copy of a speech which is shortly to be delievered by the chief executive officer of the West German camera manufacturer. The second release gives technical data on the company's new products to be exhibited at the show. There is nothing of great interest here, but you never know: perhaps a surprise announcement will be made during the brief speech.

A bell is sounded, the speech is about to begin. Everybody grabs another drink and moves into an adjoining room where doors open onto a balcony, letting in welcome drafts of fresh air. Introductions are made: the chief executive officer, tall, stately, and bulging, like a North German Lloyd cruise ship, on his first visit to the United States since 1926; the chief engineer, who wears thick, sinister glasses and rather resembles Dr. Strangelove, and two or three other key officials. The chief executive officer delivers his speech in English, doing not too badly, with only occasional recourse to the interpreter standing at his side. (At Japanese functions the home office people often do not speak English, so you must listen through everything twice: once in Japanese and once in English translation.) The speech follows the script closely, but the chief executive officer adds a personal touch at the end. "I will be staying in the United States for four weeks," he says. "Fifty per cent of this time will be spent on business. Fifty per cent will be spent making friends." He beams at the audience, beads of sweat gleaming on his high-domed forehead.

There are no surprises, no last-minute announcements of new products, after all. Somebody asks a Dumb Question. Somebody asks an Insulting Question. Somebody, in a high-pitched voice, asks a Totally Incomprehensible Question. A couple of people ask Intelligent Questions, which is difficult, under the circumstances, there being so little to ask questions about. Although nobody really expected exciting news, there is a little mutter of disappointment. "I'm beginning to think this is one show, if they forgot to give it, nobody would notice," one critic sourly remarks.

The formalities over, the conversations begin again. The bar is

out of gin and out of tonic. How about vodka and orange juice? People are beginning to drift along, saying good-bye to the hosts or just sidling out, picking up their press kits at the door, moving on to the next function. And the next. And the next. . . .

So they come to the photo shows from all over the world: amateurs, manufacturers, importers, distributors, dealers, photofinishers, professional photographers, the trade press, advertising men, models, marketing men, publicity people, technicians, scientists, and engineers. The best brains and the most influential individuals from all facets of the global photographic community are mixed together for a few days in the frenzied, superheated atmosphere generated by a big show.

What the photo show really provides is a forum for the exchange of ideas, and maybe in the long run this swapping of an invisible commodity has a more enduring effect than all the chrome-and-glass hardware out there in the booths. For although photographic shows are fairs in the classic tradition, movable merchandise marts for buying and selling, they also serve a less commercial purpose. They are places where people of like interests can meet, reaffirming the bond that unites individual members of the photographic community, as if the people in photography felt compelled periodically to congregate in order to reassure each other that they and the phenomena they represent actually do exist.

Why do people go to photo shows? I have before me an expense list made up by a professional photographer after spending a day at Photo Expo 69. It goes like this:

EXPENSES

Tolls	$ 2.00
Lunch, "Four Seasons" (for two)	37.50
Parking meter	.25
Ticket for overparking	25.00
Admission to show	2.00
One Mamiya Sekor DTL	217.50
One 28-mm $f/1.4$ lens for same	119.00
One 135-mm $f/2.8$ lens for same	89.00
Beer and hot dog	.85
Total	$493.10

Obviously, some people go to spend money.

THE MYTHOLOGY OF TEST REPORTS

The prodigious quantity and variety of manufactured products in our civilization seem to threaten us with suffocation by sheer weight of numbers, even if we survive the pollution they engender or avoid blasting ourselves into bits of radioactive dust by setting off the most dangerous ones. I can imagine coming home one night and not being able to get in the door because the house is crammed full of appliances, electronic gear, power tools, communications equipment, and synthetic, disposable bric-a-brac. No space left for people, so you pitch a tent on a vacant piece of land (if you can find one) and begin all over again from scratch.

Photography has not been lagging in terms of the product explosion. If you plotted a graph indicating the total numbers of items of photographic equipment available, you would trace a rising curve from the end of World War II to the present, with the steepness of the curve increasing sharply during the past few years.

Is it possible for any photographer to keep up in detail with this avalanche of equipment and materials? Not without making it a full-time occupation. Nor is it necessary. Many of the items are highly specialized and of interest to only a minority of users. Many have very brief lives; like unsuccessful mutations in a competitive environment, they are quickly snuffed out, ending as bargain specials at the discount camera stores. Other "new" products involve relatively minor changes in styling or packaging and are of interest, if at all, as an exercise in marketing.

So out of the vast numbers of new products introduced each year, only a small proportion are likely to survive and thrive, and even fewer to have a significant impact on the course of photography. The difficulty for anybody buying a new camera or other equipment is in sifting out the residue of wheat from a bewildering quantity of chaff. This is where responsible equipment and technical specialists for the photographic press can and generally do perform

a useful labor-saving service. They carry out the tedious leg work and investigation, and from reading their comments you can learn which new products are likely to be worth your personal investigation.

However, the response to the photographic hardware explosion and the general concern with "consumerism" have taken another form, too—the test report. These are enormously popular and you'll find them on the pages of many leading photographic publications. A sample of a new product is given a series of "objective" and "scientific" tests in the lab, and its performance is compared with similar equipment previously tested or is matched against some absolute standard. A mystique has arisen around test reports. A special jargon has been invented for them. And people read them avidly. They appease what appears to be a deep and widespread craving for exact, authoritative answers to questions about the relative merits of various products.

Would that the world were really so simple. Alas, Virginia, there is no Santa Claus in photography or anywhere else, and test reports, no matter how skilled and honest the people who run them, cannot tell you many of the things you most want to know before you buy.

There are test reports and test reports. On the most primitive level, a new piece of equipment is handed to a junior assistant technical editor who is instructed to try it out and write a report—and hurry up because the deadline was yesterday. If he is hip about equipment, you might get a useful report, but on the level of personal opinion, not scientific accuracy.

A number of years ago a consumer testing service ran one of their periodic reviews of new camera equipment. They called a friend of mine, a free-lance writer but no great technician, who in turn called me for information. "What do you think of the model so-and-so? Have you tried it? Is the lens pretty sharp?" Things like that. Oh, boy. He was able to gather enough opinions to write a convincing-sounding report, but it shook my confidence in consumer tests for a long time.

Far more thorough and serious efforts are made today, using advanced testing equipment and sophisticated techniques. But even with the best intentions in the world, it is exceedingly difficult to work out an effective sequence of tests and to achieve—and maintain —objectivity. God knows, it's difficult enough for a scientist trained in laboratory equipment to eliminate subjectivity. It is no less so for the people charged with the task of preparing camera test reports. Personal likes and dislikes tend to creep in and color the interpretation of data. External pressures, overt and subtle, have a way of

entering the picture. And sheer fatigue and deadline pressure are important limiting factors, too.

Even if you could eliminate all these difficulties, the value of the resulting report still would be questionable. Suppose an ideal situation: a skilled technician with unlimited time and facilities. He has no prejudices, is under no pressure, and has worked out a most accurate, thorough, and sophisticated procedure. He is testing Camera A.

Now, what particular Camera A does he test? A preproduction model? Dangerous. It probably will contain at least a few bugs which may or may not be eliminated by the time the camera goes into production. (In practice, of course, many test reports *are* based on preproduction models because of the publication's long lead time and the desire to scoop competing publications with a report.) Does the tester allow the manufacturer to handpick a model for him? Obviously, this could be misleading. Perhaps, then, he buys a production model at random from a dealer, as some consumer organizations do. But what happens if you chance to get a lemon? Or a camera that performs unusually well compared to the average production model? (Despite quality control, individual cameras and lenses in the same line can vary considerably, as anyone knows who has personally investigated the problem.) Perhaps more than one camera must be tested and the results averaged out. But how many is enough? Ten? One hundred? By the time our ideal test is completed, the manufacturer probably has discontinued the model.

I may be exaggerating the difficulties, but not much. A test can reveal a great deal about the performance of Camera A, yet not be valid for Cameras A2, A3, or A1000. And you are not really interested in the camera the test lab checked out but in the one you plan to buy. Which is why discriminating professionals still go through the tedious, expensive, time-consuming routine of personally testing (or having tested) a number of cameras or lenses in a line until they find one that performs above average.

The more elaborate these product tests become, in a sense the more misleading the published reports, because they imply a precision and validity that is unreal, at least at the present state of photographic manufacturing. People tend to read more into them than they are capable of delivering.

I believe, too, that the increasing emphasis on objectivity, laudable as it seems, may be something of a blind alley. How meaningful are objective measurements (appropriate as they may be for certain purposes) when it comes to the highly personal matter of selecting a piece of equipment you like? Take that subtle, essentially unmeasurable, but vitally important quality—the "feel" of a camera. How can

this be measured by objective criteria? I can tell if I'm at home with a particular camera only if I try it myself, and you may feel quite different about the same model. One may measure the pressure required to depress a shutter release, but what does that mean? If I am heavy-handed and you are light-fingered, what may be just right for me may be all wrong for you. The "truth" here is individual and subjective.

I now will make a radical proposal which would save an enormous amount of time, money, and effort, but which nobody will adopt: stop running test reports. Not a chance. Mythology—including the mythology of science—is deeply rooted. But if my proposal were followed, I don't believe we'd be missing much, a factual report listing the features of a new product plus some informed opinion—frankly labeled as such—would be a sufficient guide for the ultimate step. And that step would be exactly the same as it is now—acquiring firsthand experience with a piece of equipment so you can make up your own mind about it.

BECOMING A PROFESSIONAL: HOUSEHOLD HINTS

Deep in the heart of many amateur photographers lies a dream: someday, somehow, they are going to chuck the old nine-to-five routine, tell the boss what they really think of him, and become a full-time free-lance photographer. For some it will always remain a dream, but others will make it a reality. It happens all the time, as I well know from letters from students at the Famous Photographers School, from conversations with picture agents, editors, and art directors, and from the many interviews I've had over the years with people who had just made, or were about to make, the switch to professional.

One thing has often struck me during these latter conversations, sometimes with young people and sometimes with people who aren't so young at all, and that is their lack of information about the details of getting started. Things like, whom do you see? Where do you find names and addresses of picture buyers? What do you say during an interview? Will these people really look at the work of an unknown photographer? What kind of pictures should you show them? How many? How big? How do you handle color? Should you try to find an agent?

A friend of mine, picture researcher Sam Holmes, has a good phrase for these basic mechanics of the business. He calls them the "household hints" of professional photography. Those of us in the field have acquired the answers by osmosis or personal experience, and we sometimes forget that procedures that seem self-evident to us aren't that way at all to a newcomer. Nobody bothers to include them in the usual books about photography, so I'm going to put them down here, as if you were sitting across the desk from me or we were having a drink together in a quiet bar and I were leveling with you about your chances. (I'm assuming you have talent, energy, taste, drive, imagination, thorough knowledge of your equipment, and are more than a little crazy about photography. Otherwise I'd say, well, maybe you ought to try some other way of making a living.)

The first point is the importance of face-to-face contacts. The best way to get assignments, find clients, and establish yourself in this business is to meet the people who buy pictures and to show them

samples of your work. Occasionally an assignment may come to you over the transom, as the result of published work or word-of-mouth recommendation, but if you rely on this approach alone you're going to have trouble paying the rent, much less becoming rich and famous. Pictures and picture stories can be sold to publications by mail, of course, but this usually is a supplement to, not a substitute for, personal contact, unless your work already is well known and in demand.

It's unlikely that a good picture agency or photographer's representative will take you on in the very beginning and do the selling and promoting for you. Picture agencies always are looking for fresh talent but they can't afford to invest the time and tie up their overhead in developing new people without a reasonable assurance it will pay off. Later, perhaps, when you've established yourself as a reliable producer of salable pictures, you can make a satisfactory arrangement with an agency, but when you're getting started, expect to be pretty much on your own, as were most successful professionals before you. (As for individual "reps," forget it; there aren't nearly enough good ones to supply the existing demand.)

The people to meet, obviously, are the people who buy photographs and give photographic assignments, anybody who can help you establish contact with the same, and—important in the long run—anybody who can publicize you and your work so as to attract the favorable attention of potential picture buyers.

For openers, there are the advertising agencies. You can find them listed in your local phone book, but for a comprehensive United States listing, see the most recent edition of the *Standard Directory of Advertising Agencies*, prepared by Standard Rate & Data and available in most library reference departments. Names of key executives are included, but the turnover is fast and frequent in this field. If in doubt about the person to see, call the agency switchboard and check it out. At the larger agencies there may be a chief art buyer (probably a Senior Vice President, about thirty years old). He might look at your portfolio himself or, more likely, turn you over to one of the agency's many art directors. At smaller agencies there may be one or more art directors who work directly with photographers. You are almost certain of getting through to *somebody*, but don't be disappointed if your first contact isn't at the top. An experienced freelance photographer of my acquaintance recently came back a little miffed after a first visit to one of Manhattan's most prestigious ad agencies. "A guy looked at my pictures," he said glumly, "but I sensed he wasn't terribly important when I saw there were three other people sitting in the same office."

Another approach is to make direct contact with a manufacturer

or business firm. No matter where you live, there probably are nearby companies that use photography. Although more and more corporations have established their own photo departments, they may supplement the work of in-plant people with assignments to free-lancers and outside studios, depending on special needs and the internal workload. A good person to start with is the firm's public relations director. He should be interested in seeing your portfolio for his own purposes and can steer you to other key executives who use photography: the advertising manager, for example, the editor of the house organ, or the head of the audio-visual department.

I'd certainly make the acquaintance of the picture buyers on your local newspapers and any regional or specialized magazines published in your area. On a very small paper the editor or managing editor may be the person to see; larger papers usually have a chief of photography or a picture editor who would be your best contact. Even though a newspaper has its own staff photographers, it probably uses free-lancers, too, and buys pictures from outside sources. Local Sunday supplements, of which there are hundreds published around the country, are excellent markets for photography, and many of them print color. A number of photographers I know were first published in this medium, and although the pay usually isn't much, the resulting publicity and prestige can be valuable for a beginner.

On magazines a look at the masthead of a current issue will give you a clue as to whom you should see. Larger publications usually have a picture editor responsible for buying photographs and giving assignments, although the art director may be involved, too. On small publications the editor, managing editor, or art director might be the person to see. Again, if in doubt, check with the switchboard before setting up an appointment. Magazines that buy photographs are listed periodically in *Writer's Digest, Writer's Yearbook,* and *Writer's Market.* Don't take their descriptions of picture requirements too seriously, though; they often are outdated before the listing gets into type. Obtain a copy of the magazine you're interested in and study its editorial contents carefully. *Where and How to Sell Your Pictures* by Arvel W. Ahlers is a good standard reference on picture markets in general, and the *Gebbie House Magazine Directory* lists more company publications than you ever thought existed.

Another possible source of assignments is any college, university, or private school in your area. Fund raising is big business today, and photographs are profusely used in brochures, pamphlets, Reports from the President, and similar material. Contact the development director or the director of public relations, one of whom usually handles photography for fund-raising purposes.

If you have a personal relationship with a potential picture buyer or at least know somebody who can put in a word of introduction for you, fine. That's always better than going in cold. Everybody in this business values his personal connections, and up there at the top the political game of wooing and impressing clients is carried on with style and expertise, much to the benefit of American Express and Carte Blanche. In photography, as anywhere else, whom you know does count, but it's not everything, believe me.

Any picture buyer worth his job is eager to find new talent. Even in the most crowded, competitive fields there are never enough really good photographers or great pictures or original ideas. Therefore, most picture buyers will want to see you if they think you have anything on the ball. You don't need a personal introduction: it's a picture buyer's business to see photographers. Who knows, maybe you've got just what he's looking for, and if he doesn't see you, a competitor may grab you up first. That's something comforting to think about as you sit waiting in the outer office.

You could get a big assignment right at the start. It's been done —but it takes an unusual combination of talent, luck, and *chutzpa*, and it's not likely to happen. You are Charlie Brown, the New Boy, an Unknown Quantity, competing with established professionals. You have to buck what I call Charlie Brown's Law. It can be stated like this: THE CHANCES OF AN UNKNOWN PHOTOGRAPHER GETTING AN ASSIGNMENT TEND TO BE IN INVERSE RATIO TO THE COST AND IMPORTANCE OF THE ASSIGNMENT. Let me illustrate with a couple of specific examples.

Example A. You are a picture editor. You have a small assignment to give. It involves about a day's shooting at standard ASMP rates for black-and-white, and if the pictures don't come off, you have other material in the bank to take their place. You know a new young photographer who seems to have a lot of promise. You'd like to try him out; who knows, maybe he'll develop into somebody really good. You take a chance and give him the assignment.

Example B. You are an agency art director on a big account. The client, who manufactures panty hose, is becoming restive. If the new campaign doesn't work out a damned sight better than the previous one, he may pack up his panty hose and seven-figure billing and move down the street to your arch competitors, Gunz, Mindel, & Simpson, who have been trying to steal the account for years. Your job is at stake, and the college tuition for your kids, and the mortgage payments on the house in Westport, and the trip to Mykonos you promised your wife next fall, not to mention your professional pride. You think of several establishment photographers: big names, creative, reliable—and very expensive. But you've got the money to spend.

And you think of the young kid whose portfolio impressed you so much, a kid right out of Haight-Ashbury, wearing dirty chinos and buffalo-hide sandals, but you have a hunch he's brilliant, a new Avedon, maybe.

Guess who gets the assignment? Under this kind of pressure it takes uncommon guts and self-confidence to take a chance on the unknown. Sometimes daring pays off, of course, and the people who take such chances and make them work are the creators and innovators whom everybody else imitates. But you can lose your head at this game, too, so the natural tendency is to play it safe and conservative. Thus Charlie Brown's Law and why you shouldn't expect instant big-time success, no matter how good you think you are. Stay loose; you've got to be around for a while.

The mechanics of interviews with picture buyers are simple enough. Rather like a job interview. You don't drop in unannounced; you make an appointment first. A phone call, for local clients and contacts, is quickest and easiest. For out-of-town appointments, send a letter, allowing ample lead time. Maybe the person you want to see is booked up or is going to be out of town the day you want to see him but could make it on an alternate date. Be on time, of course. If you have to break an appointment—try to avoid doing this—let the person or his secretary know and set up a second date.

The logical strategy is to schedule a morning, an afternoon, or a full day (or several days for an out-of-town trip) in which you see as many people as practical. Don't pack your schedule too tight. Allow time for waiting, traveling between one office and another, traffic jams, subway breakdowns. Two or at most three interviews are probably enough to give you a busy and possibly productive morning or afternoon.

I'd try to avoid late-afternoon appointments, at which time your man may be tired and anxious to break away and go home. Friday afternoons are particularly hazardous; if you've ever worked in an office you know how the worst crises always seem to break on Friday afternoon. The best client-hunting seasons are fall, winter, and spring, simply because in the summer many of the people you want to see may be away on vacation at the time you try to set up an appointment.

Let the person you're talking to lead the interview. If he or she feels like chatting, fine; otherwise, don't force small talk. The person you're meeting probably is busy, sees many photographers and pictures during a week, and is accustomed to making fast decisions in these matters. During an interview with a knowledgeable picture person you may pick up some useful tips, perceptive comments about

your work, or suggestions for additional contacts, but don't demand them. Above all, don't make a pest of yourself.

I'm reminded of my unfortunate friend, Garth, an aging 35-mm man with considerable talent but a peculiar affliction. Garth is convinced, despite all the evidence to the contrary, that the Abominable Snowman actually does exist, and he is unable to carry on a conversation for more than five minutes, with friend or stranger, without reverting to this subject. He always carries with him a set of pictures he took in Tibet in 1960 showing the Yeti's footprints, and his greatest desire is to get an assignment back to the Himalayas. When he makes an appointment with a picture editor or art director, it's not really to sell his latest work but to convert him into a true believer. He has been known to buttonhole victims in elevators, to hail them from passing cabs, to lie in wait for them outside the office lobby so that he can plead his case. He knows a secret valley. . . . He knows a Sherpa guide, 120 years old, who can lead him to the Yeti's lair. . . . Last time, his shutter froze at the critical moment. . . . One more chance for the most sensational picture story of the decade. So people groan when their secretaries say Garth is on the phone, and avoid him at cocktail parties, and I don't know how much work the Abominable Snowman has cost him. And if he ever reaches that secret valley, word may have already penetrated and even the Yeti will refuse to see him.

In days not long past I might have suggested to some of the more casual young photographers I interviewed that maybe they ought to shave and wear a tie and jacket during interviews. But the cultural climate changes, and that advice isn't necessarily valid any more. The other day I was talking to a conservatively dressed advertising photographer when we happened to pass an East Village type with a camera, somebody right out of the road cast of *Hair*. "See him?" my friend said. "A couple of years ago he couldn't have gotten past the reception desk of any agency in New York. Now if you don't look like that, they think you aren't creative." Well, I leave it up to you to choose your own image. You're the one who has to live with it.

The most valuable aid you can have during these interviews is a strong portfolio of your work. It's worth the best thought and greatest care you can give it. The first thing a potential picture buyer will ask is to see your portfolio, and maybe he'll remember a picture or two in it long after he's forgotten your face. (Which is why it's wise always to leave a business card behind after a first interview.)

Although everybody agrees on the importance of a good portfolio, there's quite a difference of opinion about how best to prepare

and present one. At the extreme left is the dirty sneakers school that follows an "I don't give a damn; let the pictures speak for themselves" approach. The portfolio, in this case, usually is a collection of dog-eared, unmounted 11 × 14s stashed away in an old Varigam box. At the other extreme is the type of photographer who believes in making a production out of the whole thing. I once had an unforgettable visit from a photographer of this type. He entered my office lugging several dozen large prints mounted on heavy plywood suitable for permanent wall display, each carefully wrapped in tissue paper and held together in groups by rubber bands. It took him about forty-five minutes to unwrap his photographs and set them up and another forty-five minutes to put them together again, all for about ten minutes of viewing and discussion. Photographs deserve respect, but not reverence.

Somewhere between the sloppy and the pretentious lies the best approach for most photographers: a portfolio that makes its point quickly, with clarity and impact, a portfolio that reveals the essence of you, as a photographer, at your very top form. Don't think of your portfolio as a static museum exhibit, but rather as a living, adaptable organism. Change your selection of pictures as needed to fit the requirements of a particular interview. Maybe one time you'll want to show a broad cross-section of your work, another time to emphasize a particular specialty of yours, another time to sell a specific story idea or advertising campaign. Experienced professionals slant their portfolios like this, and what they bring to the Museum of Modern Art may not be at all the same as they'd bring to the *National Geographic* or Doyle Dane. But however you slant your portfolio, be selective. It's a mistake to include weak or marginal photographs just to pad things out. If you have doubts about a picture, leave it out.

How many pictures should you include? Well, you won't find unanimous agreement here, either from photographers or picture buyers. You need enough to give an idea of your ability but not so many that you overwhelm the viewer. I'd say at least a dozen; anything less doesn't give a potential buyer much to evaluate. Two or three dozen (if you really have that many strong pictures) make a good solid sample, but I wouldn't go much beyond that; if you do, you risk leaving the viewer confused rather than impressed. One successful free-lancer I know has worked out a good method for handling large portfolios. He splits them up and goes back a second or third time with a different selection. "This gives you a good excuse for repeat visits to a client or picture buyer and helps keep your name alive," he says.

Most portfolios I look at include 11 × 14 prints. Size does lend impact, and an 11 × 14 print tends to seem more important and more

impressive than an 8 × 10 from the same negative. But there's a reverse effect, too: a small print, if beautifully printed and skillfully mounted, can command attention, and I know some photographers who like to show their work in the form of small enlargements on a sheet of 8 × 10 paper with wide white margins all around. In the other direction, some people like to go up to 16 × 20 for their "show" work (or to mount an 11 × 14 on a 16 × 20 board). That's about the maximum practical limit, though, in terms of portability and convenience in showing your work to somebody in his office. (Did you ever try to carry 16 × 20 prints on the subway or load them into a Volkswagen?)

Good pictures don't need ornate treatment. In fact, if the packaging calls attention to itself instead of augmenting your photographs, it's a liability. I'm assuming, of course, that your prints are the very best you can make and have been carefully spotted. Prints on double-weight paper can be left unmounted, but they tend to curl with the passage of time even if treated with print-flattening solution. Also, the corners get broken and they acquire a generally grubby, dog-eared look after repeated handling. They'll hold up much better if mounted.

To save weight, use thin, lightweight matte board for your portfolio prints rather than the standard heavy gauge mounting board you might choose for wall display. A classic method, popularized by magazine photographers a couple of decades ago, is to dry-mount your print on a board and then trim the borders flush with the edges of the print. For an extra finishing touch, run the tip of a black Magic Marker down the raw, cut edges of the trimmed board. Another widely used method is to trim the finished print and then dry mount it on a board of larger dimensions—an 8 × 10 on an 11 × 14, for instance.

What about color transparencies? One method is to carry a loaded tray or trays and your own projector. This is the most effective way to make a presentation, but only do it if arrangements have been made ahead of time for a screen and darkened room. As a routine thing, most picture buyers would rather not bother with projection. Much more convenient for the viewer is for you to mount your transparencies in 8 × 10 acetate sheets. These are available from a number of manufacturers with slip-in compartments for 2¼ × 2¼ or mounted 35-mm transparencies. The sheets can be placed on a light box for viewing. Any experienced picture buyer can see enough with his naked eye or the aid of a magnifier, and if he wants to blow up a transparency, it can easily be removed from its compartment on the sheet.

Include a few clips of good published work if you have them. It's good psychology to establish the fact that you have been published, especially when you're making first contact with a client. Place the clips in clear acetate sheets of the type sold as notebook fillers in any stationery store.

A wide variety of sample cases is available for carrying your portfolio, and you can go as fancy or austere as your taste and budget dictate. You can get a custom-made case of elephant hide with your name stamped in gold, and perhaps this would impress some people. However, I've never heard of a buyer turning down a good picture because he didn't like the carrying case it came in. Fiberboard cases, sold by most large art supply houses, are neat, durable, and relatively inexpensive, and most professionals I know use them. Another method is to carry your pictures in an 11 × 14 salesman's sample or presentation case, the kind that closes with a zipper. You can insert your pictures in the acetate leaves or remove the leaves and store individual mounted prints in the remaining space.

When you put together a folder, make extra prints for your files while you're at it. Eventually you'll be glad you did. Somebody, someday, is going to spill a container of coffee over your prints, or lose them in the mailroom, or damage them beyond repair. It's a fact of life. When that happens, it's nice to have a replacement on hand.

Well, the hour draws late and I see you're restless to move on, because you know *I'm* not going to buy any of your pictures or give you an assignment, not today, anyway. All this advice may be very practical, you're thinking, but what I really want to know is where is the big money in photography? An interesting question. Let us explore it in some detail.

MONEY, MONEY, MONEY

Most photographers have not gone into photography solely or
even primarily for the money. The monetary motive is there, of
course: the hope of achieving a decent income or even acquiring a
fortune. But with a few exceptions it's not the bread alone but the
dream that turned them in this direction in the first place and keeps
them going through good times and bad. The opportunies for cre-
ativity, communication, travel, recognition, and human contact are
gut motives for most photographers, along with the desire for a
valid credit card.

However, a photographer is an economic unit, just as much as
anybody else, with the rent or the mortgage to pay and worries about
the new baby, or compulsory retirement coming on too fast, and al-
though he functions in a domain of magic images, he must survive
in the same materialistic, inflationary environment as anybody else.
Let us have a look at the photography scene from this down-to-earth
viewpoint of monetary reward. How much do photographers make?
What is a photograph worth, in terms of dollars and cents? Who are
photography's Super Rich and how did they get that way? (In a time
of inflation, with the economy swinging from boom to bust to possible
boom again, prices are volatile. A number of changes have taken place
in the relatively short time since this chapter was written and its ap-
pearance in type. But if exact figures are subject to change without
notice, at least the broad, relative values retain a degree of validity.)

The income range in photography today is tremendous, if you
include free-lancers and independent entrepreneurs as well as salaried
people. The extreme highs and lows, in fact, are scored by photog-
raphers working on their own, with salaried professionals somewhere
in the lower middle. During the late 1960s, *Cosmopolitan* magazine
gave a report on salaries for numerous occupations. According to
Cosmo, the range for photographers ran from a below-poverty-line
$2000 to an impressive top of $25,000-plus, with an average of about
$15,000, which compared respectably with other professions in the
survey, including accountants, lawyers, and engineers. What this type
of averaging fails to indicate is the even more dramatic differences
that exist in reality. The "average" photographer is a statistical fic-
tion. I know professional photographers whose annual income is

about zero dollars and others who seem to spend $25,000 per year on lunches alone. There are apprentices working for a pittance in the studios of big-name photographers who are grossing $300,000 per year. To understand what goes on and why, a more refined analysis is required.

The great extremes, as mentioned, are not often to be found among salaried jobs in photography. Here the range generally is from modest to comfortable, along with a much higher degree of security than most free-lancers can enjoy, plus fringe benefits and perhaps the chance for overtime pay.

Of the estimated 100,000-plus full-time professional photographers in the United States (nobody, including the Census Bureau, really knows), a considerable number is employed in about 13,000 industrial photo departments and 20,000 portrait and commercial studios. A recent spot check in Fairfield County, Connecticut, indicated that photographic trainees were earning anywhere from about $75 to $100 per week, experienced staff photographers and photographic technicians were making $8500 to $11,000, and photographic supervisors were being paid in the $9000 to $13,000 range. Out in the boondocks the pay scale for equivalent jobs tends to run somewhat less, and in nearby Manhattan, with its notoriously high cost of living, the salaries generally are a bit higher (although some trainees will gladly work for little or nothing in the studio of a name photographer in the hope that some of the fame will rub off, as indeed occasionally it does). An experienced studio chief at a top studio or the head of a large photographic department may earn up to $15,000 or more, but the higher pay here reflects managerial skill as well as photographic ability. In photography, as elsewhere, managers tend to make more money—and to get more ulcers.

Many government agencies—federal, state, and municipal—hire staff photographers, and the range here is approximately the same as for private business. For instance, the pay scale for photographers entering U.S. government service is from about $5000 to $8300 per year, depending on previous experience, with higher grades earning up to $11,000 or so. Department heads and visual information specialists may earn up to $15,000 or more per year.

On newspapers the pay for photographers is about equal to that of reporters. (Sometimes it is even better. Back during the Korean War, Bernie McQuade, editor of the Manchester, New Hampshire, *Sunday News*, offered me a reporting job at $55 per week instead of the usual $50, the extra five bucks being added because I knew how to use a Speed Graphic.) Most newspapers today, and the two wire services, follow the general pattern set by the

Newspaper Guild. Starting salaries run from $80 to $90 on smaller papers and from about $100 to $130 on larger ones; the average nationally for news photographers with five years' experience is around $200. Some senior photographers on the wire services and the big metropolitan dailies make up to $300 a week, and a few star performers earn even more. They are relatively rare exceptions, however, and the majority of staffers work "at scale," as indicated in a 1969 survey by the National Press Photographers Association. Out of 849 newspaper photographers queried, 230 said they made less than $7500 per year, 304 reported salaries in the $7500 to $10,000 range, 69 earned between $10,000 and $15,000, and 14 claimed earnings of more than $20,000.

Of course, overtime may fatten the pay check of any staff photographer, and many are able to supplement their regular income by free-lancing on the side. News photographers in particular often do commercial work in addition to their journalistic duties, or (with their paper's permission) become "stringers" for national magazines and the wire services.

"A lot of small-town newspaper photographers I know wouldn't move to a big-city job at any price," one veteran picture executive told me recently. "They have a good life. There isn't so much pressure, they don't have to commute long distances, they can own their own home at low cost, and weekends they play golf at a country club where the dues are minimal. They can pick up extra bread by taking work on the side. In New York moonlighting is frowned upon, and about all you can do are weddings and Bar Mitzvahs."

But there are always the young lions, the kids with fire in their bellies, and what they want is not comfort and security but a crack at the Big Time and the Big Money. It is difficult for newpapers to hold the very talented and the highly ambitious: they tend to move into free-lancing or higher-paid magazine jobs.

Magazines do pay better than most newspapers. In the NPPA survey already mentioned, of the 55 magazine photographers polled, nearly one-third reported incomes of more than $20,000. The trouble is, there are not many magazine staff jobs available. The great majority of the more than 6000 magazines published in the United States are house organs, trade publications, and specialized journals with small budgets and no staff photographers (although in the aggregate, they represent a lucrative market for free-lance photographers). The giant, picture-oriented magazines are growing scarcer than the California condor, and of late they have been cutting their staffs rather than adding to them. The few that survive, however, represent the summit for salaried photographers, in terms of pay and prestige.

The highest staff salaries for photographers paid by any publication in the world today are found, unsurprisingly enough, on *Life*, where the range is about $20,000 to $35,000. (At *Look* and the *National Geographic*, by way of comparison, it's about $10,000 to $20,000.) In addition to the high salary, one of the significant economic advantages of being a *Life* staffer is Time, Inc.'s retirement fund, long a legend in the magazine industry. The rule of thumb over at the Time-Life skyscraper is: if you've earned an average of $25,000 for 25 years, your retirement income will be about $20,000 for 15 years. Some staff photographers, on reaching retirement age, have preferred to receive a lump sum, and the amounts paid have been at the magnitude of from $200,000 to $300,000 or more, depending on such factors as length of service, average salary, and personal investment in the fund. So if you'd like to retire from photography with a quarter of a million dollars, what you should have done is join the staff of *Life* back in 1941.

The only time I ever heard of a magazine topping *Life*'s salary range was during the *Saturday Evening Post*'s ill-fated attempt to modernize its image back in the early 1960s. The editors were placing great emphasis on photography then and making incredible deals to attract the talent they wanted. They hired a couple of photographers at $20,000 a year *plus* $750 per page for all work published, which is not a bad arrangement by anybody's standard. One of these *Post* stars is reported to have earned about $75,000 during the first year. The only problem was that things didn't go on like that for long, the magazine's New Look proved to be no substitute for the old Norman Rockwell covers and the Alexander Botts Earthworm Tractor stories, the *Post* ultimately folded, and nobody really expects to see the day again when magazine editors will pay that kind of money to a staff photographer.

When you move out of the relatively secure and structured range of salaried positions into the era of free-lancers, entrepreneurs, and individual studio owners, the potential rewards are higher but the risks are far greater, too. Free-lance photographers and studio owners must learn to prudently save enough money when things are going well to carry them through the inevitable dry spells.

The owners of most commercial and portrait studios are small businessmen conducting a local business. For most, the risks and financial rewards are on a level with, let us say, the owner of a Carvel franchise. In a recent survey of Professional Photographers of America members, photographic studios were broken down into the following categories, which give an idea of the realistic range: studios grossing annual sales of less than $30,000, of between $30,000

and $50,000; of $50,000 to $100,000; and of more than $100,000. The latter operations are large, successful businesses, of course, employing a substantial number of people. Net profits tend to be higher the smaller the gross take is: from about 25 per cent for the smaller studios up to about 10 to 15 per cent for the larger operations.

As a portrait photographer, if you are Philippe Halsman or Yousuf Karsh, perhaps you can charge up to $1000 per portrait. If you are Zoltan Berko of Fort Wayne, Indiana, your basic "sitting fee" is more likely to be in the $10 to $15 range. However, if you shoot color (and more and more portraiture now is done in color) and effectively promote additional prints at a realistic price scale, you may be able to average $50, $100, or considerably more per sitting. The baby business has dropped off, due to the competition from the "kidnappers" working in cooperation with the diaper services, and so have graduation portraits, because of competition with the vast, highly organized armies of "school photographers." The portraits, artistically speaking, aren't much above the level of a passport photograph, but the service is cheap and efficient. The biggest and most available money for individual studio photographers today seems to lie in a full "candid" wedding coverage, plus a formal photograph of the bride. Shooting somebody's wedding is one of the most frequent ways by which amateur photographers first become professionals, and by which working staff photographers supplement their regular pay check.

To understand free-lancers and why some are broke and living in walkup cold-water flats and others own town houses in the East Sixties and drink Chivas Regal, it's necessary to have some background information about photographic pricing. There is no universally accepted price scale for most kinds of photographs. In fact, the price structure of the photographic marketplace is an ad hoc, crazy-quilt creation, rather like the British Constitution in that it is a product of custom and tradition, largely unwritten, replete with contradictions and inconsistencies, and majestically resistant to change. There is an anecdote told about the mother of photographers Robert and Cornell Capa. She was visited by a potential picture buyer while Bob was off shooting the Spanish Civil War. Being asked the price of some of Bob's pictures and not wanting to lose the sale, she reportedly picked up a stack of prints and said, "It depends on how much they weigh." And why not? Just about every other criterion has been used from time to time in determining the value of a photograph.

A more common way for a free-lancer to be paid is according to the time he spends on an assignment. You receive what is known in the trade as a "day rate," plus expenses. The minimum day rate for

editorial work, established by the American Society of Magazine Photographers for its members and generally accepted throughout the publishing industry, is now $150 for black-and-white. This, it should be emphasized, is intended as a minimum. In the publishing field, however, what was established as the floor has tended to become the ceiling, and when a picture editor tells you he pays "ASMP rates" he usually means the minimum. Industrial, public relations, and advertising clients often pay considerably more. In a recent survey of commercial studios by the Professional Photographers of America, day rates ranged from $36 to $1000, with $150 the most commonly quoted figure for black-and-white, and color generally bringing $50 to $100 more. Top public relations clients may pay up to $500 or more per day, and advertising accounts even higher.

One reason for this wide range in prices is the curious nature of the photographic commodity. Photography involves both a product —the print or transparency itself—and a service—the skill, expertise, and creativity of the photographer who produced the image. Creativity often is the decisive factor. The physical cost, in terms of material and processing, for an 8×10 color transparency by Irving Penn and one by an untalented hack is exactly the same. Yet the former might be a bargain at $1000 and the latter not worth $10, the difference being in the quality of the service rendered.

Some publications pay on a "page rate" basis, the photographer's fee depending on the amount of space occupied by his pictures. It's the number of pages (or fractions thereof) that counts, not the total number of photographs used. If one of your pictures ran across a two-page spread it would earn just as much money as a dozen smaller ones occuping the same space. A cover photograph commands a higher price than one reproduced inside, naturally, and the rates for color usually are higher than those for black-and-white. (The latter custom seems to be changing, however, and I hear of more and more publications and clients who now are paying the same rate for both. This is logical, because a good picture is a good picture regardless of the type of film it was made with. However, I suspect some picture buyers are using this approach to downgrade what they pay for color rather than to upgrade what they pay for black-and-white.)

Magazines with large circulations might be expected to pay higher page rates than ones with small circulations, and generally this is true, but there are exceptions. Some limited-circulation but prestigious company publications have page rates comparable to the giant national magazines. For instance, *The Lamp*, Standard Oil of New Jersey's handsome quarterly, reportedly pays about $300 or more per page for color photography. By way of comparison, *Life*'s normal page

rate has been $300 for black-and-white, $450 for color, and $1000 for a cover, and at *Look* the standard rate has been about the same.

The prices paid by some clients and publications remain scandalously low, not having changed appreciably since the first Roosevelt Administration, when $1.50 was big money. (A photographer I know, working on assignment for a New England branch of a wire service, once complained, "It's costing me 1970 expenses, but they're paying me 1935 prices.") It's time for such flagrant anachronisms to be abolished. Personally, I'd never advise anybody to sell a photograph for less than $5. Better to tear up the print or give it away as a worthy charity or in exchange for a credit line. Today *any* photograph, if it's worth buying and reproducing, must be worth at least five bucks.

If the price paid for an individual picture sometimes seems ridiculously low, at other times it can be fantastically higher than the ASMP's recommended $35 minimum for one-time use of a black-and-white photograph. If timely and sensational enough, one picture or a single picture essay can blow the lid off established price structures. Newspaper and magazine editors still live by what the late Wilson Hicks, former executive editor of *Life*, has called the "doctrine of the scoop," and nothing is more likely to pump adrenalin into hardening editorial veins than a chance of scoring an important beat over the opposition. If you can bring in an exclusive telephoto photograph of Mrs. Onassis swimming in the nude, or a close-up of the Loch Ness monster, or authenticated pictures of Martin Bormann, alive and well in Latin America, they will love you for it and pay you much money.

Amateurs as well as professionals can play this game because the most sensational news photographs often are accidental: a matter of being at the right place at the right time with a loaded camera and retaining enough presence of mind to shoot some pictures. A classic example of the amateur scoop is the snapshot taken aboard the sinking *Vestris* by ship's steward Fred Hansen, back in 1928. Hansen had purchased an $8.50 folding Kodak and six rolls of film in Hoboken the day before the ship sailed. He used the camera to photograph the terrified passengers and tilting deck as the *Vestris* was abandoned during a sixty-mile-an-hour Atlantic gale. Back in New York, Martin McEvilly, an enterprising picture editor for the *Daily News*, bought Hansen's roll of undeveloped pictures sight unseen for what was then the considerable sum of $500. The photographs were so spectacular they moved the publisher, Captain Patterson, to pay Hansen an additional $500, an act of generosity unparalleled in the annals of newspaper publishing. The best shot is the one you

see included in practically every collection of famous press pictures, and it has since earned the *News* more than $5000 in reproduction fees.

It was an amateur, too, who earned what is by far the largest sum ever paid for a single set of photographs. Abraham Zapruder just happened to be photographing the Presidential motorcade in Dallas with his 8-mm movie camera at the instant John F. Kennedy was shot. *Life* paid $50,000 for one-time rights to Zapruder's film, reproducing single frames in the magazine, and later paid a whopping $100,000 more for all rights. "We didn't lose on the deal," a *Life* executive dryly commented to me. It was a price, however, that may never again be matched until some photographer comes rushing in with an exclusive coverage of the Second Coming, and by that time it will be too late to matter.

A head of state is gunned down in the thin winter sunlight and a few feet of home movie film becomes worth a fortune. A woman makes a fatal leap from the high window of a blazing hotel and a snapshot of that moment wins the Pulitzer Prize. Images of death, violence, and destruction often are what command the highest prices in the news business.

A substantial source of income for many photographers is a good file of "stock" pictures. A stock picture refers to a photograph already in existence, which the photographer owns rights to and makes available from his inventory. This is not the place to discuss in detail the complicated matter of the photographer's rights to a photograph, but a passing word of explanation is necessary. Most photographers, shooting on assignment, are able to sell limited, specified rights to their pictures. The arrangement with a magazine or a book publisher, for example, often is to sell only "first publication rights" or "one-time reproduction rights," final ownership of the photographs and rights to any residual sales remaining with the photographer. (Photographs made for advertising clients are more commonly sold outright, but the initial fee here tends to be considerably higher.) Over a period of time the negatives, transparencies, and 8 × 10 record prints cross-indexed in old green filing cabinets in the back room can be a valuable source of income. Most photographers, naturally enough, want to publicize their most recent work and are less likely to call your attention to continuing stock picture sales than they are to a recent job for *Look* or *Sociology Today*, but wise photographers know the value of and fully exploit the resources of photographs already made. Among the big "stock" picture agencies, sales of from $5000 to $10,000 a year are not unknown, and some highly productive specialists may sell two or three times that amount.

The most highly publicized stock picture of all time is a photo-

graph of a Vermont village in the snow by Arthur d'Arazien. The total sales to date for this picture, and similar views taken at the same time, from magazines, brochures, calendars, and other sources exceeds $5000. It's rare to find a picture situation that earns anything like this kind of money, but repeated sales, even at a modest price per shot, can add up to a considerable sum. To cite a few examples, the cats and dogs in the files of animal photographer Walter Chandoha and the healthy All-American girls of Peter Gowland are important sources of income for both these successful photographers. Ezra Stoller is the most sought-after architectural photographer in the world, and his prestige work is seen in *House & Garden* and in the pages of annual reports for major corporations. Whenever Stoller goes on assignment, he shoots every possible aspect of his subject. Over the years he has built up what is probably the world's most complete archive of contemporary architectural photography, and if for any reason you should want a picture of the fountain at the Seagram Building or details of the kitchen in the new du Pont mansion, probably you can obtain it from the carefully kept files in Stoller's Mamaroneck studio.

As another example of how an unglamorous stock file can help one lead a romantic life, consider the career of travel photographer George Holton. He and his charming Taiwanese wife have their home base in Guatemala, in a villa on the shores of a lake famed for its tepid waters which are always at 76°F., exactly correct for processing black-and-white film. Part of the time Holton spends in Guatemala, part of the time in a Manhattan apartment, and about six months of the year traveling and photographing all over the world. He has, of course, accumulated a remarkable file of travel pictures, and residual sales of these to airlines, travel companies, calendar and poster firms, magazine and book publishers account for a substantial proportion of his income and provide the basis for his interesting way of life.

The decisive role of nerve in photographic pricing has been generally overlooked. I don't recall ever seeing anything about this in print, but from personal observation I believe it often is an important factor. If a client wants a photograph, and the photographer has enough guts and gall to demand an outlandish price, he sometimes gets it.

At a party recently I was talking with a public relations executive of one of the corporations listed in *Fortune*'s roll call of the top 100. We were discussing photography and photographers and how much they charge.

"What do you people generally pay as a day rate?" I asked.

"Between four hundred and eight hundred dollars, regardless of whether the assignment is black-and-white or color," he told me.

"How come?" I asked. "Why would you pay one guy four hundred and another guy eight hundred?"

He thought for a moment, then said, "Well, I guess it depends pretty much on what the photographer asks."

The most colorful application of this approach that I know of is a story concerning a well-known photojournalist. He was visiting the offices of a large picture magazine and chatting with the art director. The magazine was laying out a major story on John Gunther's *Inside Russia* and lacked a good picture of the author in a Russian environment. It so happened the photojournalist had recently returned from Russia, and while there, he had chanced to meet Gunther and had made a quick photograph of him, on 35-mm Kodachrome, against a background of the Kremlin towers. It sounded like exactly what the art director and the editors wanted. The transparency was produced, a stat was made, and a layout produced using the picture small at the very beginning of the feature. The art director had been waxing more and more enthusiastic all the while. Finally everybody agreed. "That's it." Nobody was about to rock the boat now. "Oh, by the way," the art director is supposed to have said to the photojournalist, "what's the fee on that Gunther head shot?" "Two thousand dollars," the photojournalist calmly replied. According to the story, he got it and went laughing all the way to the bank.

The biggest of all the big money to be earned at still photography comes from advertising. As the client usually purchases exclusive rights, fees are correspondingly high. Successful photographers in this field are the tycoons, the maharajas, and the superstars of the camera, and the incomes they earn, when business on Madison Avenue is booming, are impressive indeed.

Typical fees paid for a single photograph used in national advertising are from about $500 to $1500 for black-and-white, and from $1500 to $2500 for color. Depending on the account, the difficulty in shooting the picture, the photographer's reputation, and other variable factors, the money can be substantially more—up to $3000, $4000, or even $5000, although prices like these are rare. Plus expenses, of course, which usually run to about one-third of the fee paid to the photographer for the picture itself, and sometimes even equal or surpass it. Occasionally, of course, a photographer can get the assignment to do an entire advertising campaign, involving several finished photographs for a series of ads. The payoff here can be very lucrative

indeed. On the other hand, during a recent period of retrenchment among advertising agencies, the tendency has been to use stock pictures wherever possible, rather than giving out assignments.

The highest price I ever heard of being paid for a single still photograph was the $10,000 Bert Stern once received from a large airlines company. "This was a highly unusual situation," Stern commented. "The shot involved about forty people posed on the wing of an aircraft, it had to be taken almost immediately, and there was no chance for a retake. The tendencies of agencies under these circumstances is to go to established names; they can't fool around." In this case, they wanted Stern and were willing to pay to get him, including reimbursing him for canceling other shooting he had lined up.

If you talk to advertising photographers, you won't find they admit to being overpaid (but for that matter, who ever does?). "Ad prices haven't changed much in twenty-five years," comments Richard Beattie, who knows the business from long personal experience. Many photographers have complained, privately and in print, about the relatively small proportion of the advertising budget which goes to the photographer for his skill and creativity. For instance, the insertion cost of running a single page ad one time in *Life* is more than $60,000, but the photographer's entire fee for the photograph featured in that ad might be $2000.

Even so, a top advertising photographer can gross a quarter of a million dollars or more per year at the peak of his reputation and productivity. A key question here, of course, just as with any other business, is how much the photographer nets after paying all his bills. If his before-tax income is about one-third his gross, most people in the field would consider him both lucky and a good money manager. It takes more than sheer creative talent to net $100,000 out of $300,000 in this business.

The cost of running a big studio in midtown Manhattan or the Loop is considerable, what with ultrahigh rents, insurance, maintenance fees, service charges. Even as essentially a one-man operation, a busy advertising photographer may require a lot of helping hands, which raises the overhead still higher. "I was one guy," a friend of mine recalls, "but I was fourteen other people, too. You need a great top secretary plus a couple of assistants, a black-and-white printer, a color printer, two or three camera assistants, a receptionist, and maybe a set builder, a carpenter, or a propman, each of them earning up to two hundred or more per week. All told it's going to cost you about five hundred bills a day just to keep the studio running, and there's not much way to beat it."

Another highly successful advertising photographer voiced similar sentiments to me at the peak of his career. "I'm making more money now then I ever dreamed possible," he told me, "but I'm spending more, too. It's costing several hundred bucks a day for my studio whether I bring in a cent or not. I'd like to take some time off and work on a few personal projects I've had in mind for a long time, but I don't do it. I couldn't concentrate; it would be like making love in a taxi with the meter running."

What happens to some *nouveau riche* advertising photographers is that they overextend themselves, moving to bigger, more sumptuous studios and adding to their staff until all the money is pouring out just about as fast as its comes in. This puts them in a highly vulnerable position where a pinch in the economy or the loss of a major account can plunge them into bankruptcy. The most durable people seem to find ways of keeping the overhead down. They stay at the old place and make do with a few faithful retainers, and if they create the illusion of being big-time spenders, you can be sure it's the client's money, not their own, that they throw around so freely.

Could one photographer, working as an individual entrepreneur on a fee-per-picture basis, earn a million dollars a year? I asked around, of people who should know, and nobody felt this was within the realm of possibility even at the highest of today's prices. There just aren't enough hours in the day or days in the year. Most advertising photographs are like icebergs, the visible portion of a much vaster entity. A great deal of effort usually goes into preparatory work—hiring models, building sets, locating props, scouting locations, and then bringing everything together at the right time and place. The creation of many advertising photographers is an elaborate exercise in logistics, 90 per cent of the work being done before the photographer even looks through his viewfinder. All this takes time.

Richard Beattie estimates that three days' shooting a week is about the best any one man can do on the average. "You don't think of home, you don't think of time, when you're working at this pace," he says. "You get off a plane from one location job and get on another to someplace else. You check in at the Barclay across the street for a few hours' sleep and then you're back at work again. Every so often you just have to stop and disappear so they have time to clean up the studio for you."

What with rapid changes in graphic style and so many new young photographers trying to break into the field, advertising photography, never the world's most secure profession, has become more volatile than ever. The average life expectancy of an advertising photographer's career is about on a par with that of a front-line

machine gunner in World War I. But the big money is there, people do succeed, sometimes in a very spectacular way indeed, and if there are easier ways to make a hundred grand a year, there are plenty of tougher ones, too.

Not that most photographers ever expect to earn that kind of income. As I said in the beginning, they want to make a good living, of course, but along with the money are the other, psychic, nonmeasurable rewards that make photography so interesting to so many people. The economic profile is rather bizarre, with incomes ranging, as they do, from zero to a magnitude comparable with the earnings of corporation presidents or star professional athletes, and individual picture prices running from about two bucks to five thousand times that and more. But photographers are there, essentially, because they would rather take pictures than do anything else. How many other occupations pay so well for doing something that is so much fun?

WHAT YOU SHOULD KNOW ABOUT
MODEL RELEASES

If you've ever had a photograph published (or hope to publish one), entered a photographic contest (or expect to enter one), or sold any pictures (or hope to sell them) then you ought to know something about that much-misunderstood little legal document called a model release. For working professionals, obtaining model releases is one of the routine, if sometimes bothersome, facts of life. For the amateur and part-time pro, it can make the difference between landing or losing a sale.

In essence, a model release is a contract allowing you to use a person's picture in certain specified ways in return for "valuable consideration" received. A properly worded, signed release protects both you and your client. It is no guarantee that you won't be sued, but it can keep you from losing a suit. Sounds clear-cut and simple enough when explained in this way, but when you get down to specific cases, the subject can be clouded by legal obfuscations and complicated by endless ramifications. You will, I've found, rarely get two photographers, picture agents, editors, or lawyers to agree on some of the more controversial points involved. However, let's take a deep breath, plunge in, and find some basic guidelines to help you.

When do you need signed model releases? Obviously, when you're dealing with "people" pictures that show a recognizable likeness. (There are some exceptions to this that I'll mention later.) If a person's face is showing in the photograph and there is enough detail to make out the features even in very sketchy form, this generally is considered a "recognizable" likeness.

I once asked a legal expert for his opinion on this subject, and he gave me another definition. He said if the person's face, *in the photograph as reproduced*, measured less than one-eighth of an inch, I believe it was, then this could not be construed as a recognizable likeness. I don't know what precedents, if any, my legal friend based his opinion on, but I'm skeptical about it. First, if your lens is sharp enough, a less-than-one-eighth-of-an-inch face might very well be recognizable, and secondly, as a photographer, you rarely have control over the size of the printed reproduction.

Sometimes a subject may claim that an image is recognizable even though the face doesn't show. I remember one such occasion recently. A group of photographers were doing a candid coverage of a New England town. One of the photographs, reproduced in a local newspaper, showed a girl sitting on a park bench—no face, just her legs. Later, a young woman came to the newspaper office and claimed it was a picture of her "because I recognize my own knees." Well, perhaps she was right, although she didn't get very far with her story in this case. It makes a good point, though: somebody with a distinctive mole on his elbow or lump on his knee might successfully claim identification thereby, and a person can be recognizable even when we don't see the face.

The way in which a photograph is used is perhaps the single most important factor insofar as model releases are concerned. Generally speaking, there are two basic categories: editorial and advertising/commercial. The restrictions are much tougher for the latter. *Always* get a signed release from people appearing in pictures used for advertising or commercial purposes. But always.

Advertising and commercial purposes cover a lot of ground, including newspaper and magazine ads, of course, as well as stills used in TV commercials, photographs appearing on packages, photographs in store displays, sales brochures, subway car cards, posters, or any other filmed or printed advertising. If any photograph of yours is used to sell or promote a product or service in any way, consider it commercial use and get model releases. Otherwise you leave yourself and your client open to a possible law suit for invasion of privacy.

For any minors appearing in advertising photographs, have a release signed by the parent or legal guardian. (Although state laws vary, twenty-one is generally considered the legal coming of age.) Releases also are needed for pets, manufactured products, trademarks, and even recognizable private property. In the eyes of the law only a living person can have a right to privacy. A house or a tree cannot. But the right of the photographer to *use* a picture of a house or a tree may be challenged. In one famous case the owner of an unusual tree threatened suit against a photographer who had photographed the tree for use on a calendar! The suit was settled out of court, and no legal precedent was established; nevertheless, if you are showing a distinctive piece of private property in an advertising picture, try to get written permission from the owner.

With photographs used on editorial pages of newspapers, books, and magazines, the situation is much different. The courts, in a number of decisions through the years, have tried to balance the rights of individuals to their privacy and the rights of the community at large

to free and full information about public events. In general, the decisions have avoided anything that would tend seriously to restrict the freedom of the press.

As a general rule, you don't need model releases for people appearing in pictures of a news event when the pictures themselves are reproduced in a timely news media. If you are covering a fire, a small-town centennial parade, an urban riot, or a thruway chain-collision, you normally aren't likely to be able to get releases, nor do you need them. If you are doing a straight job of reporting and the photographs are reproduced as news, you stand on pretty safe ground.

The status of news or other timely photographs when reproduced considerably *after* the event in non-news publications (photographic magazines, books, and annuals, for example) is far from clear-cut. The nature of the pictures and the way they are used are important considerations. Are they reproduced out of context or are they shown as representative of a photographer's artistry and talent? Are the pictures intended merely to shock or startle, or are they used as a more permanent visual record of living history than a daily newspaper or weekly news magazine can give? There are no sure guidelines here. In practice, however, photographs are used this way, frequently and without excessive problems.

Public figures have little or no right of privacy, and this extends to photography, too. Popes, princesses, and politicians must, in general, bear "the white light that beats upon a throne," as one court decision grandiloquently quoted. A celebrity may actively oppose your taking a picture, but his or her right to privacy, if a photograph is made and reproduced is, in effect, nonexistent. (We are talking about *editorial*, not advertising/commercial use, remember.)

Here you might say, "These situations don't apply to my kind of shooting. I rarely photograph anything that could be called a news event." But what about ordinary candid photographs, taken on the street, in parks or museums?

If you ask a lawyer if you need a model release for the subjects in candid pictures like these, he is likely to tell you yes. He is right in the sense that having a signed release always is safer than not having one. However, the advice is somewhat unrealistic, and many great and wonderful photographs would go untaken and unpublished if photographers always followed this rule. The head of one major picture agency summed it up this way when I asked him about the problem: "Unless you are shooting in a studio or other controlled situation, you can't take a good picture and constantly worry about releases," he said. And that's the way most professional photojournalists I know feel about it.

You should be careful not to release pictures that hold the subject up to ridicule or tend to defame or put him in an undesirable light. Use common sense. If *you* were the subject, would you find anything objectionable about the picture? If the answer is yes, you'd better have a model release or not publish it.

In practice, few problems seem to arise if the photographer is working in a public place and his subject is aware of the camera. Telephoto pictures that peek into private areas of a person's life are more dangerous, even if the resulting picture is innocent of malice or ridicule. A noted "invasion of privacy" case in recent years involved a well-known photographer who made a superb set of long-lens pictures all taken from the window of his twelfth-floor apartment. One photograph showed a group of people on the street below but also included a woman peacefully reading in her lounge chair on a screened-in terrace. It was an interesting visual comment on both the crowding and the isolation of urban life. The woman was barely recognizable and certainly there was nothing objectionable about the photograph. However, she saw it published, threatened suit for invasion of privacy, and collected out of court.

If your candid pictures were made abroad and show foreign nationals, the question of model releases is more or less academic. If the photographs are published or exhibited in the United States, there is little chance that the subjects will ever see them. Also, there are obvious practical difficulties in bringing suit against a publication or photographer in a foreign country. You'd still better be careful, though. You never can tell when that colorful character might turn out to be a Harvard Law School grad gone native during a vacation!

One decisive factor is the policy of the publication or client you are selling to. Some publications, including house organs for national corporations, have a cast-iron rule: you *must* have a release for every photograph containing a recognizable person or persons. Most major photographic contests, too, require that a release be available if needed. The big mass-circulation magazines also tend to be conservative about releases. They wish to avoid trouble, knowing they could be hit for heavy damages if a successful suit was brought against them. Most threatened suits I've known or heard about never got to court. However, the last thing an editor or publisher wants is the threat of a law suit. Even if he wins the case, taking it to court probably would prove more costly and certainly more time-consuming than making an out-of-court settlement. Often, it doesn't take much to mollify a person who feels his right of privacy has been invaded. A letter of apology, a token payment, a free print or two, or even a few free copies of the publication are sometimes enough. But it's a nuisance.

Some publications don't worry much about releases. One of these is *Infinity*, official publication of the American Society of Magazine Photographers. *Infinity* has published some daring, controversial portfolios over the years but rarely has encountered problems of threatened law suits. No doubt the specialized sophisticated readership and the relatively small circulation have given it a degree of immunity that larger, more general publications don't share.

Nudity abounds today, in still photography as well as in X-rated movies and avant-garde plays, but you should get a signed release for any photograph of a nude you want to publish, even if the face isn't showing. Take the same precaution with any so-called glamour or cheesecake type of picture, too.

Public display of your photographs in an exhibition constitutes "publication" in the eyes of the law, and the same risk of possible invasion of privacy suits exists here as for reproduction in a magazine or book. Walker Evans, for instance, made a series of candid photographs of people on the New York subway. The pictures went unpublished and unexhibited for many years before one major museum finally decided it was reasonably safe to display them.

What form do model releases take? This varies, depending on use. There are what I call the "long forms." These are formidable legal documents that spell out in detail all possible uses of the picture and cover every imaginable contingency. They are fine when you are working with paid, professional models and are recommended for advertising/commercial photography. They are not always practical for location use, however. The trouble is that they tend to scare people off. Show it to a stranger you've just photographed on the street and his natural reaction is to get the family lawyer to read all the fine print.

For location shooting, a "short form" usually is better. This is a relatively brief, uncomplicated, and unintimidating release. It does not give you as full and specific protection as the longer form, but it provides you with a better chance of getting a signature. The customary practice is to ask for a signed release in return for "value received" or "valuable consideration." This could be a token payment of from $1 to $5 perhaps, or just a print or two of the pictures. (If you promise a print, be sure to deliever, though!)

How do you get strangers to sign a release? Simply introduce yourself as a photographer (presenting a card if you have one) and tell them that the photograph is for possible publication. If you give an honest, straightforward impression, and the release itself seems harmless, chances are the person will sign. People sometimes are suspicious of photographers, but if they are convinced you're not running

some kind of racket, they often are flattered by the attention. Of course, some people will refuse to sign. If that's the case, don't argue; just let it go. At least you may be able to obtain the person's name and address so you can make contact later should the need arise. With professional models, always get the release signed at the time of the shooting session.

Signed releases should be carefully filed (and cross-indexed with the matching pictures). Always keep the original in your files. If a publication or client wants to see the release, send them a Xerox or other legible copy.

As I said at the beginning, the question of model releases and their ramifications is not a simple subject. For a more detailed discussion, see the appropriate sections of *Photography and the Law* by George Chernoff and Hershel B. Sarbin, published by Amphoto, which remains the most authoritative book on the subject. If you need specific help in a particular situation or run into trouble with one of your published photographs, get yourself a competent attorney. What I've tried to do here is to give some of the background of the subject and some basic guides as they are followed in practice among working professionals in the field today.

One important idea: never pass up a good picture just because you may not be able to get a release. Perhaps you can obtain one afterward, or it may turn out that you don't need one after all. At worst you have an unpublishable picture. But one thing is certain: a signed model release doesn't mean a thing unless there is a good picture to go along with it.

PART III

SOME PHOTOGRAPHERS

HENRI CARTIER-BRESSON:
THE WORLD IN A VERY SMALL RECTANGLE

The first time I met Henri Cartier-Bresson he was painting a water color. It was at the old Magnum office and he was seated by a window, looking out at a fragment of Manhattan rooftops hazy with summer humidity. He worked with great concentration, not noticing me come into the room until we were introduced. It struck me as a strange image, my first view of this man who was so passionate and pure in his approach to photography, so well known for the ultrafast precision of his reflexes, engaged in such a quiescent and sedentary pursuit. But he is an uncommonly paradoxical man. The quiet art of water-color painting is one of his hobbies, and like many other successful photographers, he once studied to become an artist. Judging from his water colors, which impressed me as competent rather than brilliant, that would have been no great gain for the world of art; judging from his photographs, it would have been an incalculable loss for the medium of photography.

Later, as we walked along 57th Street together, the attributes that make him such a superb photographer became more evident. He carried his 35-mm camera with him, as he almost always does. In midconversation he would abruptly vanish in the lunch-hour crowd, magically reappearing a few feet away, camera to his eye. He would

make an exposure and then vanish again, once more appearing at my side, very swiftly and quietly, like a cat.

When he is out in the world, he observes everything about him, the minute visual details, the play of light, the gestures and expressions of people. We had a good lunch in a little restaurant Cartier-Bresson liked, just off 57th Street. All the time we were eating and conversing, he was observing. Two men were sitting at the dark little bar nearby. They were crouched over their martinis, heads close together, conspiring. Cartier-Bresson suddenly raised his hands, making a little frame of them. "There. Right now. That's the picture," he said in a low voice. Just as one man whispered something confidential to the other. "They are such perfect American business types," he said. I looked more closely and saw the hard, sharp, predatory faces, with dark pouches under the eyes. In their sharp-edged hardness they were like birds of prey, or a Giacometti sculpture in which all soft form has been eaten away, leaving only the calcified structural frame. He was right. It was a good picture. I would not have noticed the men if Henri had not brought them to my attention.

I called him Henri. At Magnum they liked to call him Cartier. "Cartier is flying in from Paris next week," or, "Cartier is publishing a new book." But "Cartier" sounded affected to me and somehow did not fit the man. He is a shy, balding person, a native of Brittany. The Bretons are the Yankees of France, and being a New Englander myself, I felt an affinity with the reserved and understated aspects of his complex personality.

He was in his fifties then, visiting New York to supervise the hanging of *The Decisive Moment*, a giant two-part exhibition at the IBM Gallery. He has grown plumper and grayer during the intervening years, but time has not dulled the luster of his reputation. A new generation of photographers has grown up since then to admire and be influenced by his work, and he is now, as then, one of the few truly seminal figures in contemporary photography.

"I remember him talking to me in this studio here," another distinguished photographer commented to me recently. "He was wondering about a policeman he had seen on the street. 'What would happen if I suddenly went up to him, put my camera right in his face, and took a picture?' he said. It had to be a policeman, I think—the element of danger was important. He was a little fearful of trying it, but fascinated, too. His furtiveness, his desire to move and act unexpectedly, without warning—it's so different from me. I like to call people and make arrangements three months ahead."

Cartier-Bresson was a hunter once, in West Africa, and an expert shot with a rifle. That may be significant. His kind of photography

is visual sharpshooting, requiring a hunter's patient skill in the chase and a marksman's eye, steady hand, and reflexes to score a hit. This is not to suggest that photography, for Cartier-Bresson, is only a sublimation or displacement activity for his hunting instincts any more than to say he photographs because he is a frustrated painter. But some wild, dark, danger-loving streak must lie behind the shyness and rationality of his *persona*. (He repeatedly escaped from prisoner of war camps during World War II and was active in the French Resistance.)

I attempted to isolate and identify some of these qualities that give his photography its power, in an introduction to a portfolio of Cartier-Bresson photographs I was preparing as editor of the first *35-MM Annual*. In retrospect, I can find little in that essay to add or change, other than some topical references no longer important. Here is what I wrote:

Regarded by many as the greatest photojournalist of our time, his sharpshooter's ability to catch "the decisive moment," his precise eye for design, his self-effacing methods of work, and his literate comments about the theory and practice of photography have made him a legendary figure. His influence on the adolescent art of photojournalism has been profound and far-reaching. His pictures have been published in most of the world's major magazines, he has produced many books, and his work has hung in leading art museums of the United States and Europe (*The Decisive Moment* was the first photographic exhibit ever to reach the august halls of the Louvre). In the practical world of picture marketing, Cartier-Bresson also has left his imprint: he was one of the founders, in 1947, of Magnum, a cooperative picture agency with branches in New York and Paris.

Trained as a painter, Cartier-Bresson champions a purely photographic brand of photography. A master at unobtrusively catching candid pictures of other people, he hates to have a camera pointed at himself. An adventurous traveler to remote and troubled corners of the world, his favorite themes are the humble, homely details of everyday life. However, a close look at his pictures and beliefs about photography throws some revealing light on these apparent contradictions.

Although Cartier-Bresson owned a box Brownie as a boy, and once dabbled with a 3 × 4-inch view camera, he first truly discovered photography through the viewfinder of a miniature camera and has remained passionately devoted to 35-mm ever since. He was twenty-three at the time he made his pivotal discovery, an ex-art student in Paris recuperating from a bout of blackwater fever picked up during a year implausibly spent as a hunter in the West African bush. He

snapped a few pictures with a Leica, and his imagination caught fire. He recalls how he excitedly "prowled the streets all day, feeling very strung up and ready to pounce, determined to 'trap' life . . . in the act of living."

Thus began one of the most fruitful collaborations between man and machine in the history of photography. The speed, the mobility, the large number of exposures per loading, and above all the unobstrusiveness of the little camera perfectly suited his shy, quicksilver personality. Before long he was handling its controls as automatically as an expert driver shifts gears in a car, and the camera itself—in his famous phrase—became an extension of his eye.

The excitement that caught him up then, the tension, the sense of discovery, come across sharply today in those early pictures, the images of France, Spain, and Mexico taken by an unknown amateur in 1932–34. Familiar as they are, having been widely reproduced in books, magazines, and picture annuals (and even more widely imitated by other, less original photographers), the best of them retain a child-like freshness of vision, a poetic intensity of statement that still can make your nerve ends tingle. The touching, inexpressible eyes of a Mexican peasant, the ghostly bicycle drifting past a staircase in Hyères, and the Cyclops leering through a fantastic fence in Valencia are as vivid as hallucinations—characteristic Cartier-Bresson images that, once seen, brand themselves indelibly into the memory. For many of us, as for Cartier-Bresson when he first took them, these pictures opened up a new universe of seeing. That they should endure so well, after so much repetition, is an indication of their value as works of art.

These early pictures, from a purely visual standpoint, are among his most striking achievements. As you go through his work in approximate chronological order, you can sense a growing concern with content, with human beings, with social and political implications. Sometimes his growth as a photojournalist interferes with the poet and the artist. He has commented on what he feels is an opposition between narration and poetry, and on the "anxiety that comes from not being able to force the issue, but having to allow the real picture to come at its own due time, not ours." There are some pictures, particularly from the Moscow and Indian series, which are hard to reconcile with his definition of the decisive moment as given below. But the best of his later work, when his excitement in sheer seeing is rekindled, have an added richness because of its human significance.

Throughout much of his work, and in his writing about photography, Cartier-Bresson has been haunted by a sense of time. On one hand, time is a favorite theme in his pictures. He is fascinated by the contrast between youth and age, growth and decay, tradition and

innovation, impermanence and continuity. In single pictures, picture stories, and even an entire book—*From One China to Another*—he has shown the clash of modern technology against ancient cultures, the new in startling juxtaposition against the old, the future struggling to be born from the womb of the past.

But time is, for him, much more than merely a dramatic subject for photography; it is an essential creative element, perhaps *the* essential element, in his approach to picture-taking. Photography, he once wrote, is a battle with time. Photographers deal in things which are continually vanishing; what you miss in passing can never be recalled, the flow of life can't be halted or wound back for the convenience of photojournalists. But if time is a source of frustration and anxiety, it's also a source of power. Sliced thin, with infinite precision, it becomes a key control in the creation of visual images.

Cartier-Bresson, of course, was not the first person to understand the crucial nature of time in photography. Anybody who has ever tried to catch a fleeting smile on the face of a baby realizes the importance of right timing. But it was Cartier-Bresson who popularized the apt, vivid phrase, "The Decisive Moment." And it was he who enlarged the concept of the decisive moment into a formal, aesthetic approach to photography.

The heart of his approach is contained in a much-quoted paragraph from the introduction to his book *The Decisive Moment*—a piece of writing which, like his pictures, has the Gallic virtues of clarity of thought and economy of expression. Photography, as Cartier-Bresson tersely defines it, is "the simultaneous recognition, in a fraction of a second, of the significance of an event as well as the precise organization of forms which gives that event its proper expression." As a definition of what most photojournalists try to do, consciously or unconsciously, it's the most precise ever made. On the other hand, the search for decisive moments is not the only valid approach to photography, but as Cartier-Bresson has often pointed out, his rules and definitions apply only to himself.

For Cartier-Bresson, the creative act is a lightning flash of intuition during which a message is relayed swiftly through the nervous system to the shutter finger. Composition becomes a function of the decisive moment. You compose not only by adjusting the camera's viewpoint with hairline accuracy but also by selecting the exact instant of exposure when a chaotic world coalesces into a clear, meaningful design. As in an Einstein theorem, time is a fourth dimension of space. In his understanding of how to use time creatively—and his crack-shot ability to do so—Cartier-Bresson has mastered one of the unique attributes of photography.

But if the methods of photography differ from painting, both are visual arts, and Cartier-Bresson's two years in the Paris studio of painter André Lhote were not wasted. He came to photography with a trained, subtle, and sensitive eye for composition. It is this eye, this genius for visual organization, that is one of the most easily recognized earmarks of his elusive, understated style. In the best of this pictures, new and old, the composition is so spare and lucid you feel that if you were clever enough you ought to be able to express its lovely geometry by some mathematical formula: the way lines ricochet in tangent from curves, the way blacks counterbalance whites, a self-contained system of images vibrantly alive within the tiny 24 × 36-mm rectangle. They give the quality of pleasure you get from a good sonnet, of emotion expressed under tight control. And yet the compositions aren't forced or artificial; in fact, some are deceptively artless, as if the work of a lucky snapshooter.

Indeed, some puzzled critics have accused him of being nothing more than a snapshooter. The limited validity to this charge is that in less disciplined hands the decisive-moment approach can lead to haphazard, unselective shooting. There's a constant temptation to fire the 35-mm camera like a burp gun, hoping that one of the 36 frames has nailed a bull's-eye hit. But the best of his pictures, with their rigorous organization and flashing insights into human emotion and character, could never have been caught by luck alone unaided by a rare talent. They are snapshots only in the classic sense of instantaneous exposures, snapshots elevated to the level of art.

A magazine (the now extinct French picture journal *Vu*) first published a Cartier-Bresson photograph, and magazine reportage has been his profession ever since. He is a journalist, with an intense need to communicate what he thinks and feels about what he sees. His pictures often are subtle but rarely obscure. When he uses symbols, they tend not to be esoteric, private ones but images with generally recognized meanings—the American flag draped about an old woman on Cape Cod, for example, or a maimed man hobbling on crutches past the bomb ruins of postwar Hamburg. He has a high respect for the discipline of press photography, of having to tell a story crisply in one striking picture (which is an application of his decisive-moment theory). He once said his favorite Greek myth is the story of Antaeus, who had to touch earth to regain his strength. Certainly Cartier-Bresson's journalistic grappling with the realities of men and events, his sense of news and history, his belief in the social role of photography, all have kept his work free of the taint of preciousness.

Cartier-Bresson believes that it takes more than what he terms "plastic qualities"—that is, the organization of shapes, lines, and tones—

to make a good photograph. At least equally important is the rapport between photographer and subject, a sympathetic interplay of emotions and understanding. He has said that a sense of human dignity is an essential qualification for any photojournalist, and feels that a picture, no matter how brilliant it may be from a visual or technical standpoint, is not successful unless it grows from the love and comprehension of people and an awareness of "man facing his fate."

If Cartier-Bresson's theme often is time, his subject always is humanity, which he regards with compassion, curiosity, and a wry sense of humor. He is gentle even at his funniest, as in his delightful picture of the Coronation with the solitary, newspaper-nested sleeper below the gawking crowd, or of the woebegone man in the rain on Derby Day. But neither is he afraid to look at ugly aspects of the human soul without flinching; few pictures have caught hate so naked and venomous as his war's-end shot of a woman accusing a Gestapo informer. Some of his portraits, of William Faulkner, Truman Capote, Georges Braque, Henri Matisse, and other writers, artists, and notables, have become definitive, catching as they do, with relaxed and casual brilliance, the essence of personality.

As mentioned before, for such an active, well-traveled photojournalist, Cartier-Bresson has few pictures of earth-shaking events and the men who dominate them (Gandhi's funeral being a notable exception). But this paradox actually is not paradoxical; his passion is exploring the commonplace, the day-to-day emotions and relations of ordinary people, wherever he finds them. "In photography, the smallest thing can be a great subject," he wrote in *The Decisive Moment*. "The little, human detail can become a leitmotiv." Whether taken in Bali, Barcelona, or Brighton, most of his photography is a collection of such little, human details: concrete images with universal meaning, specific, intimate, suggestive. He lives in a haunted world where mundane facts—a reflection in a mud puddle, an image chalked on a wall, the slant of a black-robed figure against mist—radiates with a meaning only half-consciously grasped. His is an antiromantic poetry which finds beauty in things seen clearly, in the reality of here and now.

All his great pictures were taken with the kind of equipment owned by many a well-heeled amateur photographer: Leica rangefinder cameras fitted with normal 50-mm lenses or occasionally a telephoto for landscapes. At this stage, after having wound so many thousand feet of film through his camera in so many lighting situations, from murky beer halls in Cologne to blazing Indonesian sunlight, he relies on his experienced eye alone, without the aid of an exposure meter. Along with Dr. Erich Salomon and Alfred Eisenstaedt he was

a pioneer in the once daring technique of available-light photojournalism and would no sooner intrude flash or floodlight into his pictures than would a fly fisherman toss rocks into a pool where he hoped to catch a prize trout.

Cartier-Bresson is the antithesis of a gadgeteer, having clung to about the same austere kit of tools he started with nearly four decades ago. Also a passionate nontechnician, he usually answers requests for exposure data with a laconic "I don't remember." But of course he does know technique, simply having mastered it to the point where it has become unconscious and automatic.

For his darkroom work he was fortunate in finding a skilled and sympathetic collaborator in Pierre Gassman, who for years developed most of Cartier-Bresson's film and made most of his prints.

Cartier-Bresson rarely wets his hands in hypo these days. Like many other busy photojournalists, rightly or wrongly, he would rather devote his full time and effort to taking pictures. According to his belief, the essential creative act takes place at the instant you push the shutter release, and nothing that you can do afterward, neither cropping nor brilliant print quality, can salvage error. (He has come out so strongly against cropping that some fellow professionals are delighted when they find a Cartier-Bresson print that shows signs that it wasn't composed full frame.)

Unlike an Edward Weston print, with its fantastically long and subtle scale of tones, or a W. Eugene Smith print, with its Rembrandt-like use of darkness, the prints of Henri Cartier-Bresson tend to be soft and muted. He loves high-key effects: off-whites and fragile grays and a touch of understated black. For some photographers, whose taste runs more to rich, fully saturated blacks and sparkling ferricyanided highlights, Cartier-Bresson's print quality seems disappointingly weak and flat. However, it is a style of printing consistent with his austere and self-effacing approach to photography, and it never intrudes upon the picture.

He works in a state of total absorption, as soft-footed and inconspicuous as a hunter stalking a shy animal. "Approach gently, tenderly, and never intrude, never push," he once advised. One observer at a party was amused to see him swiftly elongate himself like a rubber band to make a picture above a surrounding fence of heads, then shrink back to his normal, slightly stooped posture. He can fire at point-blank range into people's faces without incurring resentment, and some of his most fascinating pictures are of people staring at his camera with mild, tolerant interest.

It may be his own shyness that enables him to perform so adeptly as a candid photographer. Certainly he dislikes having his own picture

taken, growing extremely uneasy whenever he senses the presence of another photographer in the room and rarely permitting even trusted friends to point a camera at him. He is, in his own words, one of those who feel "a certain fear of black magic"; a feeling that by sitting for a camera portrait they are exposing themselves to the workings of witchcraft of a sort.

Photography *is* witchcraft of a sort, in its ability to transcend the limits of time and space, and in that sense Henri Cartier-Bresson ranks as a most proficient wizard. As Proust explored the phenomenon of total recall, triggered by a taste, so has Cartier-Bresson researched the effect of decisive moments, photographic images that act as touchstones, capturing the essence of a time, place, human being, or event, and setting off an emotional chain reaction in people who never witnessed the original. A Mexican peon stared at a man with a funny camera almost forty years ago and achieved a limited kind of immortality. Now a hundred thousand people can relive that moment and experience that same shock of recognition between two human souls. By having so skillfully exploited the camera's ability to transfix a moment in time's flow, Cartier-Bresson has left us a treasure of images. We can, thanks to him, see the world a little more clearly, and find truth and beauty in places where we did not guess they existed.

W. EUGENE SMITH:
THE CONSCIENCE OF A PHOTOJOURNALIST

"Modern photojournalism is based on Tri-X, the single-lens re-
flex, the thumb wind, the custom processing lab, and Gene Smith,"
according to Bill Pierce, in a colorful overstatement of the situa-
tion, which contains, despite some inaccuracy, a core of truth. All
the items listed by Pierce, with the exception of Smith, originated
after modern photojournalism had reached its peak and begun its
lapse into its lamented decline and merger with other, less clearly
defined modes of visual communication. W. Eugene Smith is neither
the father, the sole son, nor even the Holy Ghost of photographic
reportage. But he is one of its dominant features, like a Pike's Peak or
the Crater of Clavius, and anyone who would achieve insight into
contemporary photography, its achievements and limitations, must
consider his impressive contributions and the reasons he has become,
as they say, a legend in his own lifetime.

One—and the most enduring—reason for W. Eugene Smith's

mythological impact is that he has a Great Eye. His images, from the early years prior to World War II up to the present, consistently have been powerful, sensitive, and moving. No visually aware person can view his great picture essays, on the country doctor, the Spanish village, Albert Schweitzer, or the best of his Pittsburgh epic, for instance, without being deeply affected and coming away not only with a profounder respect for the medium of photography but also with an altered vision of the human condition.

Another factor is his superb craftsmanship as a printer, which is the envy of many peers and the ultimate goal of many imitators. You cannot experience a first-rate Gene Smith print as a reproduction; you must see it in the original. His photographs are on the dark side, often with melodramatic ferricyanided highlights, but merely printing dark is not the secret. He has created a photographer's vocabulary of blacks, which are rich and deep but retain the necessary detail to communicate what he wants to say. "A good Smith print is not dark!" he commented during an interview with Bob Combs for *Camera 35*. "It has a feeling of being dark, but if people really look, and unfortunately many fail to look, they will find that in any area where it is important to see detail, this is quite easily accessible to the eye, and quickly."

Only those who have slaved in a darkroom over their own 11 × 14 enlargements are fully qualified to appreciate the quality of Smith's printing. You wonder how it is possible for a human being to produce those infinitely deep and subtle shades on the imperfect materials available. Does he have some secret formula or printing paper? Today Gene makes most of his prints on plain old Polycontrast developed in Dektol diluted 1:1, and spends not the seventy hours sometimes rumored but perhaps an hour or two at most in producing a print that satisfies him. "How do you get those Gene Smith blacks?" somebody once asked. "By bleeding into the developer," somebody else replied, and that is as satisfactory an answer as any, the detailed recital of his tools and techniques revealing little.

Even more central to the Gene Smith cult is the photographer's own stated attitude toward his craft and toward life itself. A man born ahead of his time, he has survived into an age which is, temporarily at least, in tune with some of his own values that seemed irrelevant and impractical to many only a decade or so before. I do not know what Lord Byron would have been like if he had survived to age fifty-plus, but if that had happened, he and the Smith of today might have had something in common: a profoundly romantic stance toward the universe, a passionate commitment to human values (especially lost causes), a talent for self-dramatization.

Smith has enacted the anti-Establishment role on the stage of his own life on numerous occasions. He quit *Life* magazine (on a retainer basis) in 1941, rejoined in 1944, resigned again in 1954, partially made up with the magazine in the early sixties, then broke away again. He has made arrangements for books and major photographic essays with other publishers, only to cut the connection because of what he felt were compromises with his personal concepts of integrity, and at considerable loss to his income and reputation for reliability.

On the occasion of his resignation from *Life*, he wrote: " . . . superficiality to me is untruth when it is of reportorial stature. It is a grievous dishonesty when it is the mark of any important subject. . . . I do not accuse them [the editors] of a lack of integrity, for as they relate within the concept framework of their magazine factory, as they relate to its dominant precedents, they are apparently sincere and honest men. However, I cannot accept many of the conditions common within journalism without tremendous self-dishonesty and without it being a grave breach of the responsibilities, the moral obligations within journalism, as I have determined them for myself."

So W. Eugene Smith, the radical romantic, has stated (in his convoluted and baroque writing style) and acted out (in his controversial and crisis-ridden life style) beliefs about such unanswerable problems as the nature of truth, of beauty, of honesty, of dishonesty, of the ultimate nature of social relationships, of whether the universe is inherently good or evil (or both, or neither). He asks, as a man and as a photographer, searching and disturbing questions which, obviously, he has not been able to resolve for himself, but which he is able to pose in singularly vivid form, visually, verbally, and on the printed page. Many people listen and respond to the charismatic charm, to a moral voice crying out in a relativistic wilderness, to one tormented human being calling to another.

W. Eugene Smith has, indeed, been a tortured soul (although scarcely unique in this aspect), some of his misfortune arising from outside circumstances, some of it self-imposed. His father committed suicide when Gene was a teen-ager, during the depths of the Depression, in Wichita, Kansas. This and the sensational newspaper accounts of the tragedy were a traumatic experience. As a free-lance photographer in 1942 he was accidentally injured by a dynamite explosion during a simulated battle scene, an event which left his hearing permanently impaired. Applying for duty with Edward Steichen's Naval Aviation photographic unit, he was turned down on grounds of physical disability and lack of sufficient college education. A review board commented: "Although he appears to be a genius in his field, he

does not measure up to the standards of the United States Navy."
(Eventually he became the only photographer to be honored by
receiving three Guggenheim Fellowships.) A civilian combat photog-
rapher on Okinawa, in May 1945, he was badly wounded in the
head, chest, and back by Japanese shellfire. It required nearly two
years of operations, treatments, and painful convalescence before he
recovered, and his health has been precarious ever since.

The rumors about Smith always seem to be circulating in the
field of photography: Gene Smith is bankrupt; Gene Smith has just
landed a $20,000 assignment; he is desperately ill, he is miraculously
recovered; he is on the verge of suicide, he has never looked better.
Indeed, as a suffering man (and nobody who is a friend of Gene's
can doubt that the pain, whether external or self-inflicted, has been
intensely real to him), he shows a remarkable ability to endure
and even thrive under it all.

I saw him, after a lapse of years, and on the heels of the direst
rumors, at a Museum of Modern Art birthday party for Edward
Steichen. Smith was, implausibly, wearing a tuxedo and looking un-
commonly plump and jolly. He continues to photograph and to make
his superb prints in his loft in the West Thirties. He attracts new
disciples and wins increasing recognition for the excellence of his
work in publications and museum exhibitions.

Recently, at a photographers' party in the Village, where he
was attired in his more characteristic garb of a Midwest farmhand
just in from the fields, Gene was listening attentively to a young
photography student who was passionately expounding his theory
of the total objectivity of the photographic image. Gene Smith,
listening to one of the kids, and deeply impressed, although not agree-
ing, just as they were listening these days to what he had to com-
municate. In a conversation with me that same evening he remembered,
too, a tape-recorded interview that had taken place years before and
that I had almost forgotten. The subject had been lighting, but before
we got through we had covered a great deal more than that, and Smith
had given a more valuable statement about photography and his
attitude to it than I had realized at the time. I reproduce it here, as it
happened, along with my sometimes obtuse questions and Smith's
sometimes obscure answers. It was, in retrospect, a lively dialogue.

Q.: *What is your attitude toward available-light photography?*
A: My attitude? It is quite friendly. However, let me give my
definition of available light. This, to me, is simply any light that is
available in any form—lighting that I can photographically take hold
of and utilize, from an irregular nearly none at all, to a lighted

match, to the headlights of a car, to flares, to anything. My attitude, first, is that the final picture must rise above the adequacies or inadequacies of light, overcoming and using light to state what its purpose is and what its characterization was intended to be. Secondly, I've never found I've been able to take pictures without light, no matter what is said in brag of the fast lenses and film speeds of today— excuse me, of tonight—and therefore, when I am in a situation where I cannot see my subject, it is my simpleminded attitude that I must add light of some kind. In the midwife story, for example, there certainly was no light in those dark little cabins and I had to add light, so I used speedlight . . . I used oil lanterns, I used candles. Lighting, like any other singular of technique, is not *the* problem. The beginning and final problem is whether I eventually solve what I set out to do, with a sufficiency of command and depth not to demean my intent.

Q.: *The argument advanced by the available-light purists usually is that any introduction of an artificial light source tends to destroy the appearance of the actual scene. How would you answer that?*
A.: Silly little children talking in their narrow dark! I've heard them say, many times, that available light is the one, the only true approach to photography. These purists are soiled from their insufficiencies—that righteous blindness afflicting nearly all holders of the singular truth—seeing surface or less, yet unqualifying in their condemnations. What should we do? One day you go into a room to make a portrait of a man, and there's a 25-watt bulb hanging over his desk, so you use the available light. It's a small cell of a room, a dark room, and this one bulb actually is the only source of light. It's rather far over the subject's head, so the exposure has to be fairly long, the film very fast, and the souping-up considerable. Of course you end up with a picture that is probably dark, perhaps moody, and certainly grainy—a picture that may be completely contrary to this man's character and what you're trying to say about him—*if* you have something to say about him. Anyway, the next day the same photographer goes back and finds they've just put up a large bank of fluorescent lights where that doggone little old bitty bulb had been. This time you can shoot at 1/50 at $f/8$, have modulation, and no need for basketball grain. Who reformed the man—was it the light, or his neighbor's wife? Now, by light alone, which is the honest picture of the man?

Q.: *Same man, same situation?*
A.: But entirely different in visual effect.

Q.: *Tell me, do you ever study the light before adding flash or flood and then try to duplicate the effect of the original source?*

A.: Sometimes, yes. In one picture of mine that I set up for color I used sixteen flashbulbs. Well, I calculated the effect of each bulb, and the final result looked like available light, with a needed depth of focus. But certainly in the midwife story I didn't try to duplicate the existing light. What with the dark skins and the white sheets and the oil lamp sitting behind them, I could not possibly have seen the necessary details—the expressions and the emotions and the relationships I was trying to relate.

Q.: *Sometimes, then, you are forced to create your lighting entirely rather than to simulate what already exists?*

A.: Certainly. Again, in the case of the midwife essay, I would have been considerably the liar and untrue to my essay-subject and to my moral responsibilities if I had passed up those pictures requiring the aid of additional lighting, and which often was contradictory to the lighting as found. And if—during and after the event, say of the birth of the child—if that birth was less a fact, less of truth, any different for my having added speedlight—I just don't believe it!

Q.: *How about the psychological difficulty of introducing artificial light—don't you find this sometimes disturbs the atmosphere you've been trying not to disturb?*

A.: Yes, this is a problem. It's a problem that is just one more phase of the difficulties a man always has when he intrudes himself with a camera. He has to be able to overcome these difficulties, to revert his subject from this added stimulation back into the flow of normal circumstances before taking pictures. I prefer, if possible, not to use flash because this is a continual tap-tap-tapping like the drip dropping of water. On the other hand, if you put a bounce floodlight into a room, after a few minutes it becomes a normal part of the environment. Actually, I've had people ask me to leave it on after the shooting was over because the return to normal light level was now an intrusion, and they wanted to finish what they were doing with the floodlight on. Again, all of this must go back, is charged to the man himself, the photographer. He has to be able to bring off a penetrative analysis of his subject, and lighting is but one of the useful tools of interpretation.

Q.: *Speaking of lighting as one of the tools of interpretation, can you pin down concretely what you expect of it, or what it should actually do in a picture?*

A.: The purpose of light, in the photographer's concern, is for a preciseness of clarity—to see, or not to see, as is chosen. Above all, light has to be functional, it has to underscore and intensify the characterization. A picture which has to work against its lighting, where the statement to prevail must overcome the inabilities or mis-statements of its lighting, is not a complete picture. There are many pictures that survive—possibly some of these could be called very good—in spite of deficiencies in lighting, or in the particulars of the other techniques involved. Or is it that the image compulsion of these photographs is beyond the knowingness of idea or intent of the photographer? Perhaps here enters the element of accident that gives some photographers one-time glory. But these are never complete pictures; these, no matter how powerful, have failed to varying extents—do not say all that could be wished or is possible.

But worse is that so few, truly, fully try, in photography, I mean—and "try" is not necessarily of exposures made, of hours spent, of sweat expended or weights carried, nor of blood-blister complaints against editors and camera clubs. I think standards are too low, frighteningly low—conveniently low, and that many of the slovenlies are drummed as being virtues, or at least as necessities.

Q.: *What do you mean?*

A.: It is impossible, in this short time, to search fairly and give analysis of these ills of photography or of its few but sturdy attributes. Here let me just touch upon this: photography is still young, it is not yet far enough away from its beginning. I believe that photographers—and this is not the full carcass—are intimidated by the very ease of photography, as well as by its difficulties. By its difficulties, until they have the feeling that—well, since there are so many things almost impossible to overcome, let's just sidle around them, daring nothing, and go ahead anyway, along the accepted paths —some of the biggest names do—and let us rely on its other nature, that quality of easiness. The lack can be explained, virtued, can be rationalized into a pardoning of ourselves from the trouble.

Lighting. . . A print also is of lighting, shaded in grays—a print is the summation. In much of the work I see—ignoring all else—considerable improvement could be gained by the sometimes not simple device of making a good print. By this I don't mean trick printing to disguise the original, but I do mean a very careful printing and a reforcing of values back to the values present when the photograph was made, and with attention paid to an emphasizing of the important, the subduing of the irrelevant. I do not wish to be bothered with pretty or densitometer negatives, I desire to see the print.

Q.: *You don't insist on a straight print, then?*

A.: No, when they get photographic emulsion to the point of adequacy, where it can handle the light the world is equipped with, then I would say perhaps straight prints conceivably could be made. But not today. You cannot make straight prints working under the conditions of light as you find it or improve it or have to put up with in awkward places. In the studio, of course, you can shade much nearer to easier fractions in value. But out in the world, far from lab tests and theory's stale tower—am I not supposed to utilize the ofttimes magnificence of lighting's extremes and inconsistencies? Such as—such as even the bare sun, or its reflective children kicking sharp shafts from any variety of objects straight into my camera lens— these, giving wonderful muscle and command, but overpowering within the same photograph a delicate pattern of infinite counterpoint, no less important. Should I not attempt such as this, if it works for my photograph, even when the range is beyond all possibility of film for recording—and when I print am I supposed not to try to bring this back, forcing the scale back to the reality of vision as of my observations? And am I never to attempt an intensification of reality, to a vision that lifts photography, as it does all other arts, beyond the mediocrity of dull tediums and so-called records? I doubt if I contradict those few accomplished photographers, master printers, who advocate the straight approach—when I say that a straight print is a drugstore print or a player-piano interpretation. If so, I know damn well my answer. For myself, at least.

Q.: *Then you would say that the initial problem of lighting at the moment you take the picture can't be disassociated from what you are going to do when you print it?*

A.: Certainly it is related. It has to be, and I usually see the print as I photograph. Rebalancing can be done—shadows lightened or highlights darkened—but you can't remake the direction of a shadow or alter a dominant light that adversely cuts a face, forming painful light forms contrary to the good of the photograph. . . . As a matter of fact, that is why, in doing many essays which are an involvement with the intimate actions of people, I dislike using sunlight.

Q.: *Direct sunlight, you mean?*

A.: Yes, direct sunlight, but understand my qualifying of this within a purpose. Here the reason is, quite simply, that when the light is softer—when there is not such strident contrast of light—the people can move about completely as they wish, and I follow, freed of the light; I can circle to the movement of the people, attentive

in sense to the emotionally active compositions, the important statements that arise from the engaged-in activity. And there are rich variables in this less arrogant light. But with direct sunlight, in this situation, the sun is often quarrelsome to my content and compositional· desires, as motivated by these dramas before me—the sun is too brutal a destroyer of shadow areas here. Again, I suffer the limitations of film against the freedom needed for my search—and I am resentful when the garish is without purpose and overpowers the fragile, the beautiful, the quivering entrancement of inner living. However, as before indicated, I believe a lighting domination by the sun, intelligently used, can be magnificent. I probably care for it more as strong sidelighting or as backlighting—but not necessarily. I might be just as pleased with it directly over one of my shoulders —I don't know which shoulder—like the instructions of photography simplified, say—or I might like to use it directly overhead or in any other way—I am fluid to a situation. I think it was Alistair Cooke who wrote an article about traveling across country—and I think I remember one line in which he said that you should tour this country with the sun at your back. Other than it being harder to drive with the sun in your eyes, I don't agree with that at all. The beauties and even the ugliness—the contours of the country and of the man-made are so enriched, for me, by the late evening light or the early morning light as experienced when driving into it— there is luxury in those long sidelights dancing in upon the textured contours, changing shapes into shadows, weaving in and out again in endlessly fresh variation—all in a rhythmic play that will give movement to the dullest lump. . . .

Q.: *If you were helping a serious beginner, how would you suggest ways by which he could increase his awareness of light?*
A.: Not without seriousness—that he should drive the countryside, or walk a short block with the sun in his eyes. He can use a sunshade for his eyes, as long as he will continue to look—and to see. Two quite different things—to look, and to see. However, if someone were to ask, "How do I use one flash? . . . Where do I put it?" . . . "How do I use two flashbulbs?" . . . the best thing I can think of suggesting that they do would be to take a floodlight and try the practical experiment of seeing. Get a bust, just a head bust—they are not yet ready for the kind that usually make the covers of magazines—one that is neither white nor dark but is neutral in color, and then start with one floodlight. Move it around the room, see what happens, and remember that what they see can also be done with flash. Become aware of distance, become aware of direction,

126

become aware of bounce, become aware of the absence of light, become aware of reflectiveness—by reflectiveness I mean where the main light sets up many counter reflections from around the room onto the subject. Then try two lights and see how they can be played against each other, bring relationships of every degree in variation of—say, of the background, from white to black—say, of the bust, from white against black, or in silhouette against white. The variations are infinite. After this rather practical experiment, they should do this same kind of analyzing in moving through their daily existence. To see, as they were doing when giving themselves the straightforward lesson. Now it should become a straightforward part of their existence. This studying of light is something—one of the things I do constantly—wherever I am. Not necessarily as a discipline, either, but as a sensory pleasure that later I will be able to use. When I was the user of many flashbulbs, I knew precisely how I intended each light to come in, and it was mainly a question of practice, practice, and practice. This does not mean I claim always to have used intelligent lightings . . I'm not a natural technician nor a lighting expert. As a matter of fact, I'm rather like the Kentucky mountaineer measuring a distance by sight: he may not know whether it's twelve feet or fifteen feet, or if there is such a thing as a yardstick, but he can look at a cabin he's building and look at a tree and cut it within a fraction of an inch by the measure of his eye—and that is knowledge, not information. It's the same way with light. I know no technical terms of light—I don't know what others call a Rembrandt lighting, and I doubt if he did—or this and such lighting, and although this named kind of knowledge might help you—I am not ridiculing it—the important thing in gaining this usable knowledge is simply to be aware, aware, aware. Let it be made a constant side play of practice, just for the sake of light. And this being aware should not be a burden, for it is a wonderful way to pass the time of day, the time of night, or any other time—it interferes with nothing, and it leads to far more than the experience of light.

Q.: I wonder if you could illustrate that. If you were taking my picture now, sitting here behind this desk, with the light coming in through the window, what sort of running commentary goes through your mind as you're looking at the light?

A.: The subleties my mind is aware of—I doubt if I can so quickly conjure them into meaningful words. Well, I feel each slight shift that you make, and with each there is always a ripple of changing values . . . when you lean to that side—too heavy, in highlight on the left cheekbone, on the temple—the eye has lost its catchlight—the

balance is wrong, gaining nothing from its wrongness. Now, as you lean forward, turn your head, the light has become too flat, has lost its modulations—the catchlight has come back to the eyes—there is little separation with the background . . . I would begin this way, it would be nearly subconscious—subordinate, for I would be concentrating on you, as individual, as the subject. All now must be made to work simultaneously, for there is but one exposure to each picture. I would be walking about, searching you out, feeling the play of light—talking and walking, seeing with two visions—one focused sharply to your face and one that is softly aware of everything behind you. By leaning to this side, I see heavy conflicting highlights on that vase increase . . . but I could throw it against the dark turn of that wall. However, the other side of your face—the opposite side from the highlight—would be dark, nearly the darkness of the wall and with little separation between your head and it . . . I'd have to bring one or the other up a little, in printing—to get a decent separation, to make these elements work together. . . . Now I have become aware that you are slowly rocking back and forth—as you rock back there is a little jut of white behind your shoulder—that's an immediate annoyance. Well, it would either have to be thrown out of focus to the extent that it is soft in pattern in the background, or hidden, or I'd have to continue juggling these elements, or search from a new direction. . . . But these are so few of the things I must see, the things that must be correlated instantly. . . .

Q.: *Do you ever have occasions where the quality of the light itself suggests a picture, where the illumination is so strong or evokes such a definite emotion that the idea for the picture comes out of the lighting itself?*

A.: It often happens—in reward for being aware. One of my better pictures from the Pittsburgh project happened that way. Crossing a bridge, I was caught by the light of the late sun striking strong patterns out of a maze of railroad tracks. I stopped, and I played with it, but I wasn't satisfied, so I marked the time and place and came back at a later date to have a longer time to work the place with that lighting. Actually, the picture was made weeks later, because the daily weather was not suitable to give me light of the right kind. There were many times on that Pittsburgh project when I would mark certain places or themes that I wished to return to when atmosphere and light were working with me . . . say, with just a faint touch of fog in the air to give me separation between a church on the crown of a hill and the factories, the homes behind it. Sometimes the need may be pouring rain, or perhaps a smoke handling wind

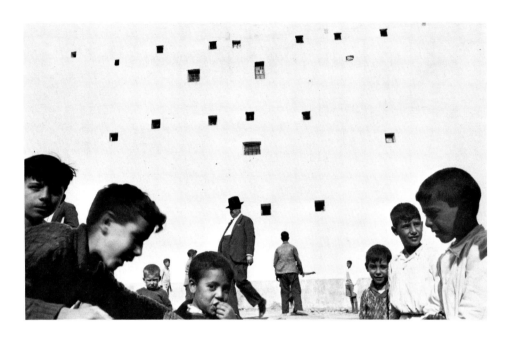

"Photography is the simultaneous recognition, in a fraction of a second, of the significance of an event as well as the precise organization of forms which gives that event its proper expression." Henri Cartier-Bresson, Introduction to *The Decisive Moment.* (Magnum)

"I am a stalker. I stalk weeds and beaches . . . and people. If I could be a painter, I would.

But I cannot paint. I cannot sit still long enough." Alfred Eisenstaedt.

"Pick a theme and work it to exhaustion. Pictures are a medium of communication, and the subject must be something you truly love or truly hate." Dorothea Lange. (The Oakland Museum Collection)

"The purpose of light, in the photographer's concern, is for a precise-
ness of clarity—to see or not to see, as is chosen." W. Eugene Smith.

"Photography is a battle with time." Henri Cartier-Bresson. (Magnum)

from the northeast. Sometimes I have seen the place, setting the scene in my mind, and then anticipating the various lightings with the aid of map or compass—returning then, at the time of my projected imagining . . . sometimes tracing the path of the moon between two branches. . . .

Q.: *With the new fast films like Tri-X and improved developing techniques and faster lenses making available-light photography so easy that anybody can do it, do you think this in the long run will help raise the over-all standards of photography?*

A.: No, I don't think it will. Let's say that for the most part they can now make bad pictures even worse under a broader range of conditions by utilizing the "new" techniques. These are wild horses to ride, and the same chance in potential—I know *I* haven't tamed them yet to my complete comfort. If we are ever going to raise the quality of photography, it's going to be by instilling a desire and a philosophy and a discipline into the minds of photographers, rather than from having placed faster films and faster lenses, and developers, in their hands and darkrooms. Very few photographers will take the time or the energy to use, say, an $f/1.1$ lens with the delicate care within the specifics of purpose and limitations that these lenses require. Although these lenses are marvelous, they, like all photographic equipment, are unequipped with brain. No—often they're only going to make worse pictures, where they might ordinarily have made fairly adequate ones.

Q.: *I wonder if you'd talk about some specific pictures of yours, in terms of lighting. Take the Spanish village set—nearly everybody has seen these pictures, in the museum shows or the magazines. . . .*

A.: And I'm delighted they frequently argue with me that they were photographed in color—it lends support to my present dislike of color in photography.

Q.: *You get that argument?*

A.: Yes—very heavy argument from people insisting it was in color. In fact, the same thing came up the other day when some color of Pittsburgh was brought into a magazine, and the art director—I was not there—turned and said, "You know, there is more color in Gene Smith's black-and-whites of Pittsburgh than you have here." By that he didn't mean glaring, garish colors—these pictures showed brightness and flames enough—but something else. I've noticed quite often that if you use a richness of light and tone—and of course this is a use of light—you achieve the psychological feeling of color

without the vulgarization that frequently results from the color materials we have today.

Q.: *Take the deathbed scene from the Spanish village story— how was it lighted?*

A.: Well, there was one candle, burning in a completely dark room. How to solve it? If I exposed for three seconds at $f/1.2$, I still would have been under, and I couldn't have held—I would have lost the emotional clarity. I very quietly took the reflector off the flash —I think I used flash on but three occasions during the whole essay —and looking at the light the candle was throwing, feeling the mood of the light, I brought the bare bulb right to the point in front of the candle and made the photograph—which I knew was going to be a horribly difficult negative to print. It was, too—but is that important? There was a somewhat similar situation with the Schweitzer pictures by the oil lamp. Except here the oil lamp dominated—was the main light source. I gave a quarter of a second exposure—it may have been a half—hand held, to photograph with its light. In this situation I could have managed with just the oil lamps, because of it being just the one man. But by bouncing my handkerchief-covered Mighty Lite off the dark stained floor, I managed just enough additional light to retain the detail and the soft roundness my eyes saw but which I knew would be lost by the film.

Q.: *Would you say this was a case where the addition of an artificial light gave you a print that was closer to actuality than a straight available-light picture?*

A.: Closer to the seeing—closer to the psychological situation of the moment as well.

Q.: *Do you have any preference between conventional flash and speedlight?*

A.: Well, I think the great value—other than its special uses—of speedlight over conventional flash is simply that if you must intrude with the popping of a flash, at least you don't have to clamber over and around people to change bulbs, and this is a great improvement. For it is desirable to have the least possible belaboring of subjects, and the least possible amount of photographer-caused confusion. I think photographers too frequently make themselves obnoxious—shamefully, unnecessarily so, as if unthinking, uncaring for the decent rights, the dignity of those who have fallen subject. Perhaps I am shy, but I am frequently—by amateurs and professionals—embarrassed for photography and for human dignity, when I see a callous, noisy,

roughshod, trampling, raking-over of the subject's feelings. I think of many news stories, public occasions from the past—however, I was again reminded of this when I watched—and photographed— during a two-day session on the piers where the survivors of the *Andrea Doria* were being landed, in all the chaotic conflicts of that ruptured world. I would rather mingle quietly, letting the world happen, in its honest complexity—photographing as the nearly unobserved observer, or, as in several of my essays, to become an intimately accepted participant. But there, the way it was on those piers— though it be news, fast breaking, I void this as excuse. No editor's call or threat, nor could my needs coerce me to do such as throw body blocks to hold harrowed mothers with their tiny children, or to physically harass children lost from parents, or to harass any others of the distressed, the grief-stricken—to grab, to shove, to hold them as bewildered subject prisoners; shouting, shoving for this fake situation or that cliché, demeaning the tragic, defiling the dignity and the feelings—photographer-reporter teams wearing unwarranted arm bands of mercy, masquerading in this lie, to gain access to the heart core of the working areas of the officialdom of aid—a final working area rightfully barricaded to the press. No constructive purpose is served, for news is not necessarily constructive—remember, such as the Weinberger kidnapping, Grace Kelly?—clobbering the tragic, the pictures often without semblance of honesty, without merits as pictures; what purpose, what value these pictures—are they no more than sucklings from human tragedy, for passing on for the consumption of the morbid feasters? I accept the reporting of tragedy. I admire truly great news photography—the kind almost never picked by the Pulitzer committee—but I wish the press would not abuse their power or needlessly bruise the already bruised. In such a situation I could not bring myself to use flash or strobe or the flying tackle—in such a situation, where the popping of lights in the eyes of the dazed, the shocked, the near hysterical is an aggravation to serious problems— here, then, I will say, if there must be photographs, here, in decency, is the one irrevocably right time and place to use discretion in a broad sense and available light in the narrow sense—in that if there is not sufficient light already present, and if the whole level cannot be gently raised, then put away the cameras, for neither humanity nor photography is thus served.

The contemplation of things as they are
Without error or confusion
Without substitution or imposture
Is in itself a nobler thing
Than a whole harvest of invention.

—Francis Bacon

DOROTHEA LANGE: A HARVEST OF TRUTH

Dorothea Lange tacked the above quotation from Francis Bacon onto her darkroom door in 1932, during her early years as a photographer. It remained there until her death of cancer at the age of seventy in 1965. It would be difficult to find a more apt statement of the principles that guided her career or a better creed for documentary photographers, of which she was one of the best.

Her great theme was the tragedy of human erosion. She discovered it (or was discovered by it) during the black trough of the Depression in San Francisco. The hinge point at which a person's life begins to swing in a new direction is not always visible. With Dorothea Lange it can be located precisely. She was an established, successful portrait photographer. Her studio had a bright south window with a shelf where she made by sunlight proof prints of current portraits. While waiting for the proofs to darken, she would look out the window at the homeless, unemployed men drifting past. (Today a Playboy Club stands at the corner she used to watch, and Bunnies have replaced the derelicts.)

"The discrepancy between what I was working on in the printing frame and what was going on up the street was more than I could assimilate," she said during an interview much later in her life. Taking her camera, she left the studio and went "out there," finding a bitter reality. In 1933 San Francisco was sick and blighted, a city of bread-lines, soup kitchens, strikers, rootless men—the "walking wounded," as she later called the victims of social and economic injustice.

At first she worked alone and unassigned. But her pictures caught the attention of Paul Taylor, a University of California economist and, eventually, her husband. He hired her as a photographic assistant in his study of California migrant workers. When the Resettlement Administration (later the Farm Security Administration) formed a photographic unit under the direction of Roy Stryker in 1935, Dorothea Lange became one of the original members of the group, along with Walker Evans and Arthur Rothstein.

Viewed from today's perspective, it is the timeless, universal quality that seems most important in Dorothea Lange's Depression photographs. They are statements about human suffering and how people respond to it that transcend the particular circumstances of time and place. They still have a power to move. I recall a small child, born to the age of affluence, who was accompanying his father through a Museum of Modern Art photography exhibit containing Lange's famous "migrant mother" photograph. He stopped in front of the picture and stared, fascinated. "Why is that woman looking so sad?" he asked. His father tried to explain about the Depression and the hunger and hopelessness many people felt then. I don't know if the boy could understand, but as they moved on, he kept staring back at that archetypal image, haunted by something he saw in it that disturbed him.

However, it should not be forgotten, Dorothea Lange's pictures once were as hot and timely as a newspaper headline or radio broadcast. Lange's purpose was not merely to record the evidence of suffering and injustice but to initiate reform. As a catalyst, she succeeded brilliantly. The photographs now hanging so quietly on chaste off-white museum walls or hidden in the green filing cabinets at the Library of Congress once provoked controversy, helped mobilize the conscience of the nation, inspired John Steinbeck to write *The Grapes of Wrath*, and contributed to the creation of agencies for relief and rehabilitation. Her images (along with those of her fellow photographers in the FSA) not only recorded historical fact but also helped alter the course of history itself.

Her career epitomizes all that is best in the tradition of documentary photograph, which has been—and continues to be—one of

the significant ways that human beings have devised for using the camera.

Dorothea Lange saw the world with uncompromising directness and honesty, recording what she saw in unretouched, unmanipulated images. To speak the truth as she saw it, directly and simply, was Lange's great gift as a photographer—and as a human being. The total honesty of her vision, so unpretentious, yet so keenly discriminating, informs all her work, whether the subject is a starving migrant farmer, a crossroads store in Alabama, a California superhighway, an Irish country fair, a sunlit oak tree, or her own children.

Lange's main involvement always was with people and the human condition. She tried photographing nature once but gave it up. "People, only people" were the touchstones of her inspiration. Even when recording the artifacts or architecture of contemporary life—a sharecropper's shack, a Midwestern road flowing toward a vanishing point on the infinitely distant horizon, or neon calligraphy in a California town—she saw them in terms of their human relevance. For her, environment was an extension of man, rather than aspects of a universe transcending man. (One curious—and lovely—exception is a series of photographs she once took of an oak tree, which remind one of Edward Weston with their silvery luminescence and vigorous interplay of shapes.)

She never considered herself an "artist," yet artistry raised her work above the level of record and visual evidence. Although her first concern was with content and purpose rather than composition and technique, she had a strong sense of graphic design. She studied under Clarence White, worked with Arnold Genthe, spent many hours behind a portrait camera in her studio. This discipline and practice aided her greatly when she left the studio to photograph the evanescent, unpredictable world "out there."

She was extraordinarily selective in her choice of what to put in and what to leave out of a picture—a reflection of the clarity of her own thoughts and feelings. She achieved an unforced simplicity and power even in her complex photographs of groups—qualities stemming from the right details organized to make her point instantly clear. But her essential concern always was with what she was saying. She used her "art for life's sake," as George Elliot says of her.

Miss Lange had an especially sensitive eye for the beauty and meaning conveyed by simple human gestures: the bent back, the chin resting on a hand, cupped fingers shielding eyes from the burning sun. She often used this silent language of stance and gesture ("body language" in the later term), to speak eloquently of love, pity, entreaty, defiance, or despair.

She had a witty and trenchant eye, too, for the juxtaposition of things that make an ironic comment without words: the neon sign of a car dealer framing the decaying grandeur of a Victorian house, a trailer truck loaded with new cars on a California highway passing the shattered hulks in an auto graveyard.

The Lange images of the Depression rank with the definitive pictures of the era. By their power and compassion they have burned themselves into the collective memory of millions. Like the Brady and Gardner photographs of the Civil War, they have become archetypal images—enduring records from another Time of Troubles whose hard outlines already are becoming blurred by myth.

She never sought ugliness for its own sake. Even her photographs of the most sordid, shattering subjects affirm her faith in the essential value of human life. Yet she never sought to soften or dilute the ugliness, either.

"Pick a theme and work it to exhaustion," she once advised a beginning photographer. "Pictures are a medium of communication, and the subject must be something you truly love or truly hate." But as she pointed out later, the theme that guides a photographer need not necessarily be a conscious one. "It can grow almost of itself, depending on the photographer's instincts and interest." As she found her leitmotiv while looking out her studio window at men on the street.

One panel in a recent Lange retrospective exhibition—by far the most powerful in the show—is a climactic summary of Lange, the documentarian. It is called "The Last Ditch" and is introduced by her own words. "I am trying here to say something about the despised, the defeated, the alienated," she wrote. "About death and disaster, about the wounded, the crippled, the helpless, the rootless, the dislocated. About duress and trouble. About finality. About the last ditch."

In this panel (her reputation could stand on these few photographs alone) the pictures show people trapped and destroyed by forces they cannot control or even comprehend. Here are faces, young and old, eaten away by the acids of hunger, disease, and despair. You can almost smell the poverty and defeat transfixed in the photographs— the sour stink of unwashed bodies and dirty clothes, of mouldering mattresses, rotting wood, kerosene lamps, open privies. Here is shown the dead end of hope. Yet in the defiant stance of the man on the White Angel breadline (turning his back toward humiliating charity), in the gesture of the Woman of the High Plains, and even in the tormented eyes of the Shacktown child, a stubborn, irreducible core of human dignity remains. These are not only victims of social

and economic forces; they are individuals. Through Lange's extraordinary empathy and sharpness of eye, we are able (in however limited and momentary a way) to share their inner life.

Dorothea Lange continued to photograph for government agencies as the Depression era merged into the cataclysmic years of World War II. Then, in 1945, after covering the United Nations Conference in San Francisco, she collapsed, struck down by the first of a series of illnesses that plagued her later years. Yet she continued making photographs during periods of relative health, of her family, of the Mormons, and while visiting Ireland, Asia, and Egypt.

These later phases of her work are less familiar than her Depression pictures. Here are many happy, charming images. She obviously was delighted by her opportunities to travel, enjoying the people and scenes she encountered. Her picture essay on Ireland is particularly successful, full of warmth and life but never mawkish or sentimental. She approached her more personal, subjective projects with the same honesty and directness, the same passion for truth-telling that mark her documentary work.

However, Dorothea Lange never again seemed to find, by conscious search or intuitive revelation, a theme that gripped her with the same passion she experienced during her FSA years. Then circumstances and her sense of mission acted as a burning glass, bringing all her talents into intense focus. During her last twenty years she created individual photographs of high merit, but her output lacked the sustained fire of the Depression documentaries. (The toll that ill health took from her creative energies is, of course, impossible to calculate.)

Part of her search, represented by a number of photographs in "The New California" series, was to explore old, familiar ground in new terms of prosperity and abundance rather than stagnation and depression. "This latter work she considered not a document but a sketch for a document," John Szarkowski, head of the Museum of Modern Art's Department of Photography, wrote in his introduction to her retrospective exhibition. "The record of the sixties that she wanted to make was beyond the reach of one photographer. During the last two years of her life she worked to define the conditions under which a new documentary unit might provide for this generation a service parallel to that performed thirty years ago by the photographers of the FSA."

An examination of her life's work strongly reveals Dorothea Lange's skill as a portrait photographer—a skill she acquired early and maintained at a high level until the very end. If only the portraits she made during her long career remained for us to examine, one

would say: "What an extraordinary photographer!" There is a haunting portrait of her mother, slightly blurred, slightly off focus, vibrant with life, like Julia Margaret Cameron's portraits of Thomas Carlyle or Sir John Herschel. Then, of course, there are the migrant workers, the Dust Bowl farmers, the Southern sharecroppers often photographed outdoors with the blazing sun like a merciless Kleig light, revealing every line, mole, and wrinkle. And there are gentle, lyrical portraits of children, too.

"Time has edited these photographs," Dorothea Lange wrote of her pictures during her preparation of a major exhibition she never lived to see. "They are a product of the files. . . . A photographer's files are in a sense his autobiography. . . . As fragmentary and incomplete as an archaeologist's potsherds, they can be no less telling."

In the total body of her work Dorothea Lange has given us her autobiography, and through her pictures she has left a rich harvest of truth for us to share.

ALFRED EISENSTAEDT: A SNAPSHOT

On Saturday mornings we used to sit together in Alfred Eisen-
staedt's office high up in Manhattan's Time-Life Building, going over
his pictures and talking about them. They assign each *Life* photog-
rapher a tiny cubicle, narrow and windowless, like a monk's cell
or a graduate student's carrel. It is a kind of expanded locker for
storing equipment and prints, with just enough room to sit in, killing
time between assignments. Not much more is needed: the real ex-
istence of *Life* photographers occurs not here but outside, in Wash-
ington, Moscow, Hong Kong, Tel Aviv, the Galapagos Islands, or
wherever the editors decide the picture stories are.

It was peaceful there on Saturday mornings with the office
nearly empty, the typewriters quiet, the telephones silent. Sometimes
Eisenstaedt's next-door neighbor, Fritz Goro, would pop in for a mo-
ment. Once we encountered David Douglas Duncan, gray-faced with
fatigue and wearing combat clothes, just off a plane from Vietnam
and turning in his undeveloped film to the lab. But mostly there were
no interruptions and we just sat scrunched together in that narrow
cell and talked and looked at Eisie's pictures.

The photographs dominated the little room. There were tall stacks of yellow Kodak printing paper boxes filled with them, thousands of pictures: 11 \times 14 and 8 \times 10 prints, contact proofs, color slides, tear sheets from recent issues of *Life* and old yellowing pages from the *Berliner Illustrierte Zeitung, Die Dame,* and *Picture Post* dating from the thirties. They dominated the room with a felt presence, the ghosts and echoes of many moments past. Looking through them was like leafing through an old family album, except that here, instead of picnics and birthday parties, there were wars and coronations, and instead of relatives and old friends you saw the faces of everybody in the Establishment who was anybody in politics, science, business, music, Hollywood, the theater, art, or writing during the past forty years. It semed incredible that so much of our age could have been recorded by just one human being, one eye at the viewfinder, one shutter finger. Eisenstaedt himself sometimes finds it hard to believe, acting not so much like the creator as the bewildered curator of a vast and valuable file he never seems able to cope with or get properly organized.

These thousands and thousands of images are Eisenstaedt, the photographer, defining his role and contribution better than any words. Eisenstaedt has one of the least abstract brains I know. Unlike Henri Cartier-Bresson, for example, he has never rationalized his approach to photography or evolved a conscious, systematic philosophy of the camera. He is visceral, intuitive, spontaneous, emotional, Zen, and concrete.

So there is no self-defined image one can turn to in trying to evaluate his life's work. It must be pieced together bit by bit, rather like reconstructing a dinosaur from bone fragments. What you find, it seems to me, when you fit all these pieces together, is the evolution of photojournalism in microcosm, as filtered through the mind of one individual. You could make a history of the craft from these pictures: the crude but exciting early experiments with available light; the cinematic fluidity of long-shot, medium-shot, close-up; the emphasis on spontaneity and immediacy; the telling of a story in human terms; the use of unexpected angles and viewpoints, the saturation coverage provided by 35-mm.

The photographs also reveal two Eisenstaedts, side by side, yet fused into a unity: one of them the perennial amateur with a love of nature and the pictorial; the other the experienced old pro with four decades of assignments behind him. The two grew up side by side like compatible Siamese twins.

In his early teens, when he was a schoolboy in Berlin, Eisenstaedt's uncle gave him a simple Eastman folding camera. He still has

a few snapshots dating from pre-World War I Berlin: pretty views of ice skaters in a park, the kind of pictures any bright boy might have taken. And here these early pictures are stored along with pictures of Hitler and Kennedy and Agnew, neatly dated on the back in the photographer's spidery European script. As a compulsive curator, Eisie rarely throws anything away.

Drafted into the Germany army at seventeen, he was sent to the Flanders front as an artilleryman. On April 12, 1918, in the harvest season of mud and killing, his unit was rushed to defend the village of Nieppe against an impending Allied offensive. A British shell exploded in the air fifty feet above his head. Shrapnel hit him in both legs, but he could consider himself lucky: he was the only person from his battery to survive.

After the war Eisenstaedt was nobody, a high-strung little man in his twenties, working at a job he detested—as a salesman for a wholesale firm dealing in belts and buckles. The mind boggles at the image of Alfred Eisenstaedt, the Salesman. Although he hated the job and did poorly at it, he needed the work; he was helping support his parents with whom he was living in their Berlin apartment. The Eisenstaedt family had done well in the department store business before the war, but now all their savings were gone, exploded into nothingness by the postwar inflation of Weimar Germany.

The job was lucky from another standpoint, too. It pushed him back into photography again, as something to absorb his spare time and to relieve the grayness and boredom of daily life. "There were amateurs all over the place," he remembers, and he became one, too, using a Zeiss folding camera. He carried it with him to the Berlin parks and woods to photograph spider webs spangled with dew or the morning light breaking through the trees. These early prints have a quaint and innocent quality, with their soft-focus effects, sepia tones, and unabashed efforts to be arty and pretty.

Eisenstaedt had been limited to making contact prints on printing-out paper (the only technique he knew) until a friend with more experience showed him how to make enlargements. It was an electrifying revelation. To be able to crop a photograph—to blow up a detail, a face, a hand, an arm! The potentials of photography expanded for him, vastly and suddenly.

He is still as enthusiastic an amateur today as he was in the parks of Berlin or working with his wooden enlarger and papier-mâché trays in the family bathroom decades ago. On vacation he stands on the lawn of the Menemsha Inn on Martha's Vineyard, with a Rube Goldberg arrangement of tele lenses and extenders, trying to record a distant Texas Tower in Rhode Island Sound just as the sun sets

behind it. Only one night a summer is just right; otherwise he has to wait until the following year. This time the rain has stopped and the clouds have blown away. Everything is all right except for the mosquitoes that land on his balding head (some willing assistant usually shoos them away). He gets the pictures. The assembled guests, all of whom know Eisie and what he is trying to do, break into applause as if for a successful performance.

During vacation he is a camera nut of the most incurable kind, rising before dawn, driving miles to locate a particular tree, crawling through underbrush to catch a heron before it flies off from a remote pond, or walking the sand dunes (at astonishing speed for so short a man), looking for pictures. "I am a stalker," he once said. "I stalk weeds and beaches. If I could be a painter, I would. But I cannot paint. I cannot sit still long enough."

He might have remained an amateur except for a tennis game in Czechoslovakia in 1927. He was there on vacation—with his camera, of course. Watching the players, he was fascinated by the slanting afternoon light and the long shadows it cast. He photographed a girl with her racquet raised. The picture was bought by *Der Welt Spiegel*, an illustrated weekly, for about twelve and a half marks, and published as a back-of-the-book feature poetically entitled: "Autumn, the Shadows Grow Longer." Eisenstaedt kept on photographing and made more sales. In 1929, at the age of thirty-one, he decided to become a full-time photographer. "I think you have dug your own grave," his employer gloomily commented when Eisenstaedt informed him he was quitting as a salesman, and for what career.

Things did not work out quite so badly, although in the beginning, of course, he made many mistakes. Here was this little amateur, whom nobody had ever heard of, joining a precarious new profession and competing with all the great, established names of the day. It was a rash move, but he had the eye, the tenacity, and the energy. Also the luck. Eisenstaedt often speaks of this, as if it were a familiar spirit or guardian angel standing by his side when he takes pictures, sometimes disappointing him but more often coming to his rescue. "It was my luck that just then he smiled." "It was my luck that just then the sun came out." This is the kind of luck that all successful photographers seem to have or, by some little understood psychic radiation, to make. "When you're in the same room with Eisie, you find yourself unconsciously doing exactly what he would like you to do," a fellow photographer once commented.

He quickly rose from obscurity to become a star photographer for the Associated Press in Berlin, joined *Life* as one of its first four

photographers in 1936, and today, approximately fifty covers and two thousand assignments later, is still active, though no longer on staff. (He was quite upset that the editors did not think it prudent to send him, at the age of seventy, to cover the Vietnamese war.)

Henry R. Luce once called Eisenstaedt "the father of modern photojournalism," but this is not accurate; the New Journalism of the 1920s and early 1930s was well under way before Eisenstaedt quit his job as a salesman. A number of bright young editors, photographers, and publishers in Germany were busy leading a communications revolution; Eisie joined them and contributed to the revolution, without, I believe, really being aware of the significance of what he was doing at the time.

What they invented and worked out was the candid approach to photographic reporting, an approach made possible by technical improvements in cameras and lenses. There was the Ermanox, with its fantastic high-speed lens that let them photograph interiors by existing light. Then came the Leica, the first successful 35-mm camera, which gave unprecedented freedom and speed in shooting with its 36-exposure roll of film. These seminal new tools were explored and exploited by photographers like Dr. Erich Salomon and the now almost forgotten Martin Munckacsi, and editors including Kurt Safransky and Kurt Korff of the Ullstein publications. Eisenstaedt joined them and earned his own reputation as one of the not-so-young tigers of the new style.

During his early years Eisenstaedt captured a number of images, with the magical, haunting quality peculiar to some photographs, that, once seen, are rarely forgotten. One of these is his interior view of La Scala Opera House in Milan, during the 1933 premiere of Rimsky-Korsakov's *The Tale of the Invisible City of Kitezh*. A lovely girl to the right of Eisenstaedt caught his eye. He focused his Leica and made four exposures at about ½ second each (his camera was on an inexpensive and rather unsteady tripod) in quick succession. On one frame he caught the girl just as she turned her face toward her unseen companion in a moment as alive now as on that long-ago evening.

Another famous Eisenstaedt photograph is his close-up of the feet of an Ethiopian soldier. A mythology sometimes grows up around such pictures. Here, for instance, the soldier, whose bare soles are caked with mud, is almost always referred to as the *dead* Ethiopian soldier, and even as meticulous a historian as Beaumont Newhall writes about Eisenstaedt's coverage of the "Ethiopian War." Actually, the soldier was quite alive, lying prone during rifle practice, and Eisie's entire Ethiopian coverage was made months prior to the fighting with

Italy. But you just don't read the picture that way, and it will always be the feet of a "dead" soldier in the eyes of most viewers.

To survive as a photojournalist, Eisenstaedt had to learn how to cope with people, all kinds of people. Looking back over his career, he once commented that the most important thing for his kind of work is not the camera but the ability to establish a personal bond with the person photographed. This Eisenstaedt has been able to do with uncommon success and with a remarkable variety of human beings, from Oriental potentates to Parisian street urchins, dealing with the irascible and the haughty, the egomaniacs and the paranoids, the people who hate photographers and the hams who want to direct every shot.

His candid portraits include some of his best work and rank high with the finest achievements of any photographer in this style. Sometimes he shows the frailty of a Great Man caught in an act or gesture that cuts him down, not cruelly, but with a humor that reduces him to the absurd and finite status of a human being. We watch an exhausted Clement Attlee dozing off at his own Labor Party rally, cheek resting on hand and face pulled all askew (an image of a spent postwar Britain as well as of a weary Prime Minister going down to defeat). Or we witness the dismay of the late Senator Robert Taft during a New Hampshire primary upon having a live chicken thrust into his hands, which he holds as if it were a moray eel about to snap at him. In photographs like these Eisenstaedt can be, as Anthony Eden once called him, "a gentle executioner."

In others, his most enduring portraits, you feel the impact of another human being directly, like an electrical discharge, as if the camera and its staring lens had never been interposed between you and the subject. These are "confrontation" photographs of the most effective, revealing kind, with the subject looking directly at the photographer and, through his captured image, into the eyes of the viewer. Direct eyeball-to-eyeball contact. The volcanic energy of painter Augustus John ("I only had a short time; the light was dying."). The gentleness of Ernie Pyle with his GI shirt and the gray stubble on his cheeks. The intelligence of Oswald Veblen and the intensity of J. Robert Oppenheimer at Princeton's Institute for Advanced Studies. The venom of Dr. Joseph Paul Goebbels, Propaganda Minister of the Third Reich, sitting among his aides on the lawn of the Carlton Hotel in Geneva: an archetypal picture, with the malevolence of the Nazis' regime concentrated in Goebbel's glance as he looks up in hatred and disgust at this presumptuous little man who dares poke a camera at him.

There was an aftermath to the Goebbels picture. The Gestapo,

of course, knew Eisenstaedt had taken it. Later Gestapo agents visited him in his apartment in Berlin. They made him nervous, but were very polite, he remembers, being mainly interested, it seemed, in obtaining some extra prints for Goebbels. Eisenstaedt did not leave Germany for another three years, which in retrospect does not seem a moment too soon. But Eisie always had had a precise sense of timing. He had had to learn to think and act fast when necessary, and his nervous system seems wired for instantaneous response. "A photographer needs a short-circuit between his brain and his fingertips," he once said. And another time: "The photographer is sometimes like a lion caught in a trap. He has to do something to escape—and do it quickly. Perhaps what a photographer needs is not so much a high IQ as a fast IQ."

Although sometimes photographing his subjects unobtrusively, he is not committed to being the Invisible Man, the photographer who blends into the background like a chameleon against sand. More often he is in direct contact with the person he is photographing. "I talk to them," he says simply. I was surprised to learn how many of his portraits had been taken with the camera on a tripod. They were "setups" in a certain sense, with the background he wanted and sometimes illuminated with a small flood (although he prefers to use available light whenever this is practical). The results, however, are spontaneous and relaxed, the direction so understated and true that it doesn't show. Sometimes, though, even Eisenstaedt's talent with people is overtaxed. In photographing Vice President Spiro T. Agnew, he received a fixed smile and stony silence. All other attempts at starting a conversation having failed, Eisenstaedt asked in desperation: "Mr. Vice President, won't you please ask *me* some questions?" Agnew thought for a moment, then said: "Are you a member of the Silent Majority?"

Along with his sensitivity to human beings, a second salient quality of Eisenstaedt's photography is his pictorial sense. "Pictorial" is a much-abused word. But in the broader meaning of a concern with visual beauty, there is no more apt word to describe Eisenstaedt's seeing. All his adult life he has been concerned with beauty in its traditional, post-Renaissance Western sense. He started as a "salon" photographer. In his manner of composing, seeing light, and using color his style is rooted in the work of painters like Rembrandt, Rubens, and Franz Hals, whose paintings he admired and studied in Berlin during his early years as a photographer. Their influence is echoed, sometimes subtly, sometimes overtly, in his later photographs.

He loves natural beauty and all things romantic and nostalgic: sunsets, flowers, city lights after dark, a resort in autumn haunted

The enigmatic detail: Edward Steichen recalls that many people have asked him how he induced John Pierpont Morgan to pose with a dagger in his hand. Actually, the triangular highlight under Morgan's left hand is only the reflection from a chair. (The Museum of Modern Art)

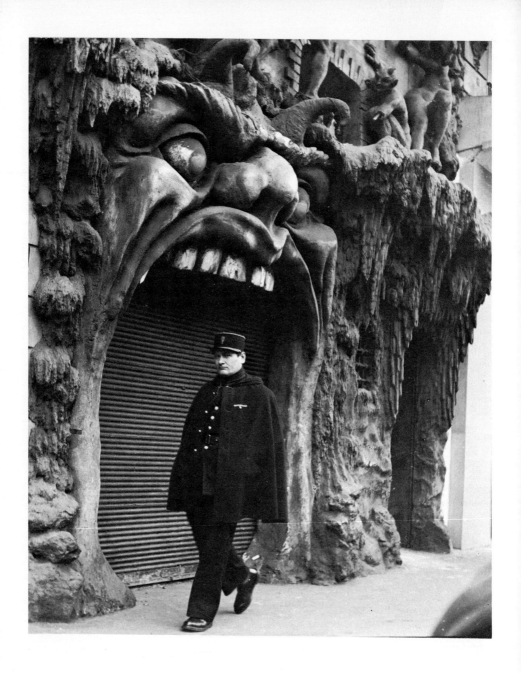

Visual puns: Image ambiguity can add humor to a photograph. ABOVE: Gaping jaws of a funhouse giant appear ready to devour a blandly unconcerned gendarme in Robert Doisneau's photograph. (Rapho Guillumette Pictures) OPPOSITE: In Elliott Erwitt's startling view of a horse in Bahia, the question is: what happened to the other half of the animal? (Magnum)

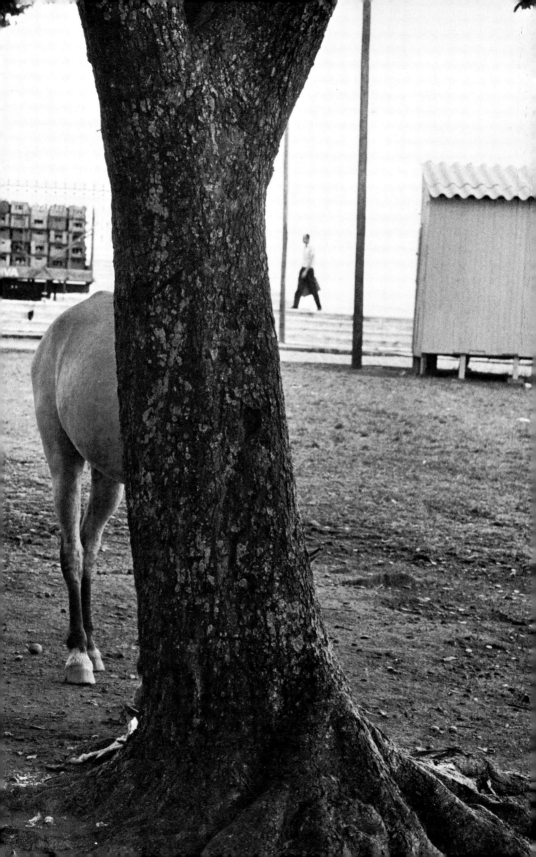

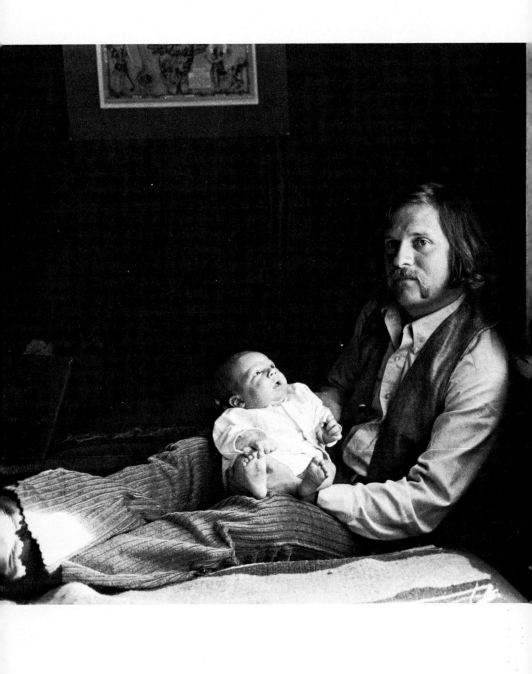

The ambiguity of the extracted moment: Who is this man, the baby, and the mysterious cat in the window? What is their relationship and why are they together in the camera frame at this moment in time? Hugh Harpole's deceptively serene photograph raises more questions than it answers. (Famous Photographers School)

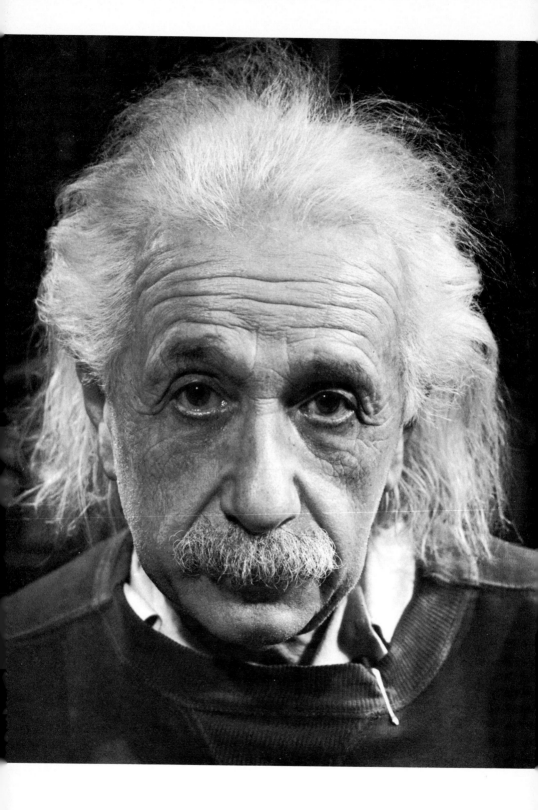

The ambiguity of human expression: The portraits that wear the best are often the most subtle and complex. OPPOSITE: In Philippe Halsman's great portrait of Einstein, what do you read: sorrow, certainly, but also pity, gentleness, a childlike pathos? The viewer participates in the act of seeing.

ABOVE: Irving Penn's portrait of French novelist Colette is a complex, enigmatic photograph: the expression at once noncommittal and evocative. (*Vogue,* © 1954, The Condé Nast Publications Inc.)

What does the gaze of this Mexican peon, photographed by Henri Cartier-Bresson, signifiy? Is it entreaty, mockery, friendliness, or menace? (Magnum)

by summer memories, the curves of gulls, ballet dancers, and sand dunes. Especially he loves light—natural light, available light—in all its forms. It has been a passion with him from the beginning. He is fascinated with the moods it creates and its play on textures and human faces.

Although the pictorial aspect of his work has won him a wide popular audience, it has tended to put off some of the more articulate and intellectual critics of photography. He is not an "in" photographer at the Museum of Modern Art, for example. Sometimes, indeed, he strays over that indistinct boundary, marking off the sentimental and the corny, and out of the thousands and thousands of photographs taken during the past forty years, there are, inevitably, a fair share of mediocre ones. But the totality of his achievements is one of the great visual documentations of this century.

Eisie the Legend also has tended to obscure the accomplishments of Eisenstaedt the Photographer. As a human being he is colorful, amusing, lovable, and exasperating. He is such good copy, so anecdote prone, that there is a tendency to become sidetracked from the pictures by fascination with the man. Everybody who knows him has his favorite Eisie stories involving his puritanism (when Marilyn Monroe sat on his lap, he became so flustered he shot color film at black-and-white exposures), his frugality, his nervousness, his personal vanities, his prodigious energy, his passion for keeping fit (he walked to work from his Jackson Heights apartment to *Life*'s Manhattan office during a transit strike), his encounters with man and nature (he was nearly thrown into the water by an irate Ernest Hemingway and bitten by red ants in Kenya), and his fabulous autograph collection signed by his famous subjects (Robert Frost wrote him a six-stanza poem on the spot).

Past the Biblical threescore-and-ten mark, Eisenstaedt gives no visible sign of slowing down. Trim and spry and effervescent, he vibrates with a surplus of nervous energy, reminding one, with his quickness of gesture and alertness of manner, of one of those small active birds with a normal body temperature of 110 degrees and a heartbeat twice the normal human rate. He is not much larger than many ten-year-old kids and retains a childlike enthusiasm for whatever he is doing. Quickness and impulsiveness are reflected in his mental processes as well as his motor movements. He is a frustrating person to interview for facts, even for a friend who has learned to read between the lines. A conversation with Eisenstaedt often takes on a nonlinear Alice-in-Wonderland quality of discontinuity and unconscious puns. "You have to give up," he once told me in recounting some difficulties he had on an assignment. "It's the only way to get

it done." He is like the Man with a Grasshopper Mind in the swift, erratic leaps of his thoughts, and you must be prepared to follow the jumps without warning. But to say, as has been said, that he is inarticulate, is far from true. He will talk for hours about his experiences, drawing from a remarkably retentive memory and a bottomless well of stories about the famous and the infamous he has photographed—engaging gossip, like many of his photographs, spiked with shrewd, perceptive, sometimes naïve and sometimes biting observations.

Meanwhile, he keeps on taking pictures with unabated enthusiasm. *Life*, not able to keep him fully occupied with staff assignments, recently gave him permission to take on some noncompeting outside work. At the age of seventy-one, he shot his first advertising assignment, for the British Tourist Bureau. The yellow Kodak boxes accumulate higher and higher in his little cubicle as if breeding among themselves, and his task of organizing all these images to his own satisfaction becomes ever more elusive and monumental. But the next picture remains as much of a challenge to him, as exciting and surprising, as much cause for concern and uncertainty, as the first. He continues to be the world's most professional amateur and the world's most amateur professional.

PART IV

AESTHETICS

THE AMBIGUITY OF THE PHOTOGRAPHIC IMAGE

Despite the realism of photography—its powers of detailed, even literal description—the photographic image can be ambiguous in its parts or in its total effect. In fact, ambiguity, achieved by design or accident, seems to me to be of greater importance in contemporary photography than usually is recognized.

By ambiguity I do not mean the word only in its narrower dictionary sense—an expression (visual expression in this case) that is "doubtful or uncertain; esp. from obscurity or indistinctness; also inexplicable." I mean it in an extended sense, too, as used by the British poet and critic, William Empson, in his *Seven Types of Ambiguity* (New York: Meridian Books, 1955).

To quote Empson, an ambiguity is "any verbal nuance, however slight, that gives room for alternate reactions to the same piece of language." In analyzing the effects of verbal nuances and the interaction of the alternate responses they produce, Empson touched on one of the deep roots of poetry. But it is not only verse that can evoke meanings or emotions that echo, clash, and mingle in rich complexity. A photograph, too, can generate power by a similar effect, and ambiguity is an aspect of the poetry of vision as well as the poetry of verse.

THE ENIGMATIC DETAIL

To begin with, consider the simplest and most obvious kind of photographic ambiguity—a detail in a picture (or cluster of related details) that is so blurred, badly lighted, or tightly cropped that we can't readily tell what it represents. If identifying this enigmatic

149

detail is important to the purpose of the picture (as in recognizing a tool in a how-to photograph), obviously the ambiguity is a flaw. The picture doesn't "read"; its intended meaning is garbled.

But even if the enigmatic detail is unimportant, it may weaken the picture because it is distracting. Its obscurity creates a visual riddle. We look at a snapshot and wonder: What is that pale blob that seems to be resting on Uncle Harry's shoulder? A basketball? A dinner plate? A Stilton cheese? The closer we come to identifying an obscure object in a picture, without doing so surely, the more insistent and annoying it tends to become.

On the other hand, an enigmatic detail, seen in context, sometimes may suggest an idea that reinforces the photograph's meaning or emotional impact. A curious example of this kind of ambiguity occurs in Edward Steichen's portrait of John Pierpont Morgan. Steichen, in his memoirs, recalls that many people have asked him how he induced Morgan to pose with a dagger in his hand. Actually, no such prop was used. The odd, triangular highlight under Morgan's left hand is not reflected from a knife blade but from a portion of a chair. However, Steichen's Morgan is Morgan the Corsair—a fierce and imposing figure. Even a viewer not familiar with the more ruthless aspects of Morgan's career might well jump to the conclusion that he is holding a dagger. And even if one recognizes the chair as a chair, the idea of a dagger, with its associations of potency and violence, also may arise in the mind, adding to the portrait's power.

THE VISUAL PUN

Another type of photographic ambiguity is the visual pun, or play on images, created by relating two or more objects in space with comic or dramatic effect, or by pointing out a visual similarity between dissimilar things.

Visual puns can be created in the camera by choosing a viewpoint that makes the image of a foreground object touch, overlap, or merge with the image of something in the background—for example, a man apparently supporting an automobile in the palm of his hand.

One typical comic visual pun that has retained its freshness and humor more than most is Robert Doisneau's photograph of a policeman at the entrance of a fun house—an entrance shaped like gaping jaws with teeth. Taken in a literal sense, there's nothing very funny about the picture. Here is a cop standing in front of a trick doorway. But the photographer's choice of angle forces us to see an alternate, metaphorical meaning: the policeman is about to be devoured by a gigantic ogre—the jaws are ready to close on him. The man's look of bland unconcern in the presence of his horrible danger and our

awareness of the absurdity of this figurative interpretation give the picture its comic bite.

Visual puns can be used for more serious ends, too. The double meaning of juxtaposed images can be employed for satirical effects, to suggest surrealistic relationships, or to strike a dissonant note that expresses the absurdity or disorder a photographer senses in a situation. One frequently finds a caustic, sophisticated use of visual puns in the work of Elliott Erwitt, to name just one contemporary photographer who employs this type of ambiguity in his work. A photograph he took in Bahia comes to mind: The rear end of a horse weirdly jutting out from a tree trunk, so that seemingly only half the animal is there.

Another type of visual pun is achieved by pointing up visual similarities between dissimilar things. The intended effect might be humor, as in showing a bald-headed man studying one of Buckminster Fuller's geodesic domes. Or it might take the form of showing an inanimate object in such a way that it suggests a human being or animal, with ironic consequences. A brilliant example of this kind of double meaning is Robert Frank's photograph of a new Cadillac shrouded in a winding cloth like a gigantic mummy—a corpse lying in state—awaiting its resurrection by a Los Angeles car dealer.

Visual puns of an even more complex type can be produced by putting multiple exposures on the same piece of film, or superimposing images on one sheet of printing paper. Done crudely, the effect is painfully gauche, but when handled with taste and subtlety the effect can be a lovely blending of the real and the surreal, a dreamlike fusion of memories and associations, as in the photographic montages of David Attie. The danger of a visual pun is that if it is too pat, too obvious, it quickly loses its novelty. But when used to make a significant comment rather than merely as a gimmick, it can be a valuable application of ambiguity in photography.

THE AMBIGUITY OF HUMAN EXPRESSIONS

We grin, smile, laugh, frown, sneer, leer, snarl, grimace, glower, purse our lips, wrinkle our brows, narrow our eyes, and otherwise express our feelings by the contraction of certain facial muscles. However, the way we experience an expression when we encounter it "live" and the way we encounter it secondhand, immobilized in a static, photographic image, are two quite different things.

Face to face with a person, we usually know what causes a particular expression or at least can draw upon a number of cues, conscious and subliminal, to give us a fairly accurate insight. However, removed from context of time, place, and circumstances, many

human expressions are ambiguous. Is a man glowering because he has a bad temper or because his shoes are too tight? Is that bemused, slack-jawed expression the effect of love, a subnormal IQ, or direct contact with the infinite? As has been said of the Mona Lisa, one may wonder whether a girl's complacent smile is due to the fact she has just learned she's pregnant or just learned she isn't. The truth is, we often need some explanation from an outside source to know what actually caused a particular expression.

Sometimes, as in the case of personal acquaintances and public figures, we see what we expect to see, ignoring possible alternatives. Karsh's famous wartime portrait of Winston Churchill is a case in point. To many viewers, it seems to capture the essence of the man's defiant spirt—one can practically hear the resounding words, "We shall never surrender," echo off the walls. However, according to Karsh's account of the sitting, the expression was induced by removing Churchill's freshly lighted cigar from his mouth. It is perhaps irritation, rather than defiance, showing on the great man's face.

However, I doubt if it's necessary or even desirable for us to know the exact meaning of an expression in a portrait. In fact, a degree of ambiguity may contribute to the portrait's richness and power. An expression that is too explicit quickly becomes tiresome, but one that only hints at the emotion and personality within is intriguing. It invites us to participate as interpreter, to seek and weigh alternatives.

I think of the complex blend of sorrow, pity, gentleness, and childlike pathos in Philippe Halsman's Einstein, or the shocking directness of the Mexican peon's gaze in one of Cartier-Bresson's early pictures—a glance combining entreaty and menace. (I do not know whether he wants my friendship or my heart's blood.) Irving Penn's superb portrait of Colette has been on my wall for some time, yet I feel far from certain about how I read those wrinkled, powder-white features, except to feel the exhalation of a very ancient and cynical wisdom. We all have our favorite portraits, like these, that have an enigmatic presence whose fascination is never exhausted.

THE AMBIGUITY OF THE EXTRACTED MOMENT

If one imagines time as being linear and directional, a still photograph represents a point somewhere along that line. In looking at the photograph we see rigid, crystallized present removed from the flow of time—a present whose past and future we can only surmise and whose circumstances we must try to construct from limited evidence. Thus the very act of tripping a shutter isolates the subject and contributes a degree of ambiguity to the image.

This ambiguity of the extracted moment is common to most photographs of happenings taken at snapshot shutter speeds and is the reason why pictures usually need captions in order to communicate on a photojournalistic level. The image itself is likely to raise questions and suggest multiple meanings—or at least leave room for more than one interpretation. Who are the people in the picture, where are they in time and space, and what are they doing? The function of words in a good caption is to fill in these gaps, adding the information that isn't self-evident.

The fundamentally ambiguous quality of the image itself can be demonstrated by almost any of the so-called funny picture books that have appeared on American newsstands in recent years. A photograph of Khrushchev that went out over the UPI wire meant one thing when it appeared in a newspaper with an explanatory caption. The same picture had quite a different meaning when reproduced in one of these books with a caption that gave it a comic twist. But it is not just the absurdity of the caption that causes a laugh—it is also the aptness of the new meaning, which must fit as a possible—if farfetched—interpretation of the situation and expression. The possibility of a double meaning must exist in the picture, and the words merely exploit this ambiguity.

Of course, the photojournalistic level is not the only one on which a photograph can reach us. It may have a universal appeal beyond time and place. If a picture touches us more than superficially, ambiguity may be one of its chief sources of poetry and power—the device that saves it from the calendar-art literalness which some critics from the art world attribute to all photography. The mystery of time frozen into a pattern is as profound as it is obvious—a key to what fascinates us in the work of so many photographers of the passing moment.

When we look at a snapshot (in the broadest sense of the word), it seems to me that what often happens is something like this: We experience a swift, intuitive response to the photograph as a whole—an emotional reaction that cannot be precisely verbalized —resulting from the interplay of shapes, forms, textures, lights, and darks. More or less simultaneously we try to find a rational meaning to the event or situation portrayed. Why is the photographer showing us this particular fragment of time and space? What meaning, if any, did it have for him and may it have for us? In a photograph with an ambiguous quality, we must work from subtle, equivocal clues, filling in the blanks and devising solutions. In this mental play, and in reconciling emotional and rational responses, the viewer participates in the creative act.

To demonstrate this playful use of ambiguous visual elements in provoking the viewer, I can remember no more intriguing example than a picture Henri Cartier-Bresson made in Madrid in 1933, of a fat man in a black hat walking through a playground. One might guess the location is Spain from the faces of the children. However, the geography of the picture is not important—it is a scene out of a timeless dreamscape with the burning sunlight and razor-edged shadows of high noon and a mixture of weird and banal details. What is the white wall that looms in the background with its random geometry of tiny windows? Are the bars to keep the inhabitants in or intruders out? What games are the children playing? The figures are so positioned and the picture so cropped that we can't be certain. Who is the fat man and what brings him here? If you look closely, you see that he, too, is a curiously ambiguous figure—his eyes are hidden by the black shadow from his black hat.

In itself each of these ambiguities is capable of a rational, commonplace explanation. But their total impact takes us beyond the commonplace aspects of the scene, leading us to imagine that something strange is happening. It is the ambiguity of the image—the many questions raised but not explicitly answered that give the picture its charm and power to fascinate.

THE PERILS AND REWARDS OF AMBIGUITY

Fruitful double or multiple meanings are not achieved by trying hard. One does not usually say: "I will make a frightfully ambiguous but meaningful picture," and then go out and do it. Nor is making a self-conscious cult of obscurity likely to lead to much except boring, sterile pictures. Ambiguities that have the power to stimulate us, to ring chimes or discords in our subconscious, are ones that occur spontaneously out of the photographer's response to what he sees.

Empson's warning about verbal ambiguities serves equally well with visual ones. He said: "An ambiguity is not satisfying in itself, nor is it, considered as a device of its own, a thing to be attempted; it must in each case arise from, and be justified by, the peculiar requirements of the situation."

What are the "peculiar requirements" that justify the use of ambiguity? They are to be found not only in the nature of the subject being photographed but also in the photographer's attitude toward the subject. To modern man, in a chronic metaphysical quandary, life often seems complex, equivocal, and contradictory. A photographic art that expresses this consciousness of life must be capable of complex and many-layered statement. In the poetry of vision as well as the poetry of words, ambiguity is one means that can give the statement its necessary richness.

154

APPENDIX

I—CUSTOM LAB SERVICES IN THE UNITED STATES AND CANADA

U.S. CUSTOM LABS THAT DO *BOTH* BLACK-AND-WHITE *AND* COLOR FINISHING

William H. Allen
700 East Water Street
Syracuse, N. Y. 13210

Astra Photo Service, Inc.
6 East Lake Street
Chicago, Ill. 60601

David Atherton Color Lab, Inc.
216 East 45th Street
New York, N. Y. 10017

Berkey K & L Custom Services,
 Inc.
222 East 44th Street
New York, N. Y. 10017

Berry & Homer, Inc.
233 North 12th Street
Philadelphia, Pa. 19107

B/L Labs, Inc.
916 North Charles Street
Baltimore, Md. 21201

Compo-Photocolor
220 West 42nd Street
New York, N. Y. 10036

Cre-Art Photo Labs, Inc.
6920 Melrose Avenue
Hollywood, Calif. 90038

Five-P Processing Labs, Inc.
319 West Erie Street
Chicago, Ill. 60610

Gamma Photo Labs, Inc.
319 West Erie Street
Chicago, Ill. 60610

Judge Studio
610 Wood Street
Pittsburgh, Pa. 15222

K & S Color Service, Inc.
180 North Wabash Avenue
Chicago, Ill. 60601

K/Z Photographic Industries,
 Inc.
822 S. Western Avenue
Los Angeles, Calif. 90005

John R. Kennedy
211 East 38th St.
New York, N. Y. 10016

Ludwig Photo Enterprises
P. O. Box 968
Cheyenne, Wyo. 82001
 and
P. O. Box 1034
Laramie, Wyo. 82070

Modernage Photographic
 Services, Inc.
319 East 44th Street
New York, N. Y. 10017

MP Meteor Photo Company
4630 Oakman Boulevard
Detroit, Mich. 48204

Royaltone, Inc.
16 East 42nd Street
New York, N. Y. 10036

Howard Thompson Photo Lab
2653 S.W. 27th Avenue
P. O. Box 736
Miami, Fla. 33133

Foremost Photographic Service
 Co.
1869 East Grand Boulevard
Detroit, Mich. 48202

John Fulton Photo/Art
7833 Wysong Drive
Indianapolis, Ind. 46219

G & W Photo Service
450 Park Avenue South
New York, N. Y. 10016

Image
1522 K Street NW
Washington, D. C. 20005

Image Photographic
 Services, Inc.
565 Fifth Avenue
New York, N. Y. 10017

Lee Photo Service, Inc.
P. O. Box 97
Flushing, N. Y. 11365

Lexington Labs, Inc.
55 West 45th Street
New York, N. Y. 10036

Meridian Photographic Labs,
 Inc.
64 East 55th Street
New York, N. Y. 10022

Modernage Custom Darkrooms,
 Inc.
6 West 48th Street
New York, N. Y. 10036

Motal Custom Darkroom
18 West 45th Street
New York, N. Y. 10036

Planet Laboratories, Inc.
320 Ann Street
Hartford, Conn. 06103

Veeder Photography
1922 North Haskell Avenue
Dallas, Tex. 75204

U.S. AND CANADIAN CUSTOM LABS THAT DO *ONLY* COLOR FINISHING

Bebell & Bebell Color Labs, Inc.
416 West 45th Street
New York, N. Y. 10036

B.G. & M. Color Labs, Inc.
692 Adelaide Street West
Toronto, Ontario, Canada

Chromatek, Inc.
6626 Maple Avenue
Dallas, Tex. 75235

Color Film Processing
4487 Beverly Boulevard
Los Angeles, Calif. 90004

DNJ Color Laboratories, Inc.
1311 Merrillville Road
Crown Point, Ind. 46307

Gittings, Inc.
3327 D'Amico
P. O. Box 13239
Houston, Tex. 77019

Meisel Photochrome Corporation
1330 Conant Street
Dallas, Tex. 75222

National Color Laboratories
306 West First Avenue
Roselle, N. J. 07203

Newell Color Lab, Inc.
816 Seward Street
Hollywood, Calif. 90038

Pacificolor
6303 Roosevelt Way, N.E.
Seattle, Wash. 98115

Primary Color Laboratory, Inc.
P. O. Box 50502
New Orleans, La. 70150

Prisma Custom Laboratory
(Agfacolor)
611 North Broadway
Milwaukee, Wis. 53202

ViviColor
P. O. Box 2208
Atlanta, Ga. 30301

Jack Ward Color Services, Inc.
202 East 44th Street
New York, N. Y. 10017

(List of labs courtesy of *Famous Photographers Magazine*.)

II SAMPLE MODEL RELEASES

Short forms
MODEL RELEASE
Date _____

Place _____

I hereby consent to the use by you, or by anyone you author-
ize, for the purpose of advertising or trade, of my name and/or
a portrait, picture or photograph of me, or any reproduction
of same in any form.

Name _____

MINOR MODEL RELEASE
I hereby affirm that I am the parent (guardian) of (name) and
irrevocably consent that each of the photographs which have
been taken of him (her) by (name of photographer) and/or
his (her) assigns may be used for advertising, trade illustration,
or publication in any manner.

(Name of parent or guardian)

(Date)

158

Long Form
MODEL RELEASE

In consideration of $_____, receipt of which is hereby acknowledged, I hereby give and grant unto _____, and each and all of its subsidiary companies (hereinafter referred to as the "Company"), their agents, representatives, successors or assigns and to any persons or firms on whose behalf the Company is acting, the absolute and unconditional right to copyright, use, publish, display and/or reproduce in any manner whatever, in color or otherwise, photographic portraits or pictures of me in which all or parts of my face or body appear, including, but not limited to, the right to alter, adapt, modify or use a portion or portions of such photograph or photographs, or composites or distortions of same, alone or in conjunction with any other photographic, artistic or written material, in conjunction with my own or a fictitious name, through any media of any kind or nature, or at the offices of the Company or elsewhere, for art, advertising, trademark, trade or any lawful purpose whatever, all as the Company in its absolute discretion shall deem fit.

I hereby waive any right that I may have to inspect or approve the finished photographs, or any alterations, modifications, adaptations, distortions, composites or portions of same, or any finished advertisements, materials, copy or other matter which may be used in conjunction therewith, or the manner in which any of the same is used, reproduced, published or displayed.

I further release and discharge and agree to save harmless the Company, its agents, representatives, successors and assigns and all persons and firms on whose behalf the Company is acting, from any liability whatever by virtue of any blurring, distortion, alteration, optical illusion or use in composite form, whether intentional or otherwise, that may occur or be produced in the taking, processing, reproducing, publishing or displaying of said photograph or photographs taken on _____ (date)

Date_____Model _____(L.S.)
Witness _____

ADULT MODEL

I hereby warrant that I am of full age and have every right to contract in my own name in the above regard. I state further that I have read the above authorization and release, prior to its execution, and that I am fully familiar with the contents thereof.

Date_____Model _____(L.S.)

Witness _____

MINOR MODEL

Date_____Model _____(L.S.)

I, the undersigned, being the parent or guardian of the above named model, do hereby for a valuable consideration consent to the above authorization and release.

Parent or

Guardian _____(L.S.)

Witness _____

(Courtesy Famous Photographers School, Westport, Connecticut.)